dancers
after dark

dancers
after dark

jordan matter

Workman Publishing

NEW YORK

The circumstances depicted in these photographs are not digitally altered or composited, and no hidden wires or other devices have been used in the making of these images.

Published simultaneously in Canada by Thomas Allen & Son Limited.

Library of Congress Cataloging-in-Publication Data is available.
ISBN 978-0-7611-8933-6 (PB)
ISBN 978-0-7611-9310-4 (HC)

Cover and interior design by Galen Smith
All photos by Jordan Matter, except for photo on page v by Lauren Boyer; and photos in the behind-the-scenes section.
Artwork on pages 208–209 by Gum Shoe Art.

Workman books are available at special discounts when purchased in bulk for premiums and sales promotions as well as for fund-raising or educational use. Special editions or book excerpts can also be created to specification. For details, contact the Special Sales Director at the address below, or send an email to specialmarkets@workman.com.

Workman Publishing Co., Inc.
225 Varick Street
New York, NY 10014-4381

workman.com
dancersafterdark.com

WORKMAN is a registered trademark of Workman Publishing Co., Inc.

Printed in China
First printing October 2016

10 9 8 7 6 5 4 3 2 1

To my children, Salish and Hudson, whose love, encouragement, and occasional words of blistering critique helped me discover this project. And to my incredibly supportive and beautiful wife, Lauren, who proves with this image that she's the true photographer in the family.

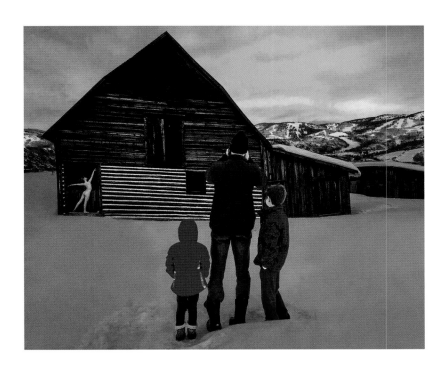

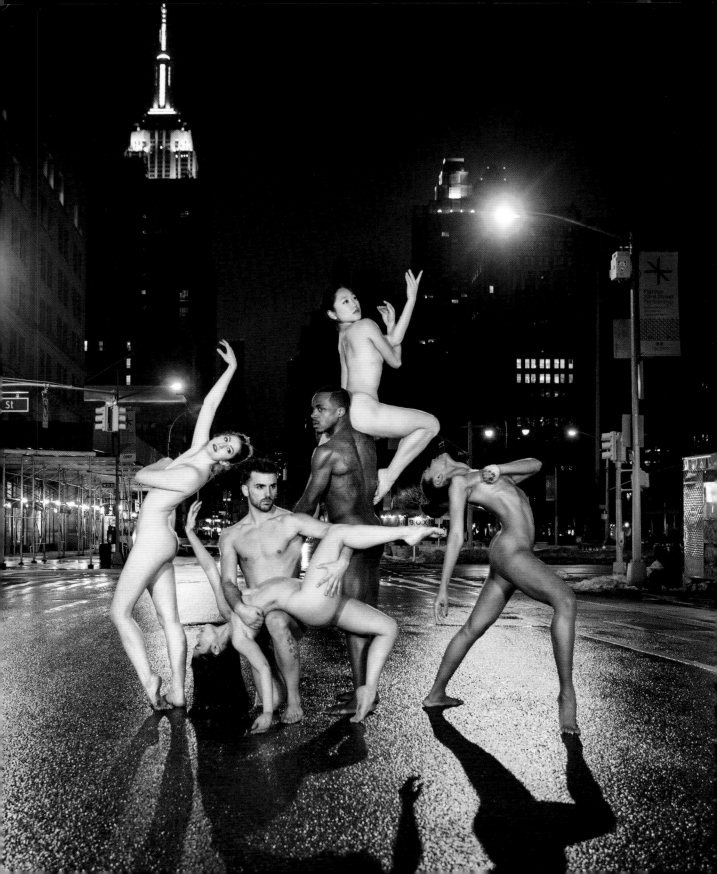

contents

< 3:10 a.m.
Sixth Avenue, New York, NY

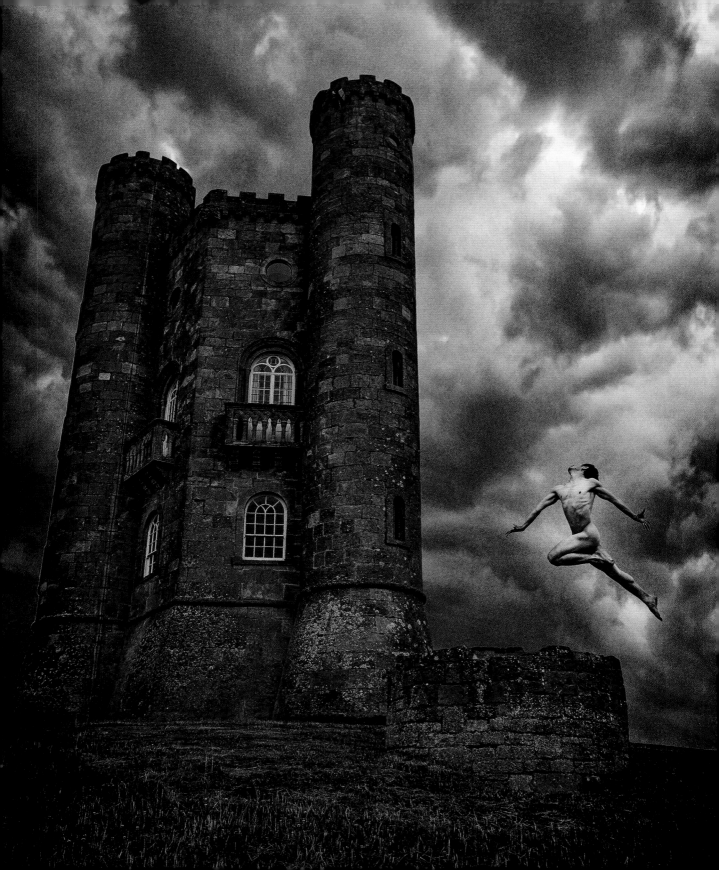

introduction

"In the end we will only regret the chances we didn't take."

LEWIS CARROLL

As a child, I found comfort in the night. I was a shy kid teased for having a funny name and bright red hair, but after dark I became a star. The chaos and vulnerability of the day became a distant memory, and the evening's tranquility brought with it joy and stability. Whatever challenges my life presented were overshadowed by twilight dreams of a better tomorrow. I fantasized about the adventures I would have and the worlds I would conquer. Many years later, my nights are still filled with adventure, but now I have the assistance of kindred spirits.

Dancers are dreamers. Many have left the comfort zone of a familiar life to pursue an ambition fraught with nearly impossible odds of success. They work countless hours over many years, driven not by profit or fame but by a quest to bring their dream world to reality. Etched into their bodies is extraordinary perseverance, and when stripped of their clothing we see each layer of muscle and every subtlety of expression. They are an inspiring embodiment of intense commitment to a life's passion.

Dancers After Dark celebrates this optimism. It is about a willingness to say yes to the unlikely, the outrageous, the impractical. There is no obvious reason why any of these amazing performers would volunteer for this project. It was frequently very cold; it was usually late; it was dangerous, illegal, exhausting, and, of course, *they're naked*. Yet they still said yes. Why? Because they shared my belief that if we leap, the net will appear. Often in life we have to run toward our goals blindfolded, trusting our instincts to guide us. These images represent our willingness to throw ourselves into the streets without fear of failure. Doing so led to beauty and exhilaration we could not have imagined.

I hope these photographs convey the immense thrill and joy we felt while creating them.

< 6:46 p.m.
Broadway Castle, The Cotswolds, England

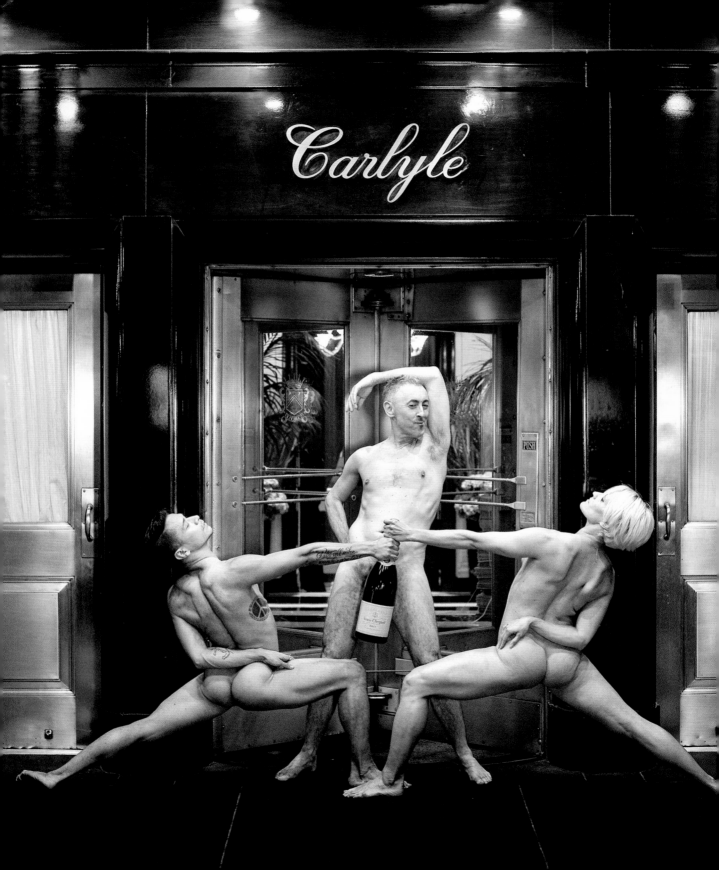

ferocity

"Ferocity can seem like a negative—almost violent—emotion, but I think every artist understands it. When I have an idea, an aim, an uncontrollable passion, I get into a space where there is nothing, nothing at all that will prevent me from bringing that idea to fruition. Then I am ferocious."

Alan Cumming *(pictured center)*

< 2:33 a.m.
Carlyle Hotel, New York, NY

"Don't count the days, make the days count."

MUHAMMAD ALI

12:05 a.m. >
Notre Dame, Paris, France

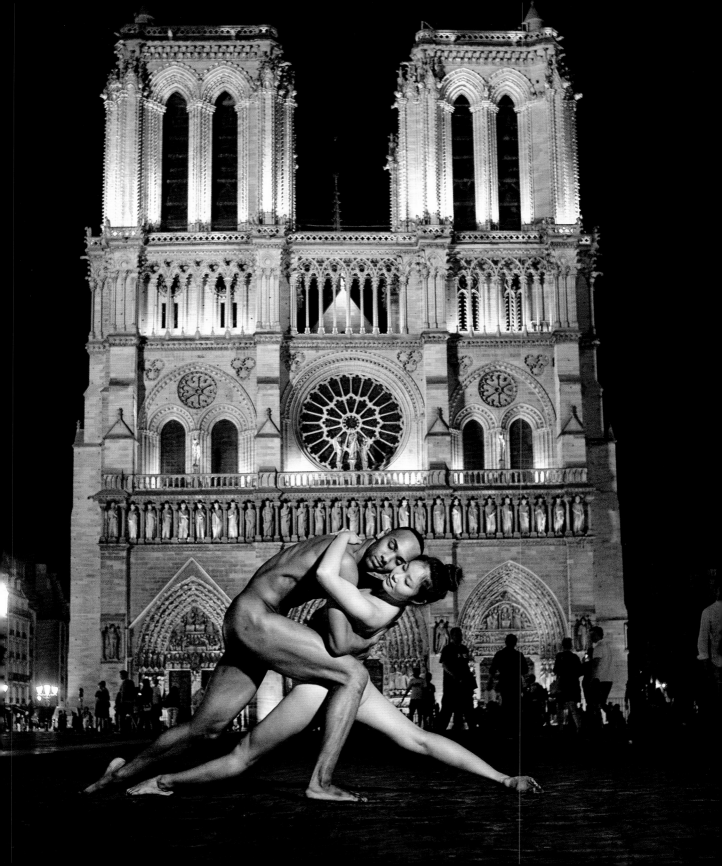

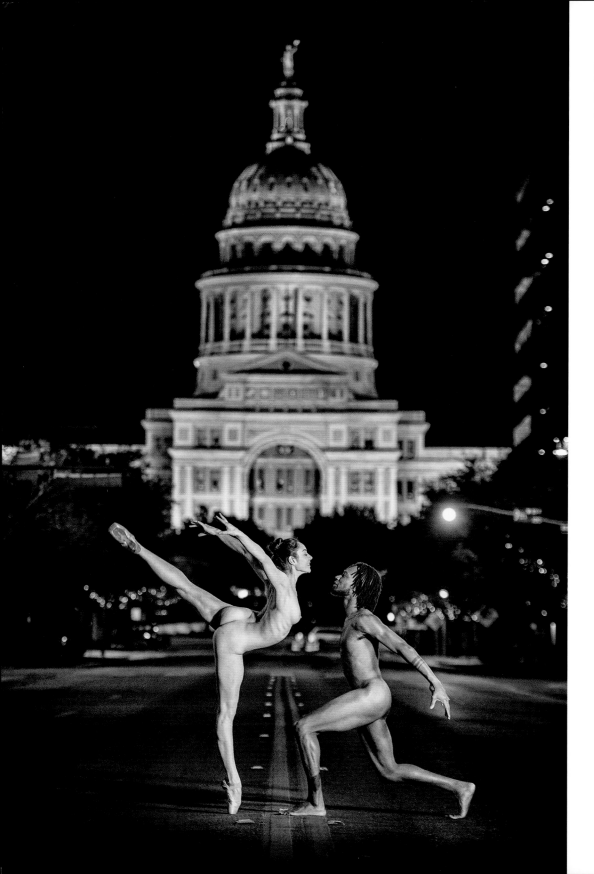

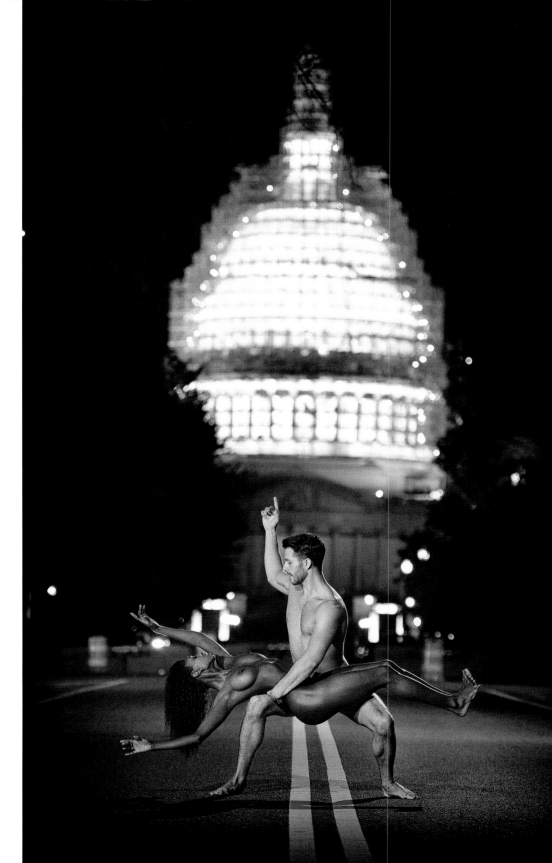

9:37 p.m.
United States
Capitol,
Washington, DC

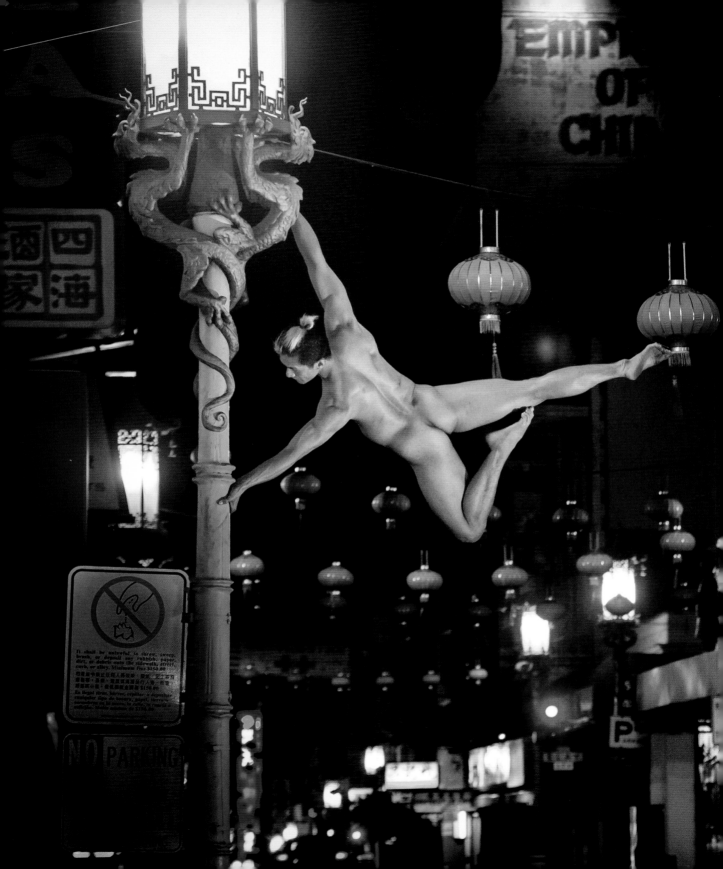

12:40 a.m.
Chinatown, San Francisco, CA

"What's the good of living if you don't try a few things?"

CHARLES M. SCHULZ

7:32 p.m.
Chelsea, New York, NY

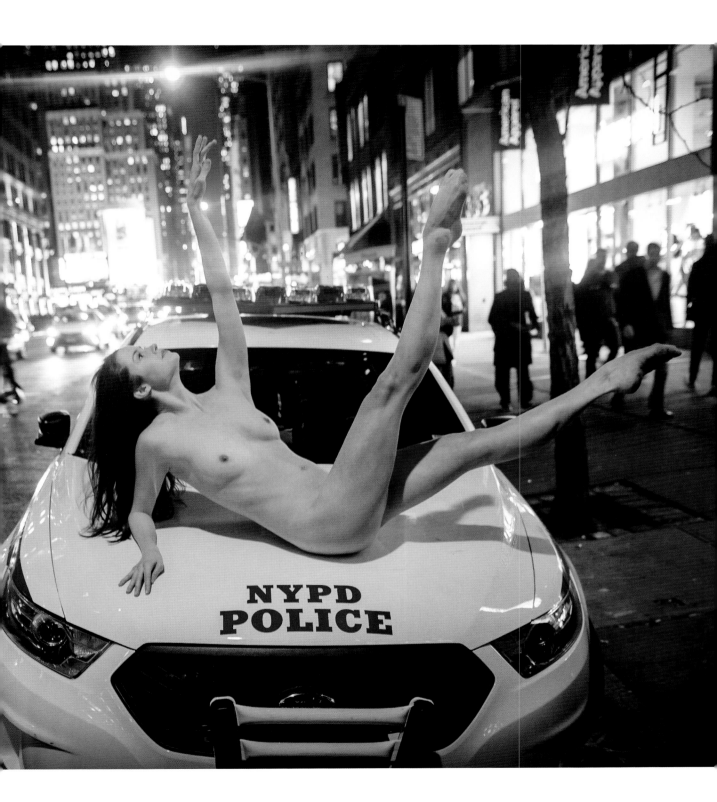

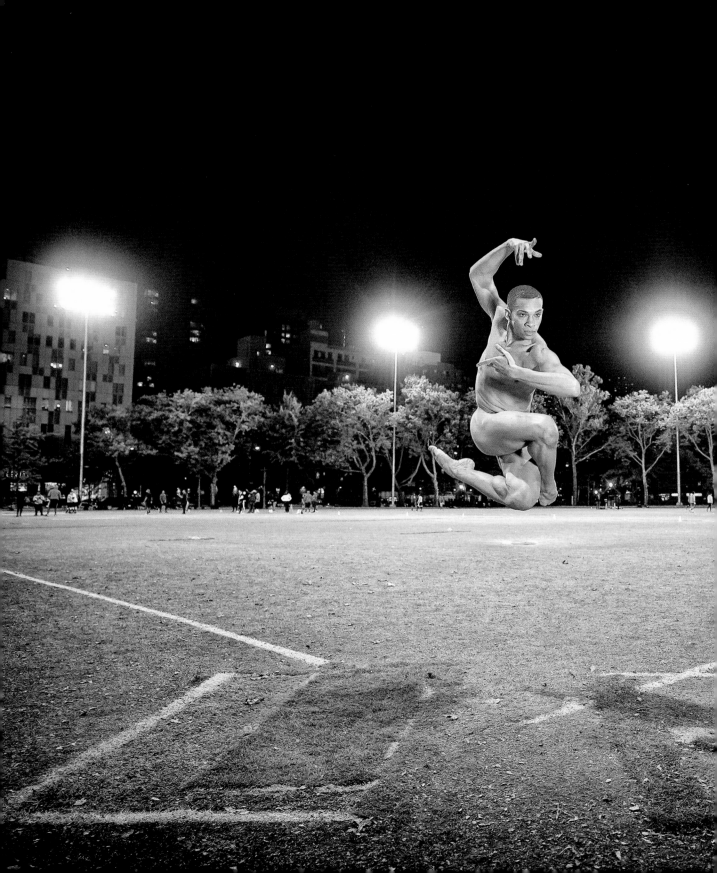

*"You can't steal second and
keep one foot on first."*

ROBERT QUILLEN

10:22 p.m.
Hell's Kitchen, New York, NY

12:51 a.m.
Greenpoint, Brooklyn, NY

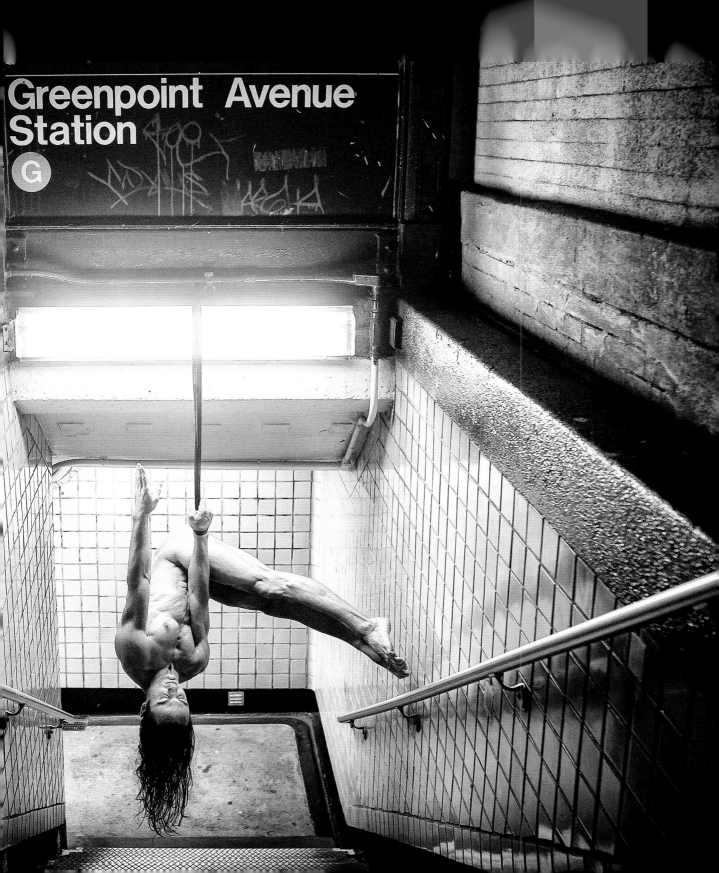

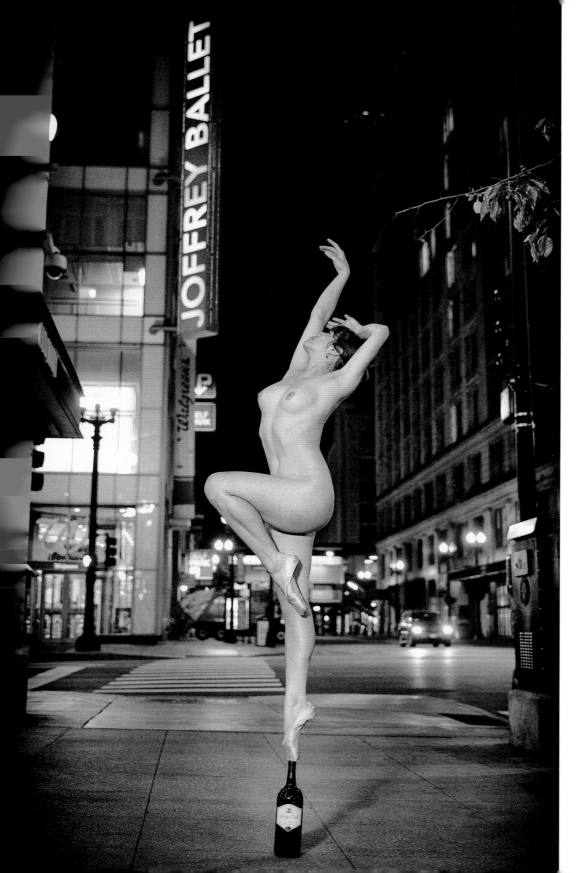

2:24 a.m.
Chicago, IL

"Start by doing what's necessary; then do what's possible; and suddenly you are doing the impossible."

ST. FRANCIS OF ASSISI

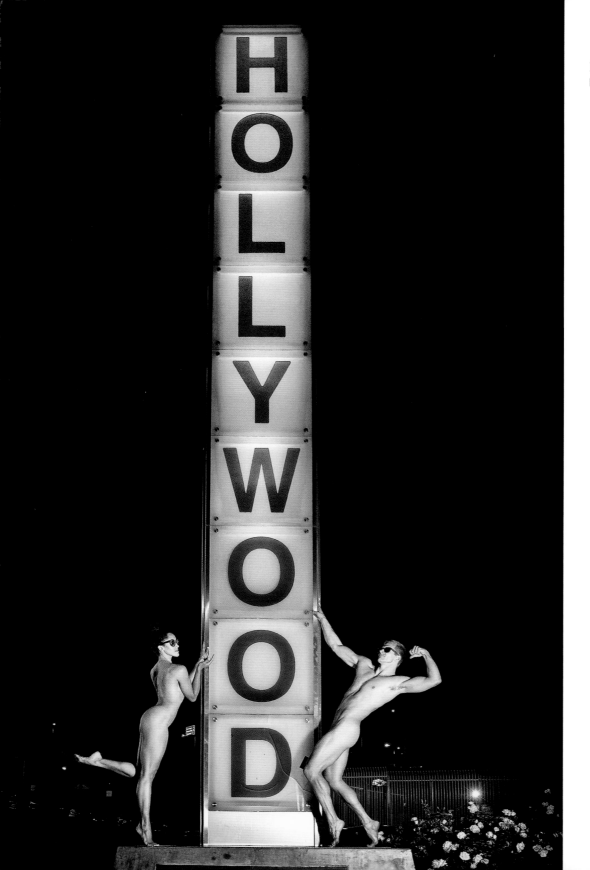

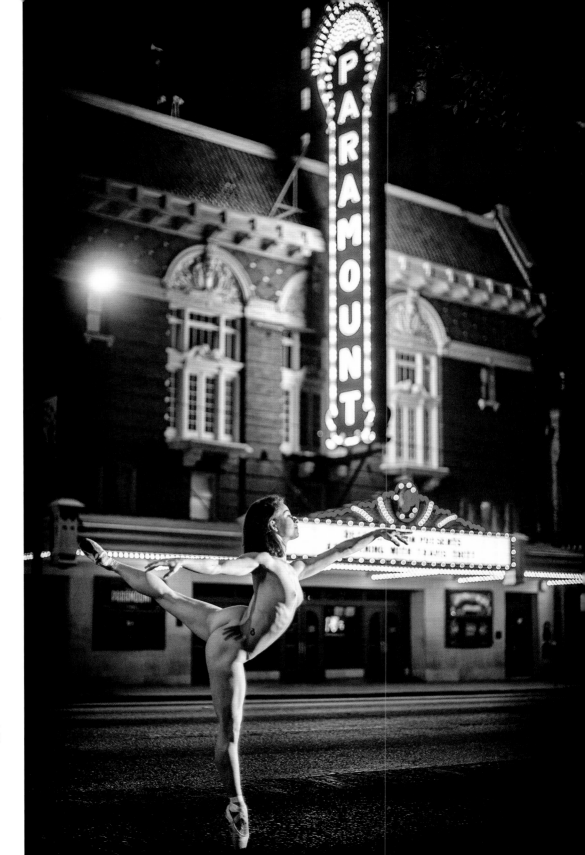

2:41 a.m.
Austin, TX

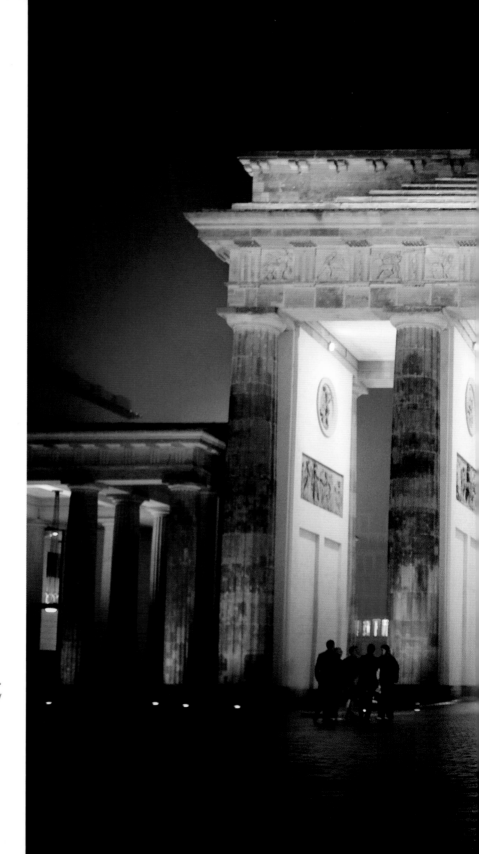

8:30 p.m.
Brandenburg Gate, Berlin, Germany

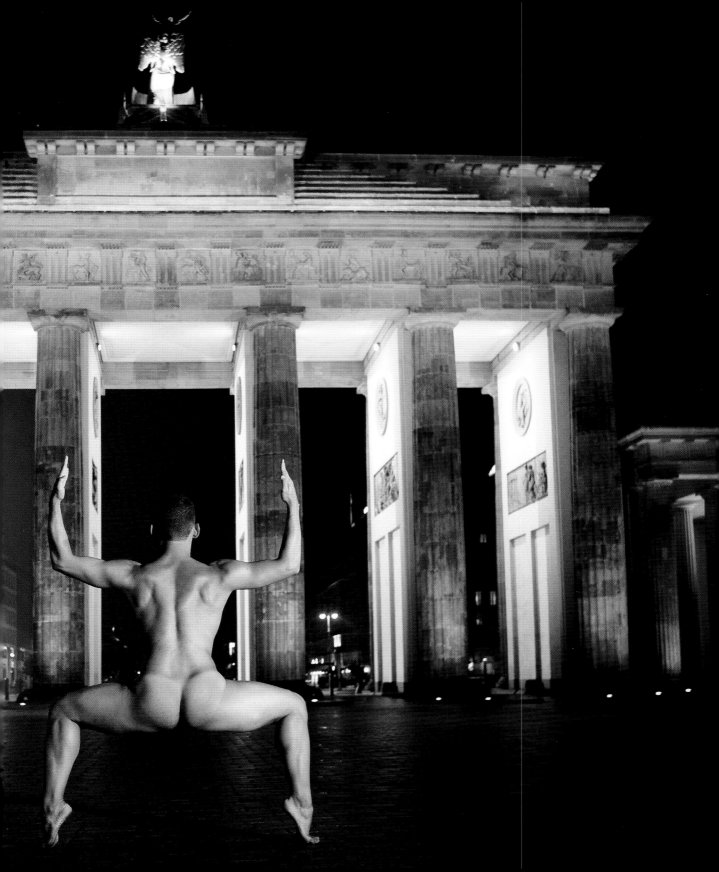

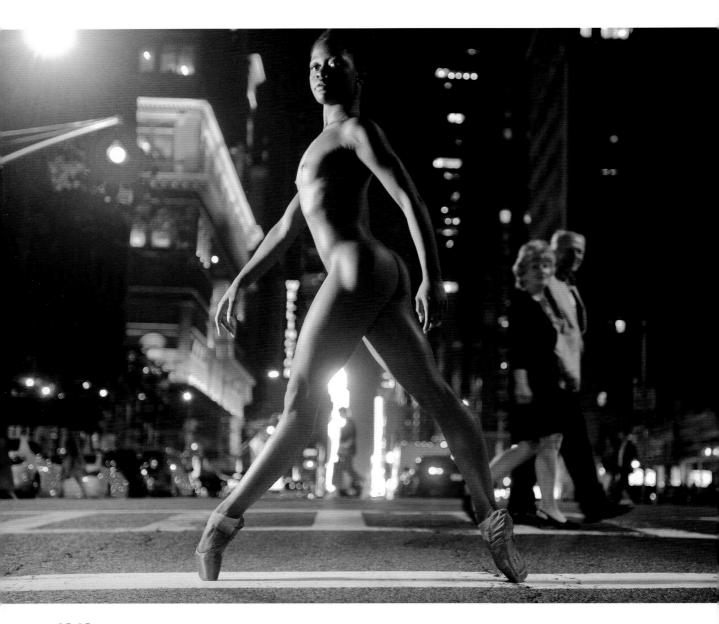

10:16 p.m.
New York, NY

"Creativity is piercing the mundane to find the marvelous."

BILL MOYERS

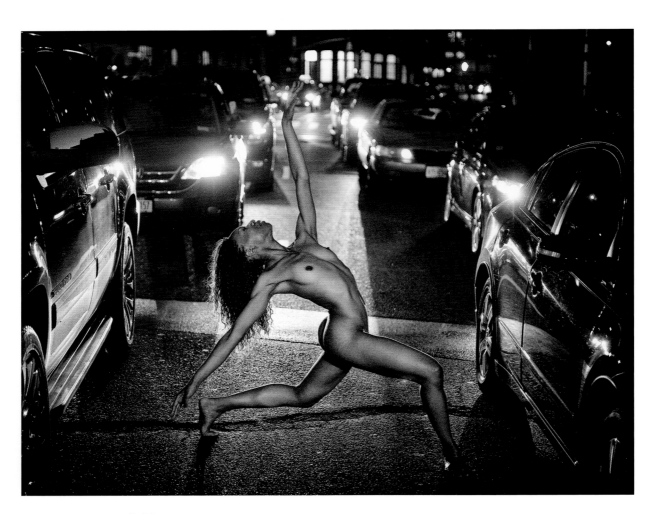

8:26 p.m.
Tribeca, New York, NY

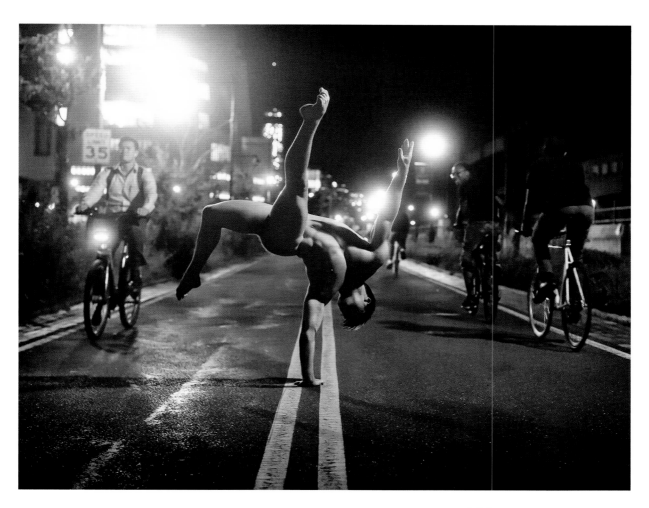

2:10 a.m.
Hudson River Park Bikeway,
New York, NY

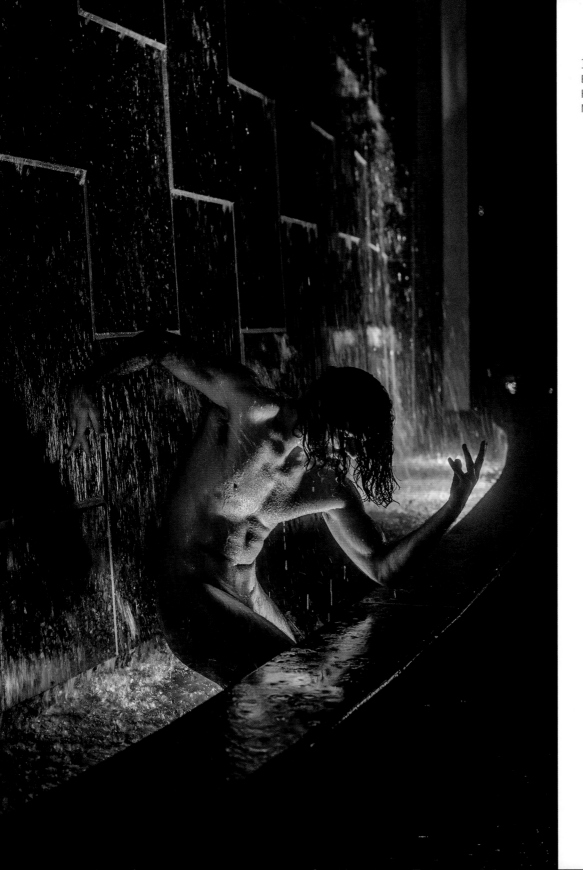

11:24 p.m.
Fontainebleau
Hotel,
Miami, FL

12:52 a.m. >
Times Square,
New York, NY

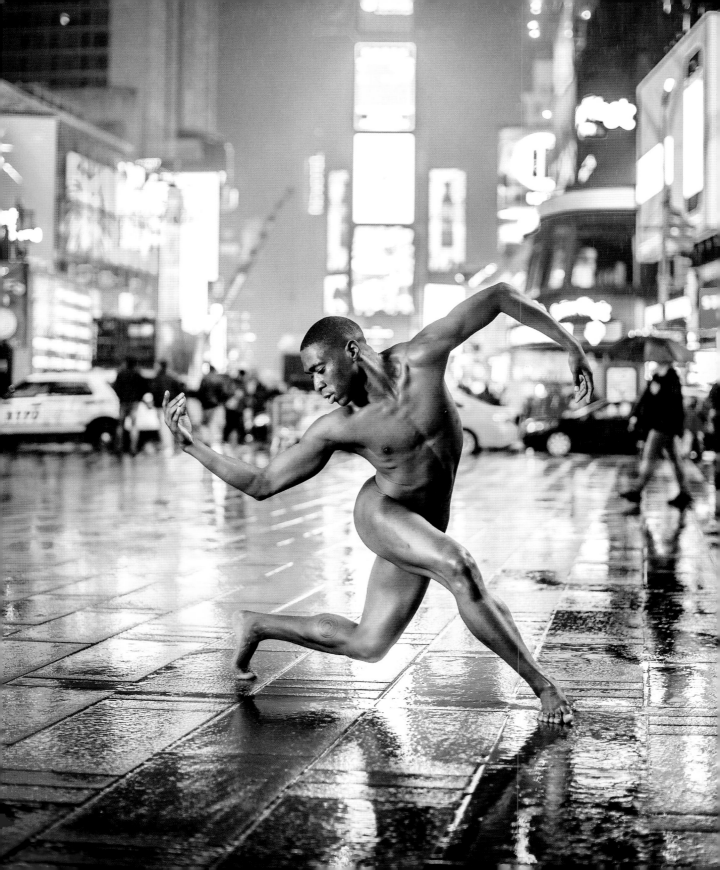

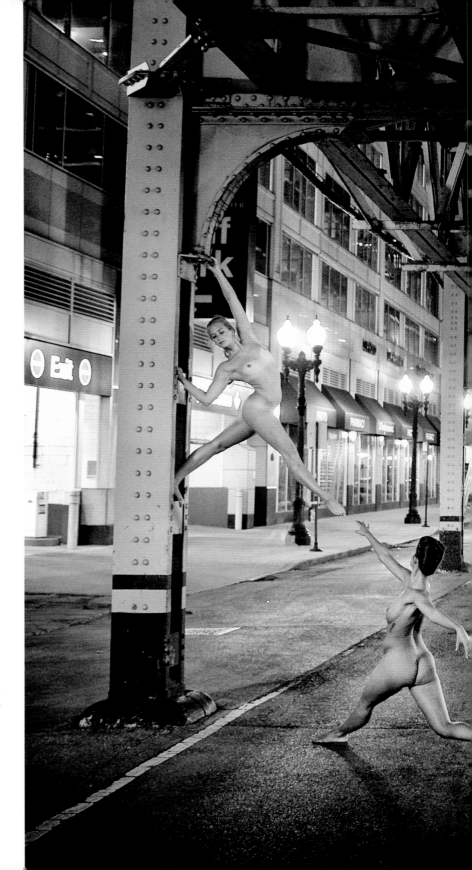

3:34 a.m.
"L" Train, Chicago, IL

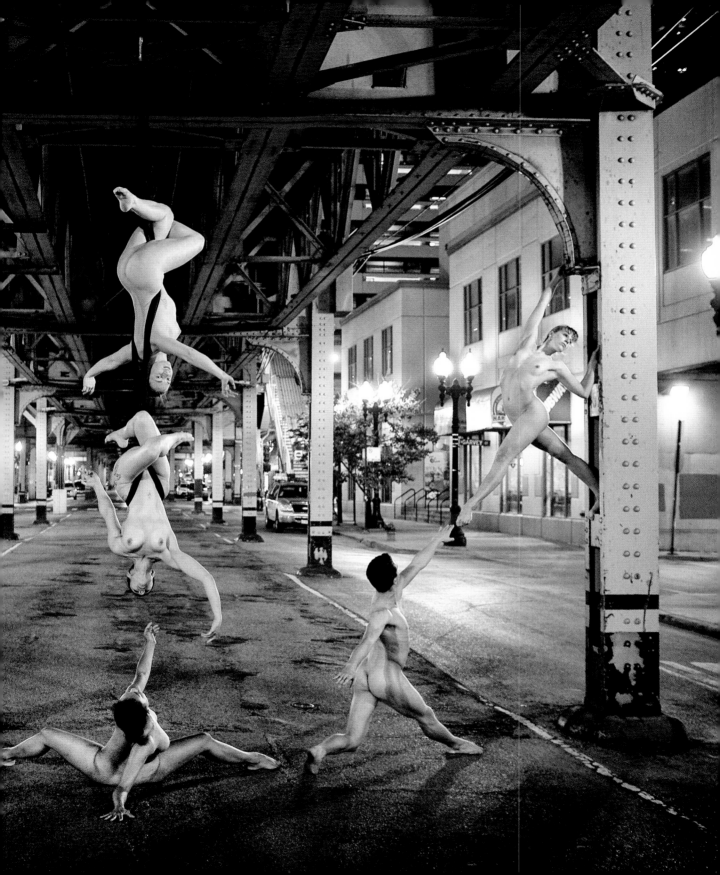

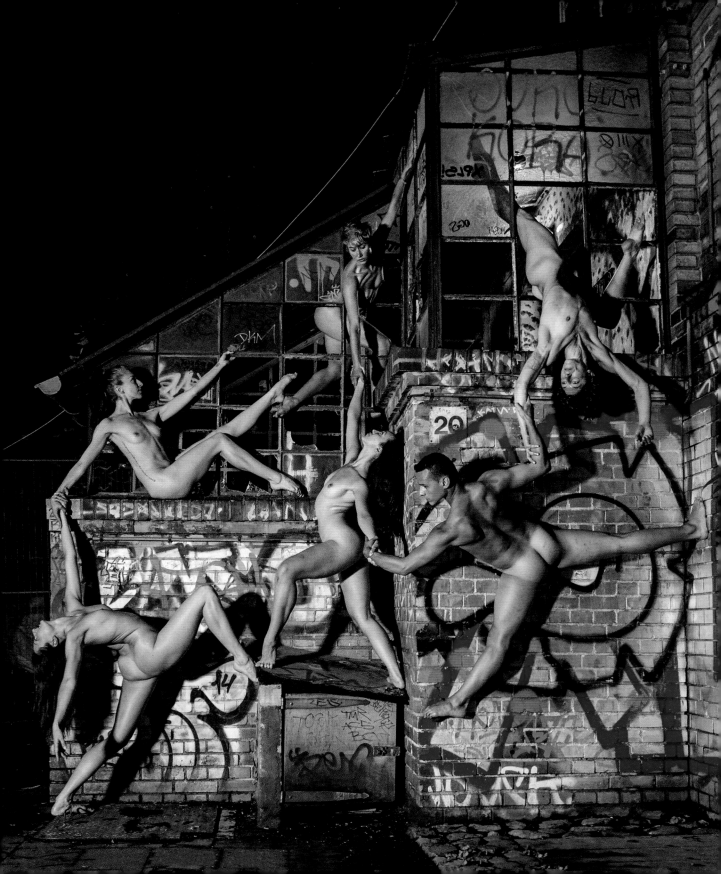

"Never tell people how to do things. Tell them what to do, and they will surprise you with their ingenuity."

GENERAL GEORGE S. PATTON JR.

< 11:04 p.m.
 Berlin, Germany

1:48 a.m.
Columbus Circle, New York, NY

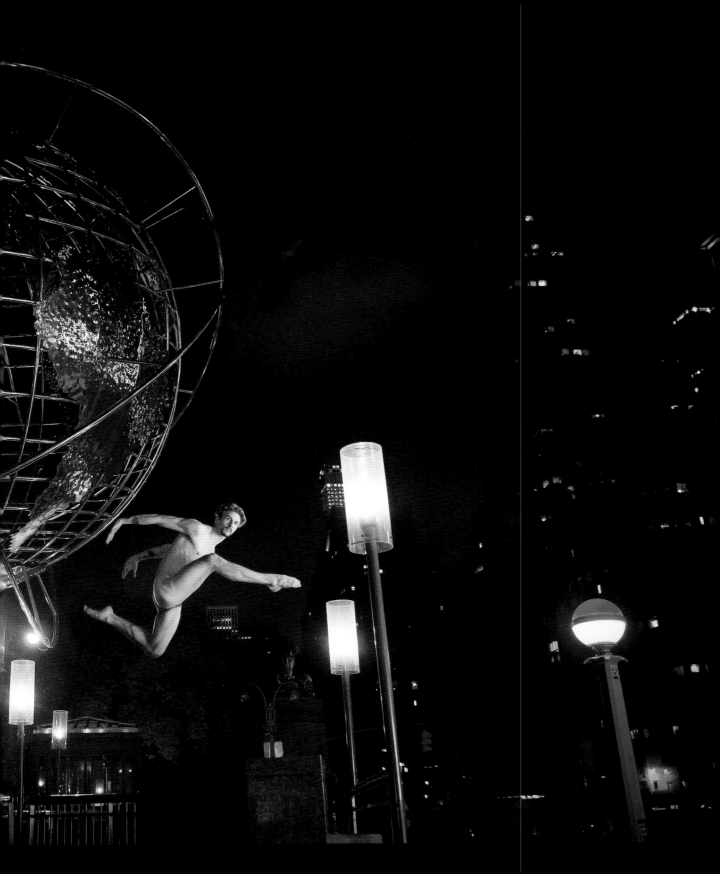

"When you're finished changing, you're finished."

BENJAMIN FRANKLIN

< 12:56 a.m.
Amsterdam, Netherlands

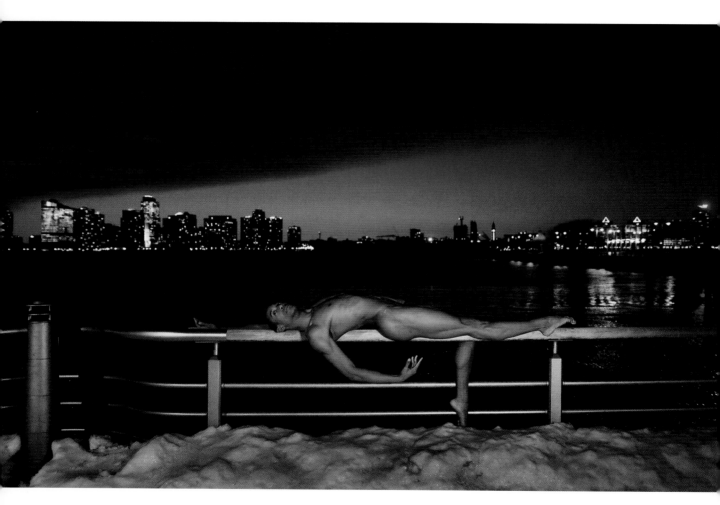

6:06 p.m.
Hudson River Park Walkway, New York, NY

6:34 p.m. >
Fort Tryon Park, New York, NY

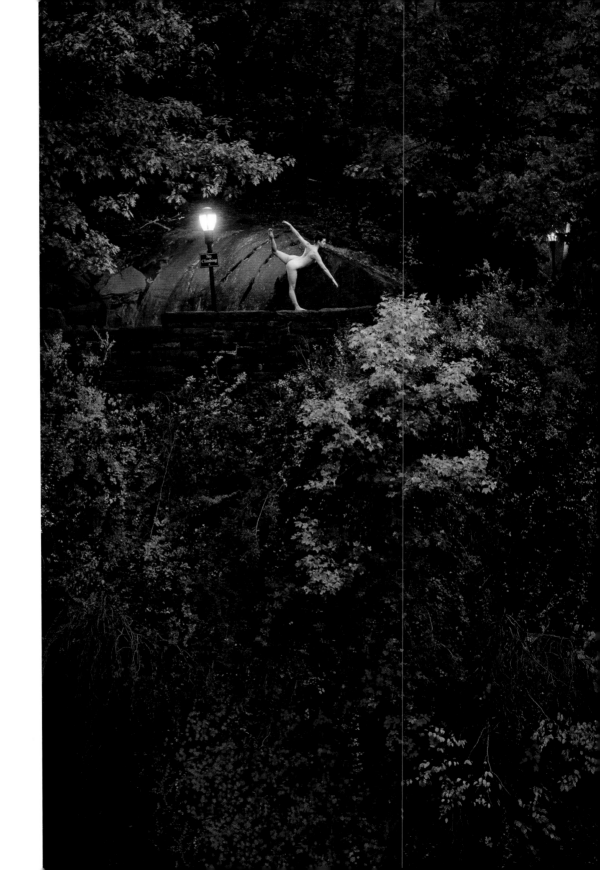

10:32 p.m.
Bryant Park, New York, NY

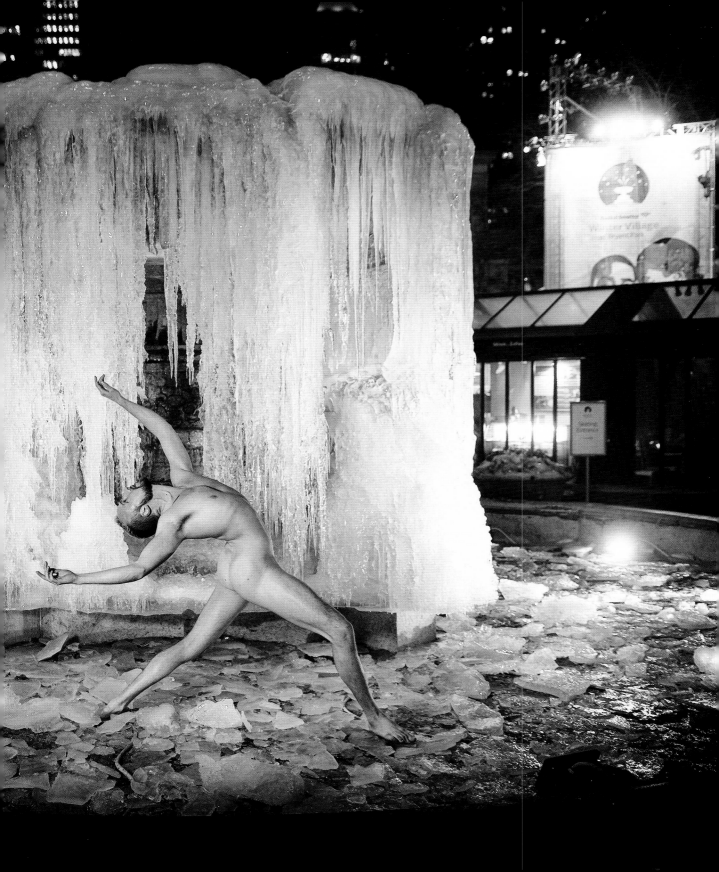

"I will not let anyone walk through my mind with their dirty feet."

MAHATMA GANDHI

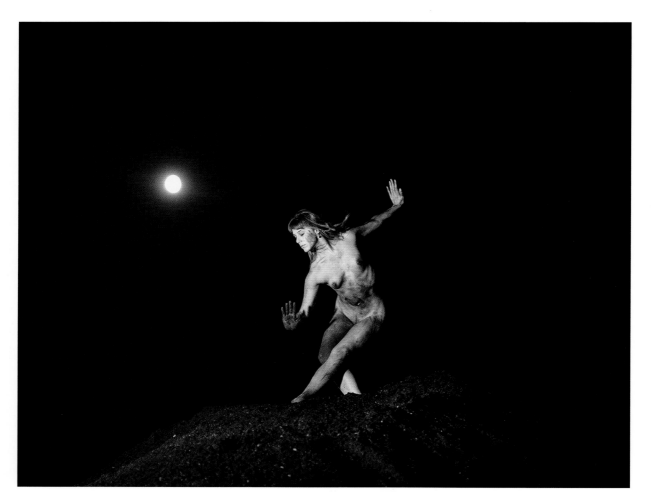

1:52 a.m.
Tar Pit, Chicago, IL

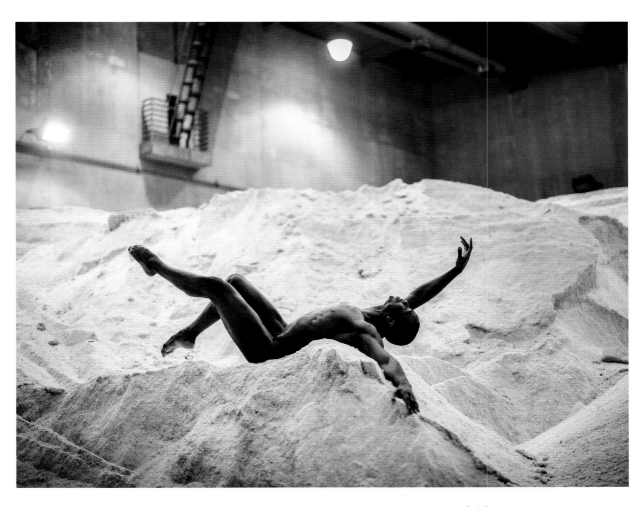

8:12 p.m.
Salt Pit, New York, NY

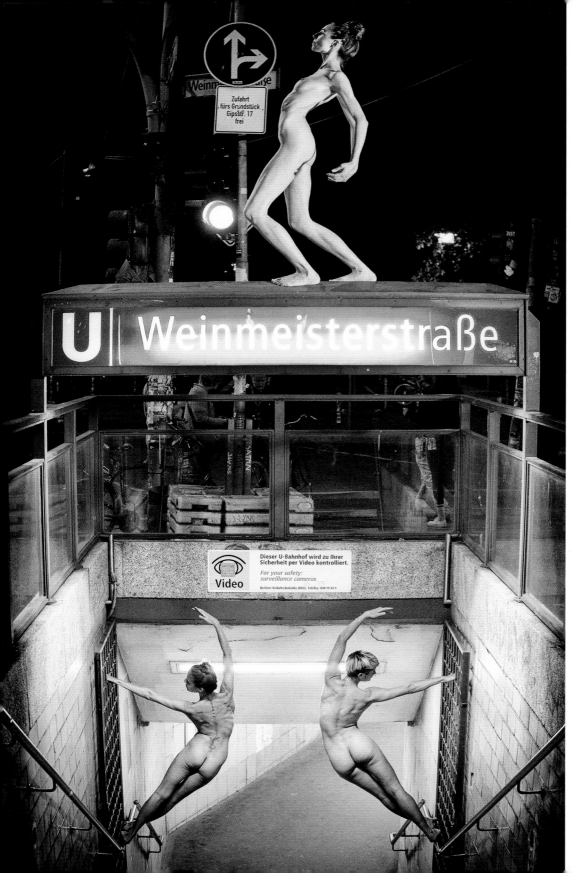

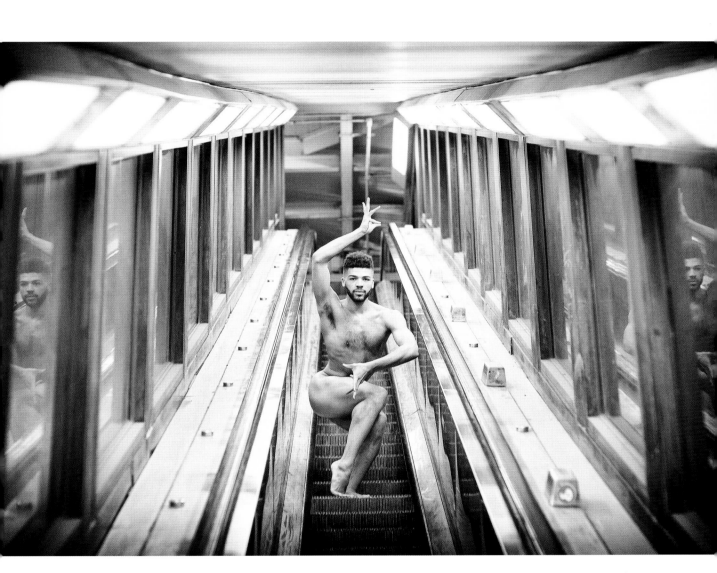

4:09 a.m.
Harlem, New York, NY

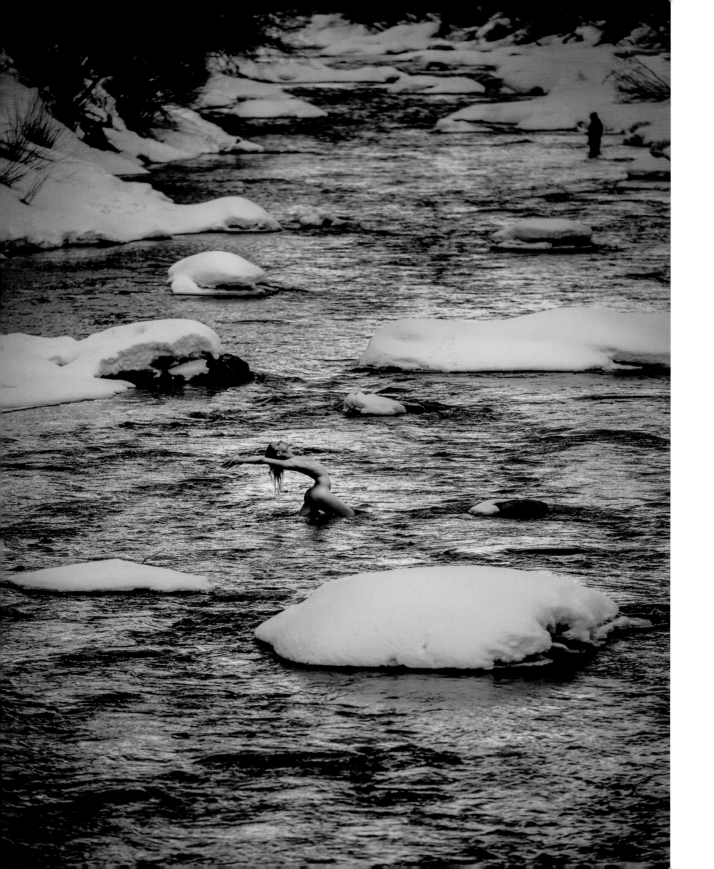

"Life is not a problem to be solved, but a reality to be experienced."

SØREN KIERKEGAARD

1:19 a.m.
Paving Factory, Chicago, IL

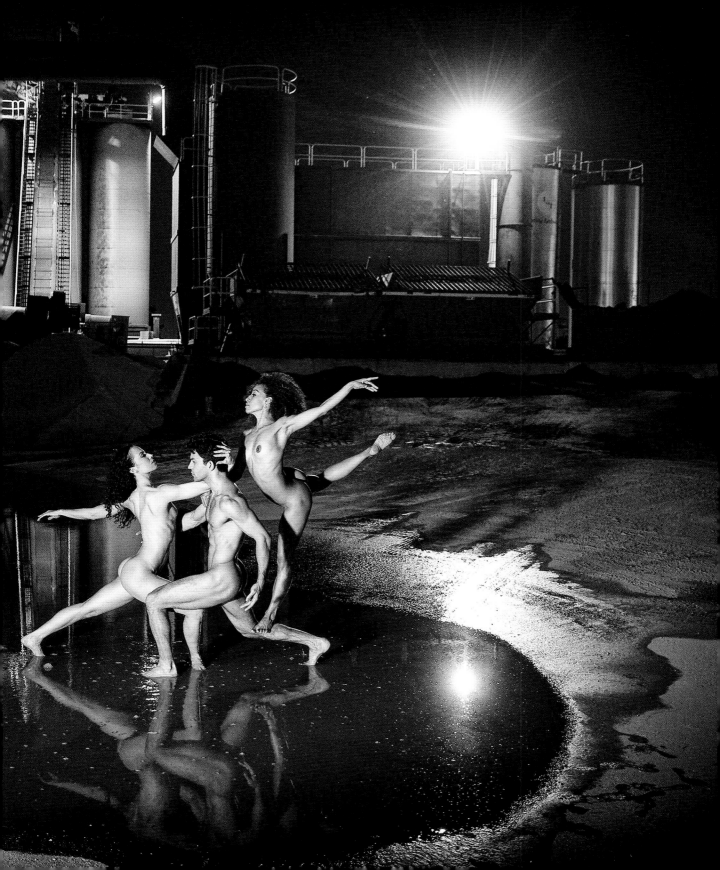

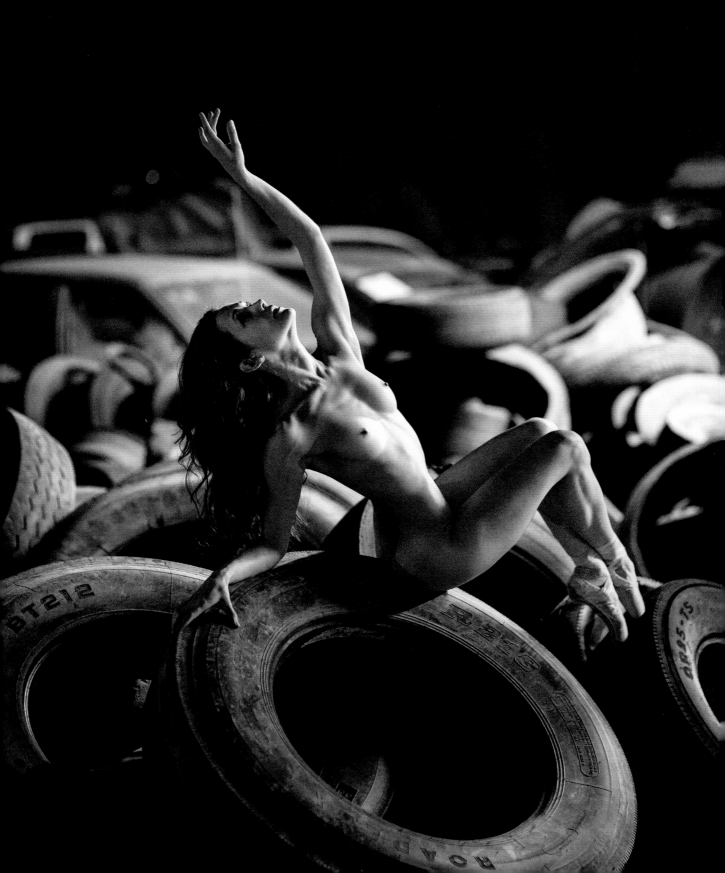

*"The most difficult thing is the decision to act;
the rest is merely tenacity."*

AMELIA EARHART

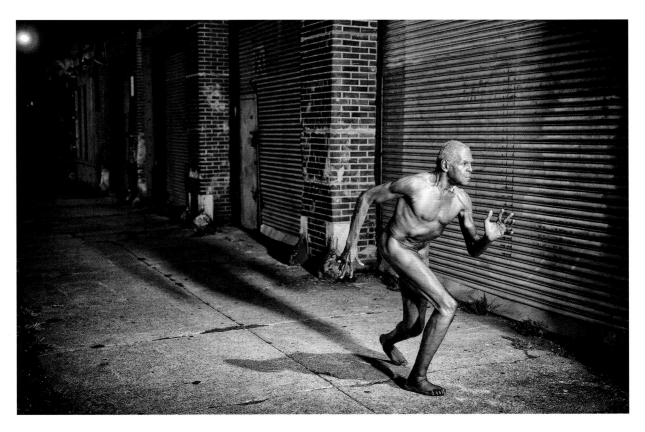

9:29 p.m.
New York, NY

< 11:11 p.m.
Junkyard, Austin, TX

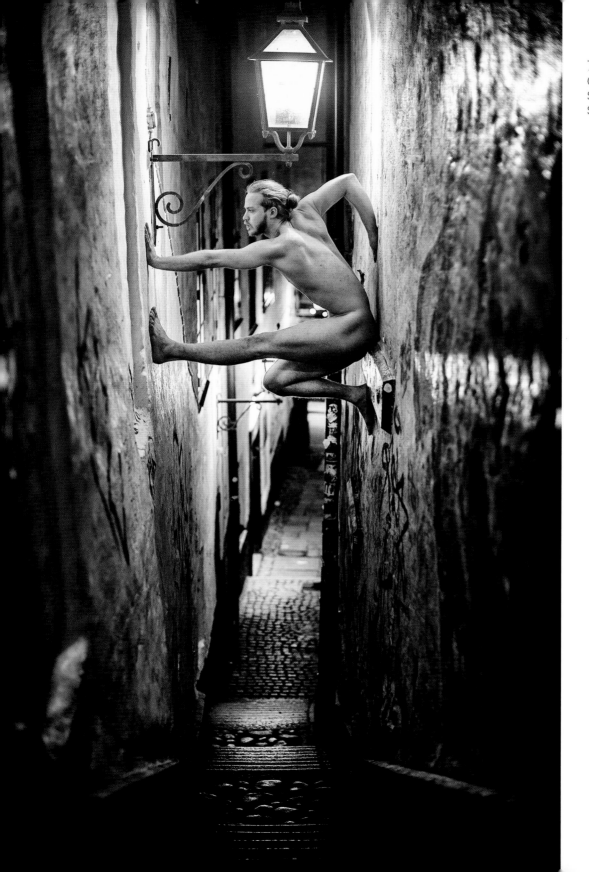

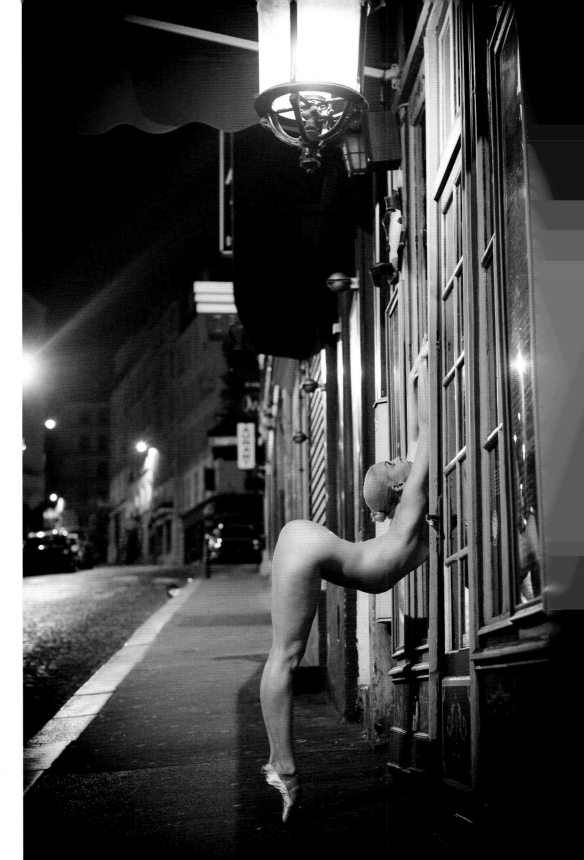

4:03 a.m.
Montmartre,
Paris, France

Gates

Number	Train
261	EMPIRE SERVICE
7887	NE CORR SEC EWR
637	KEYSTONE
3201	NJCOAST SEC EWR
6907	MID DIRECT SEC
9205	NJCOAST SEC EWR
6909	MID DIRECT SEC
3805	NE CORR SEC EWR

SEC STOPS SECAUCUS

Amtrak Customer Service

"Life shrinks or expands in proportion to one's courage."

ANAÏS NIN

11:24 p.m.
Penn Station, New York, NY

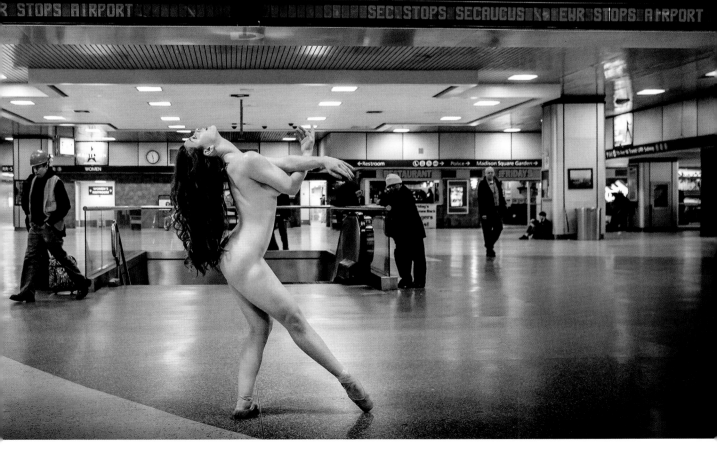

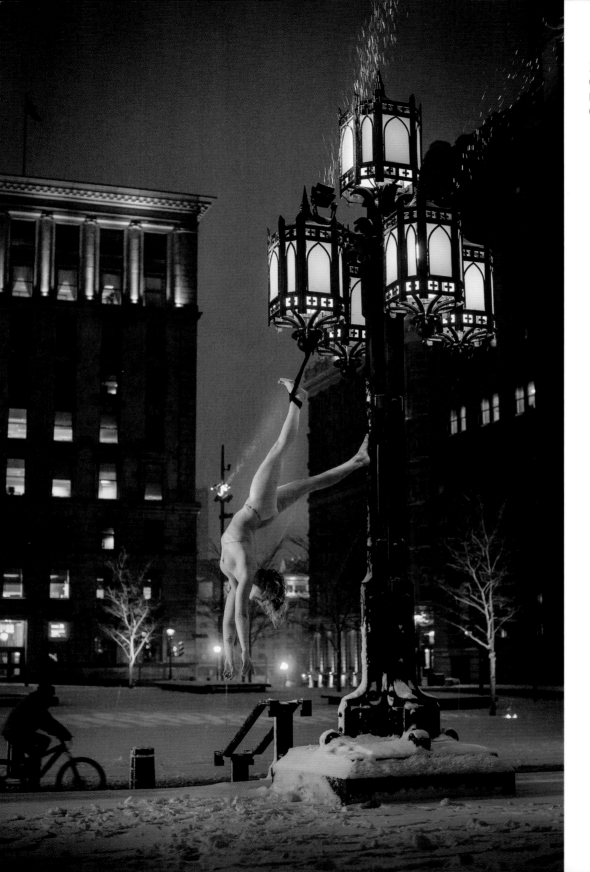

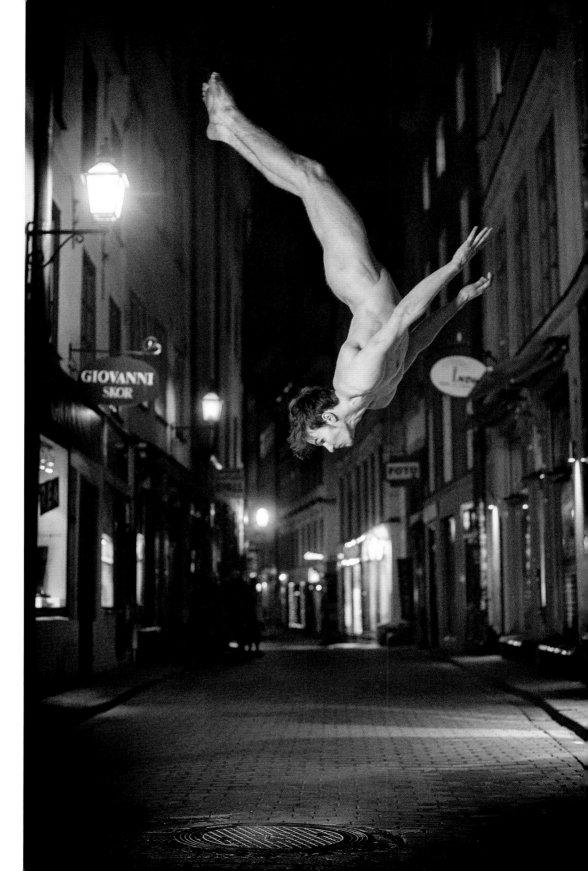

9:26 p.m.
Old Town,
Stockholm,
Sweden

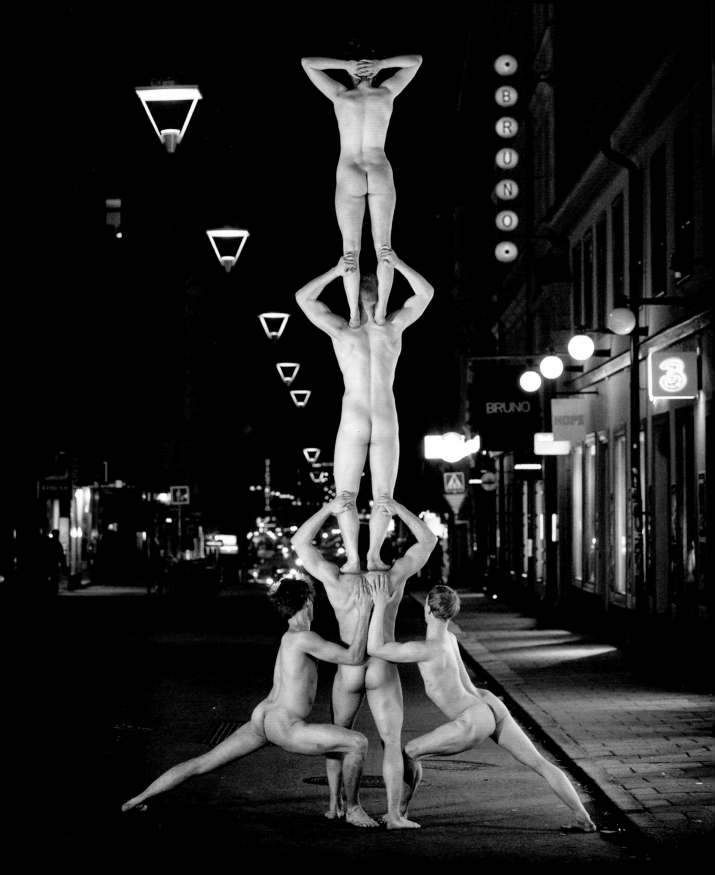

stability

"The trust of my fellow artists and friends provides me with stability. They are the literal weight on my shoulders! Knowing I have their safety in my arms provides me with the focus and power I need to ensure my stance."

Kipat Kahumbu *(pictured center bottom)*

< 10:45 p.m.
Götgatan, Stockholm, Sweden

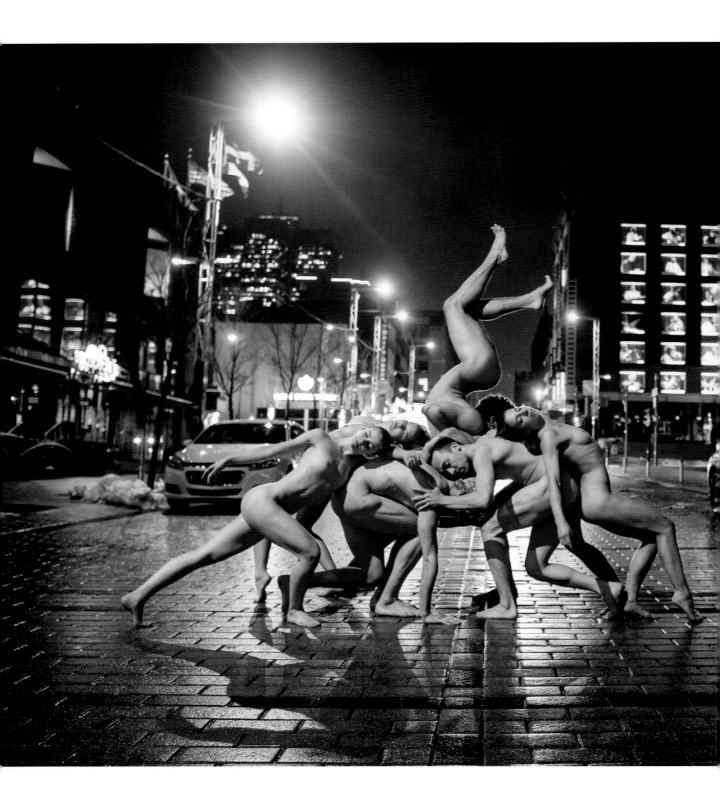

*"The question isn't who is going to let me;
it's who is going to stop me."*

1:19 a.m.
Rue Sainte-Catherine, Montreal, Canada

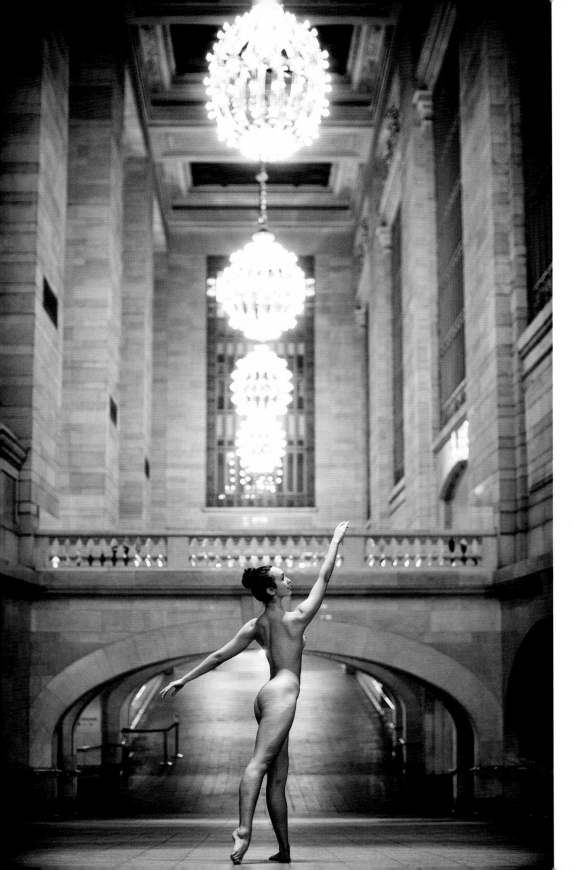

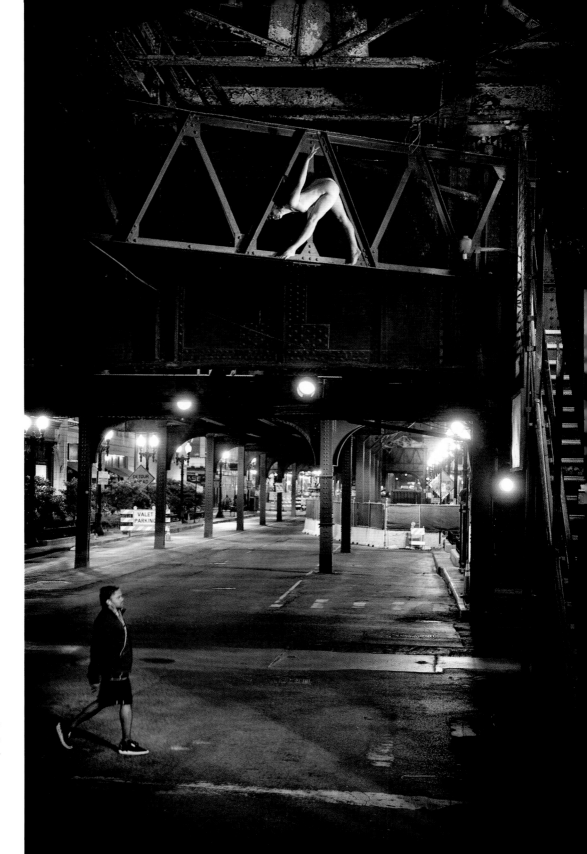

12:37 a.m.
"L" Train,
Chicago, IL

"Dancing is creating a sculpture that is visible only for a moment."

EROL OZAN

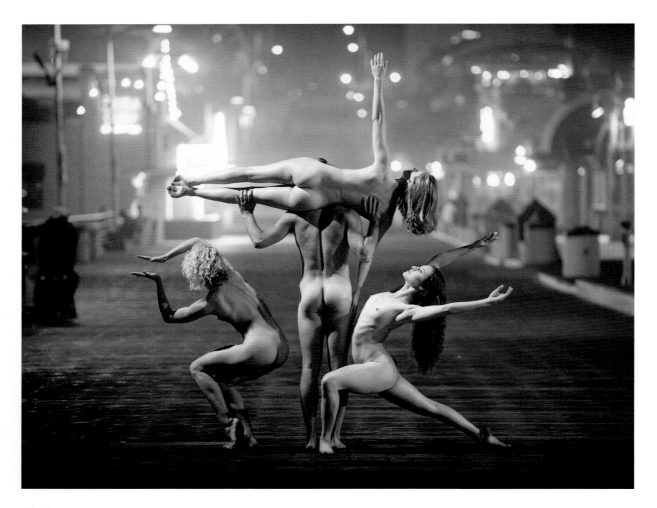

12:13 a.m.
Santa Monica Pier, Los Angeles, CA

10:11 p.m. >
Venice Beach, Los Angeles, CA

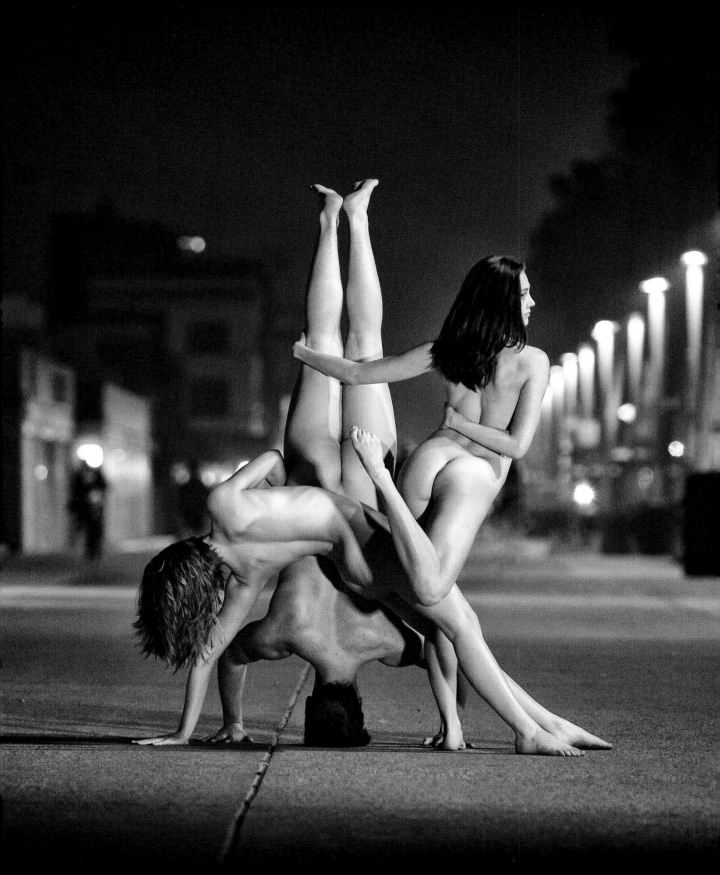

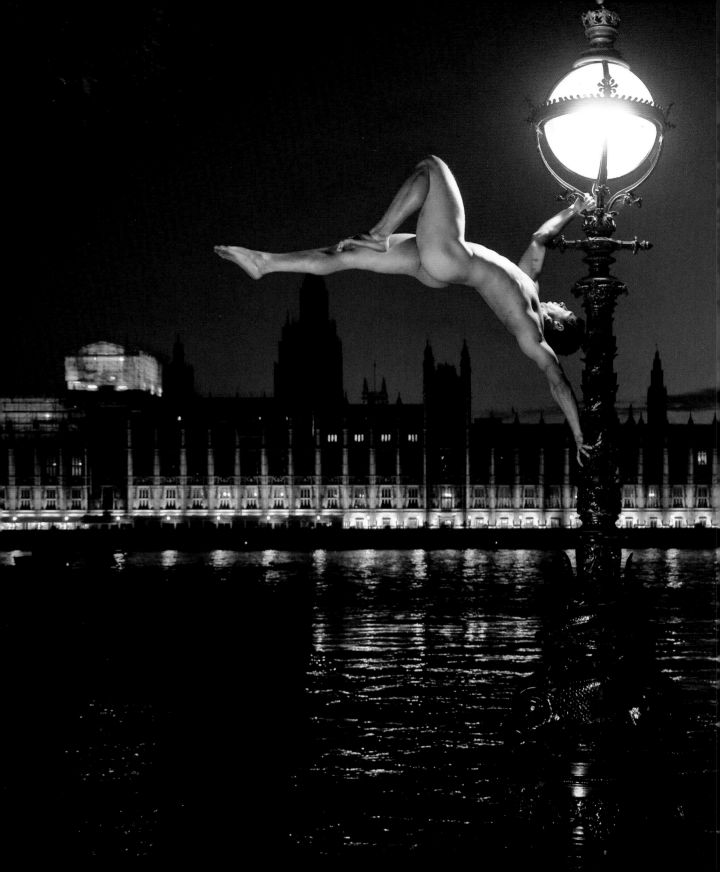

10:21 p.m.
Big Ben, London, England

"Stability is not immobility."

KLEMENS VON METTERNICH

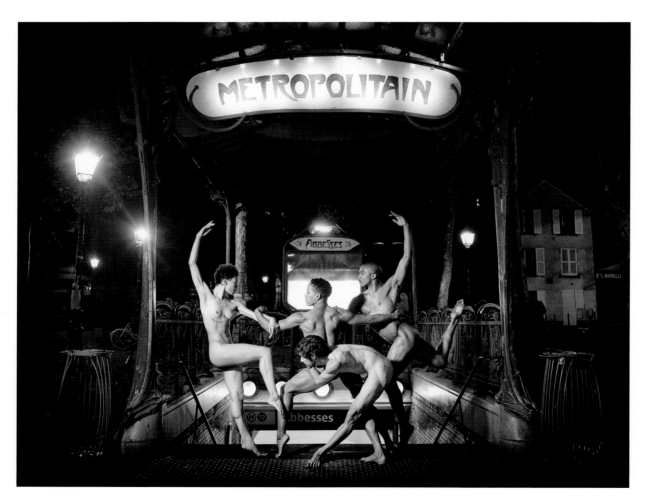

8:46 p.m.
Montmartre, Paris, France

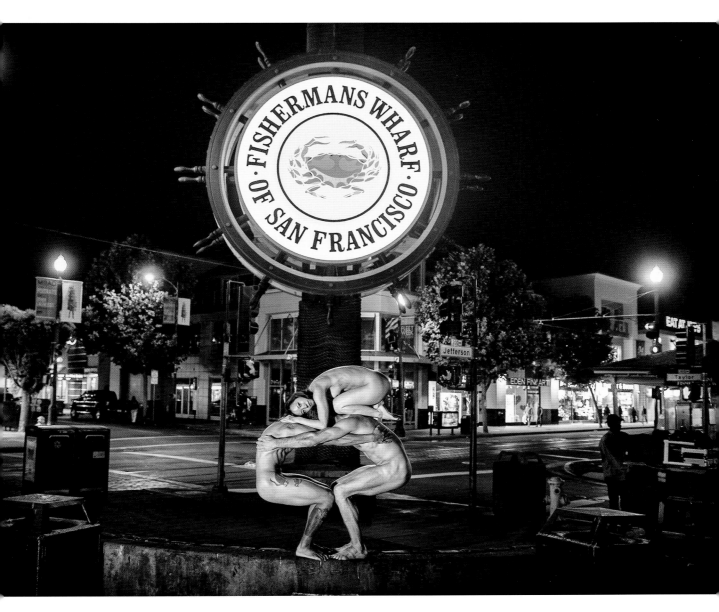

11:42 p.m.
Fisherman's Wharf, San Francisco, CA

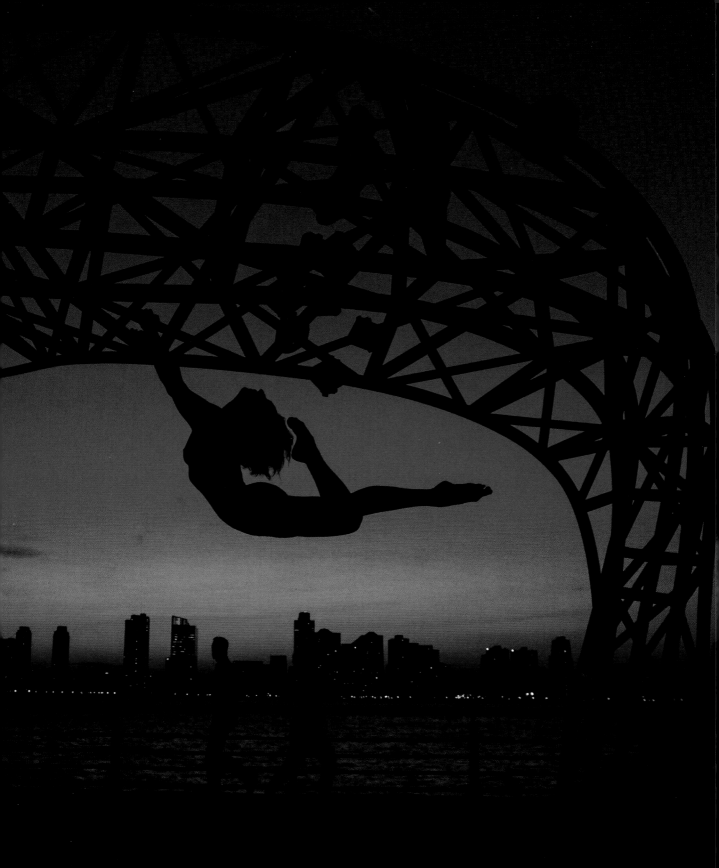

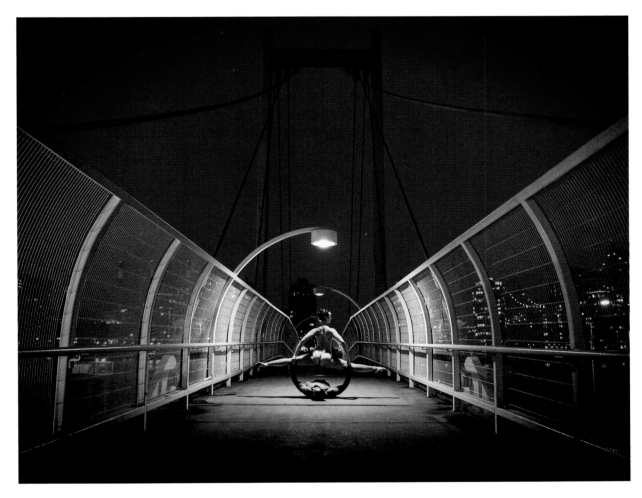

7:57 p.m.
East River, New York, NY

< 7:30 p.m.
Hudson River Park Walkway,
New York, NY

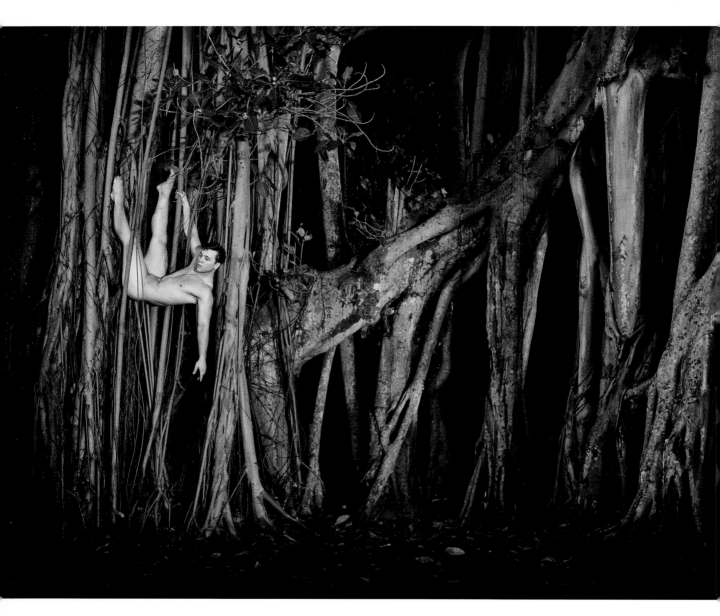

5:40 p.m.
Banyan Trees, Sarasota, FL

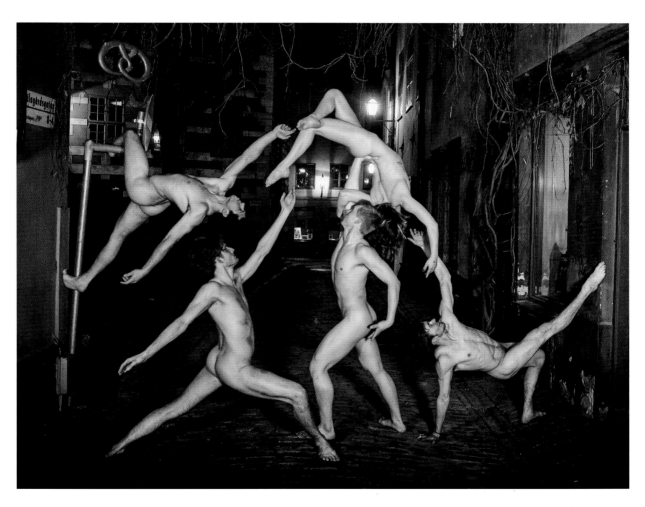

2:29 a.m.
Old Town, Stockholm, Sweden

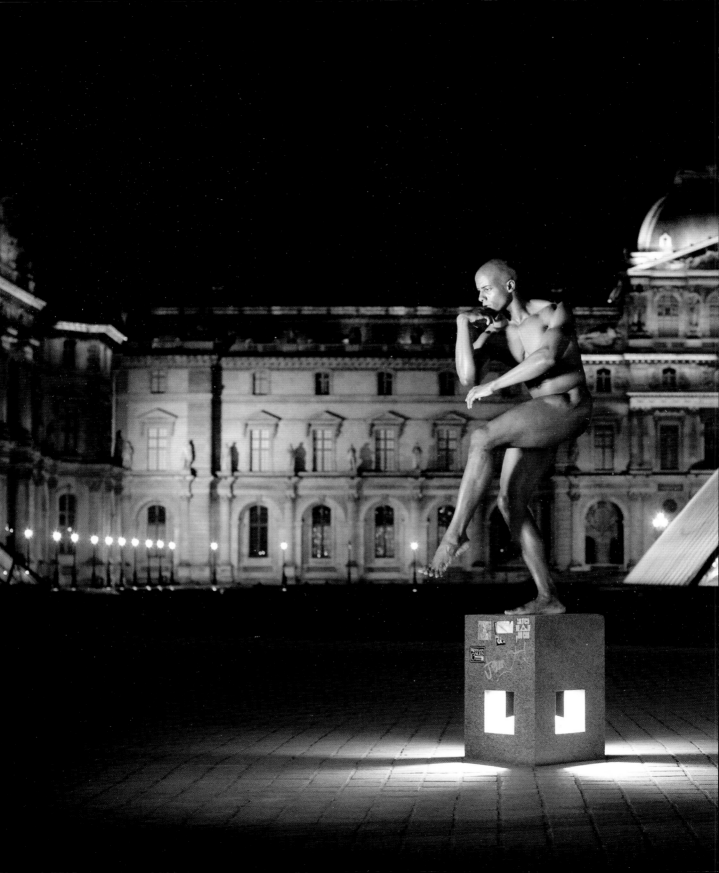

12:37 a.m.
The Louvre, Paris, France

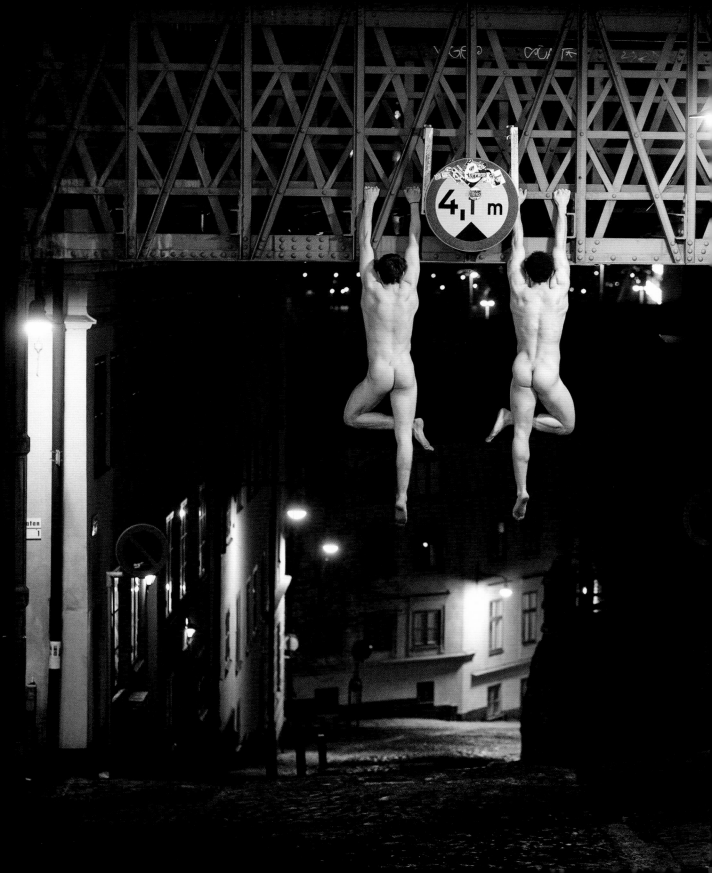

"Tenacity is the ability to hang on when letting go appears most attractive."

UNKNOWN

3:43 a.m.
Bellmansgatan, Stockholm, Sweden

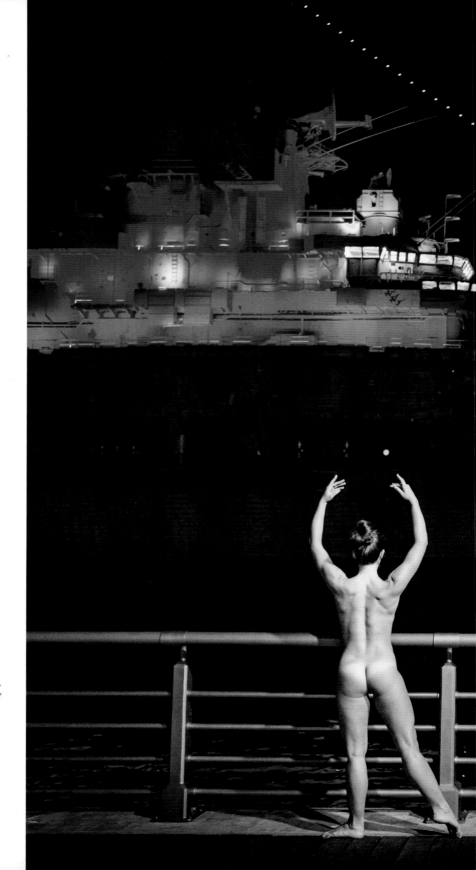

9:22 p.m.
USS *Intrepid*, New York, NY

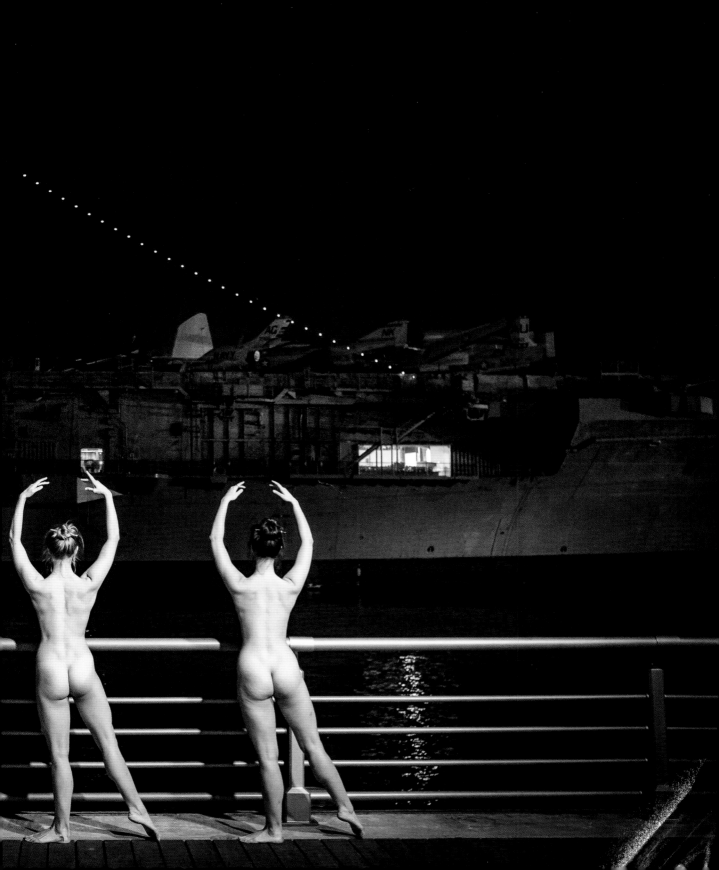

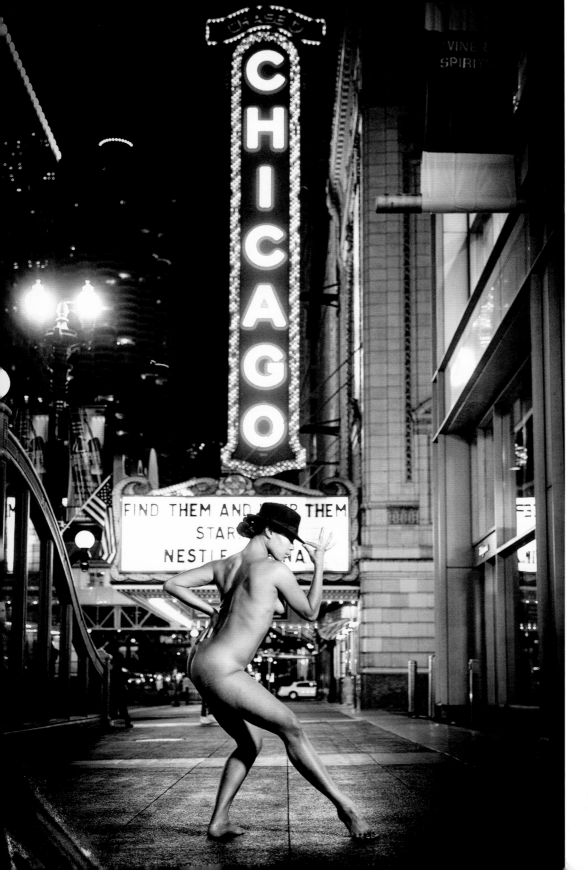

11:01 p.m.
Chicago Theatre,
Chicago, IL

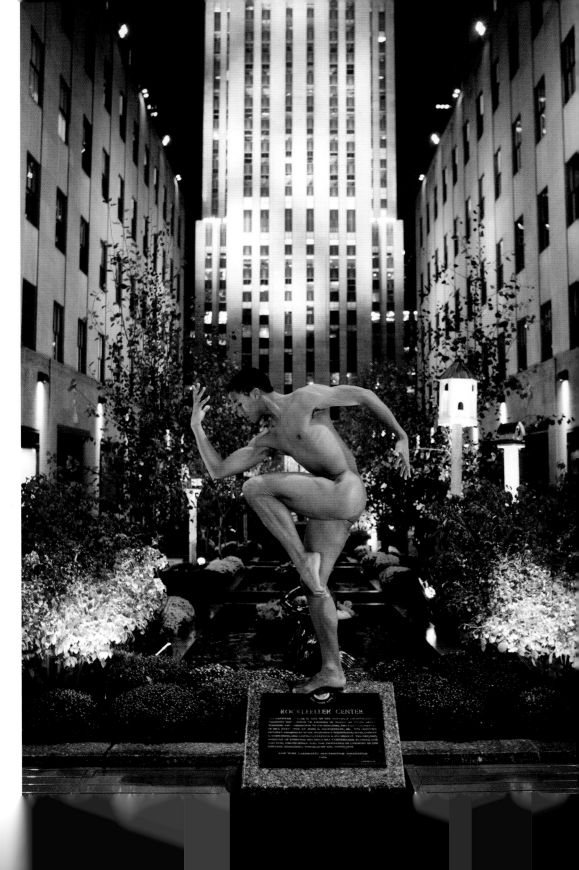

8:31 p.m.
Rockefeller

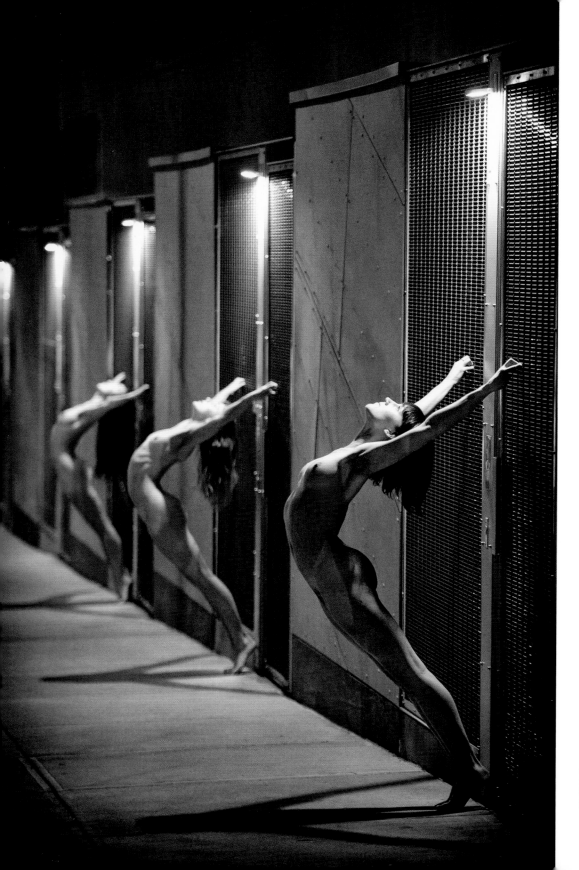

10:01 p.m.
Hell's Kitchen,
New York, NY

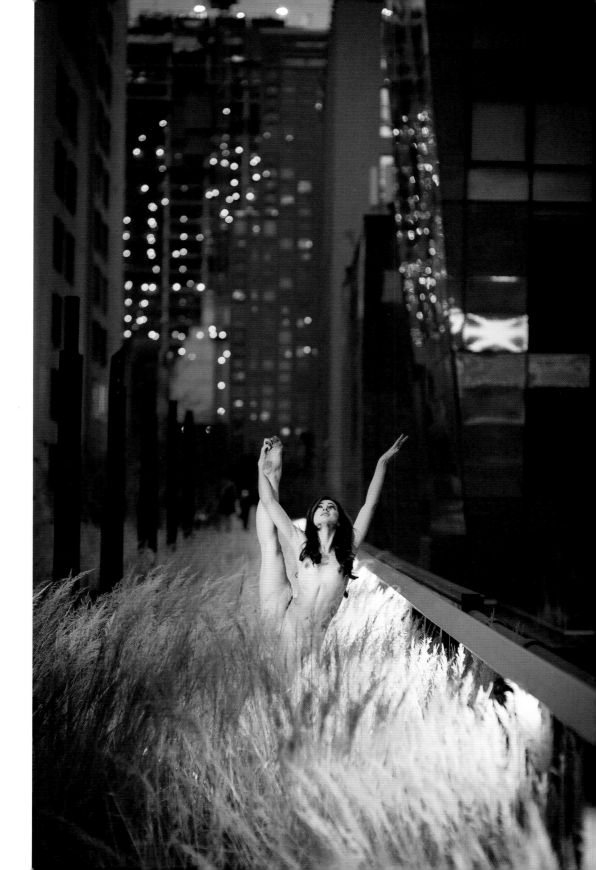

6:00 p.m.
The High Line,
New York, NY

9:28 p.m.
Bethesda Fountain, New York, NY

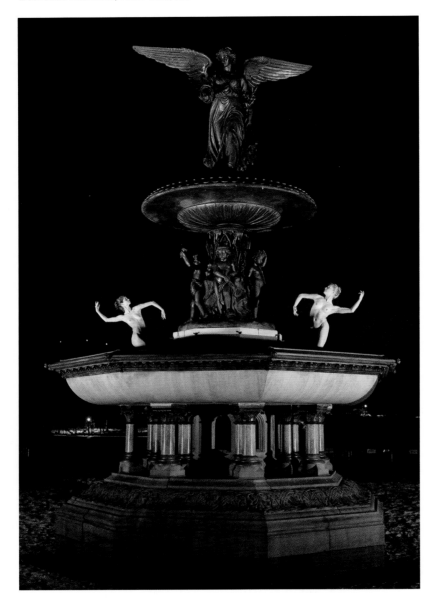

2:14 a.m. >
Maisonneuve Monument, Montreal, Canada

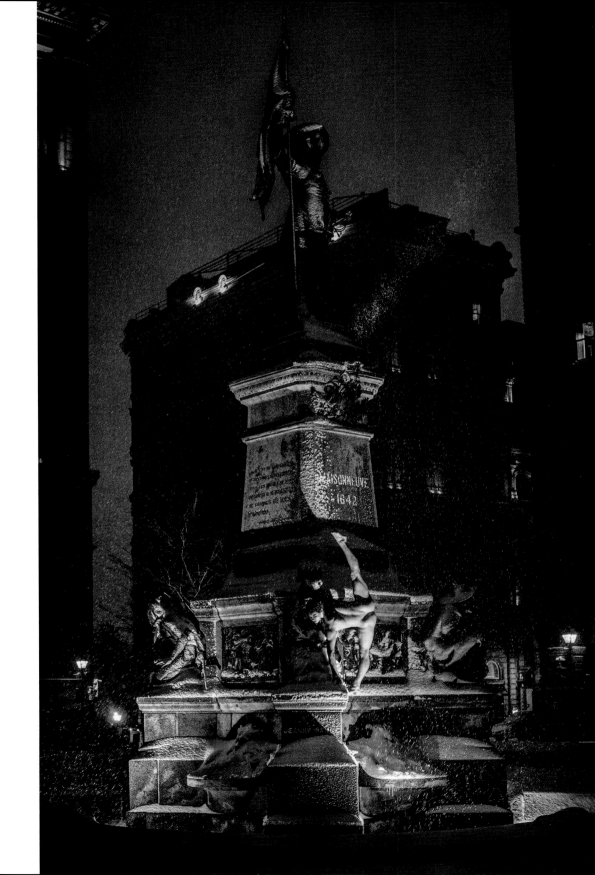

11:56 p.m.
Central Park, New York, NY

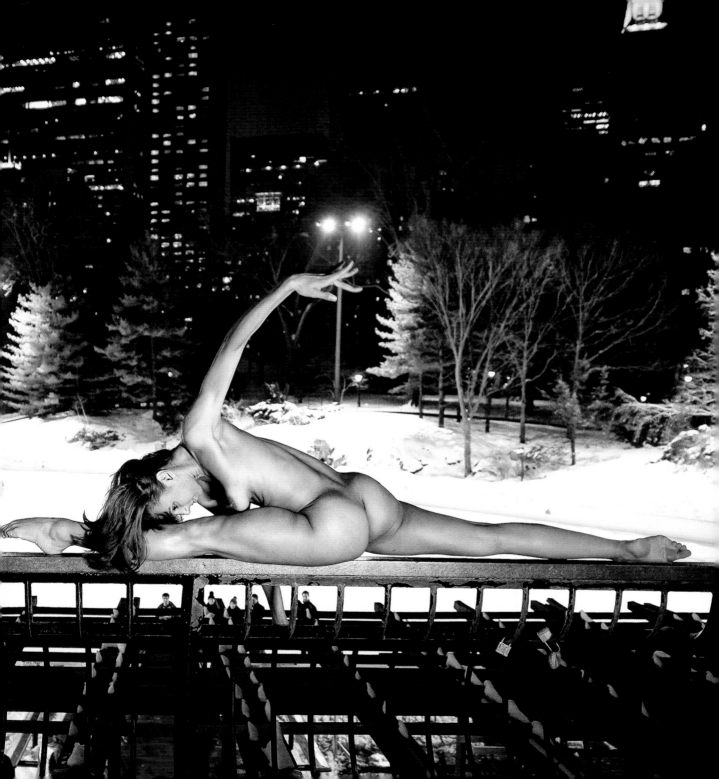

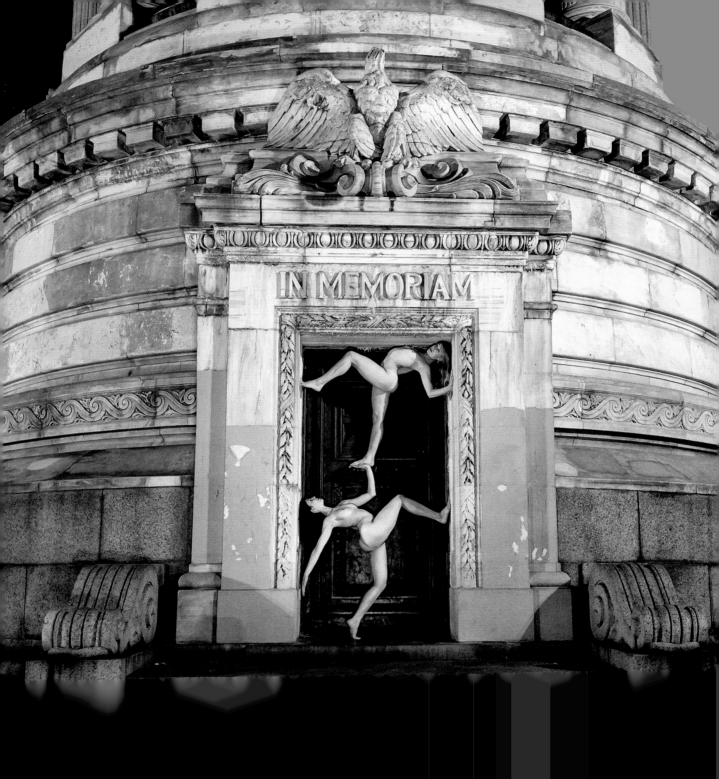

"Dance is the hidden language of the soul."

MARTHA GRAHAM

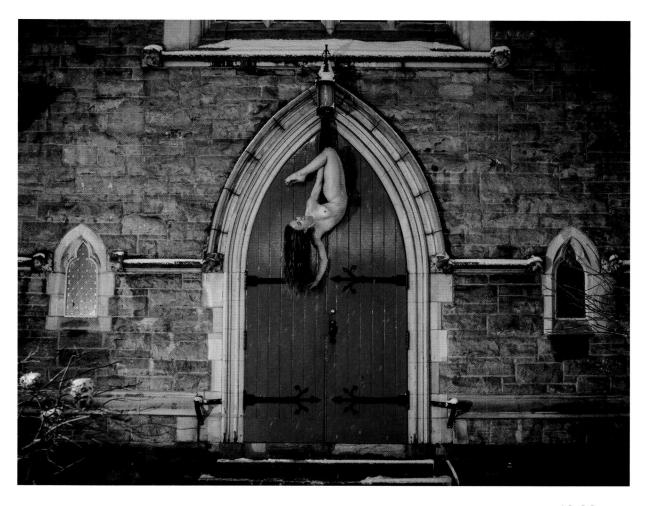

10:00 p.m.
Montreal, Canada

< 1:59 a.m.
Riverside Park, New York, NY

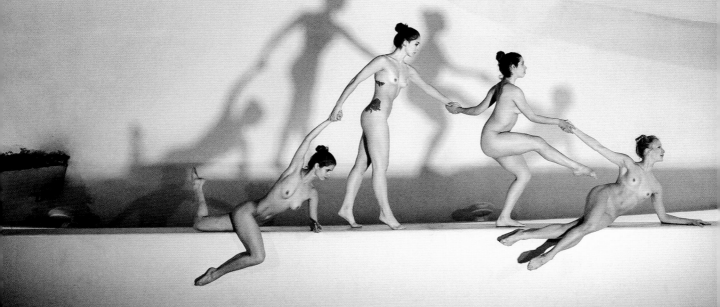

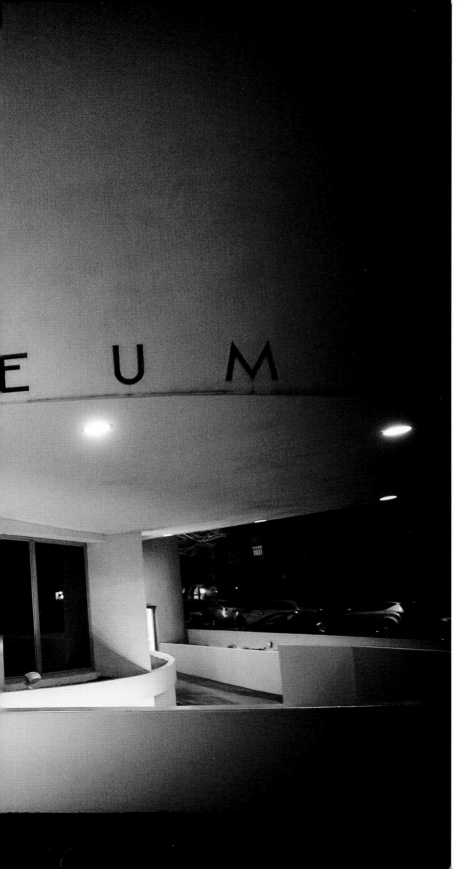

12:14 a.m.
Guggenheim Museum, New York, NY

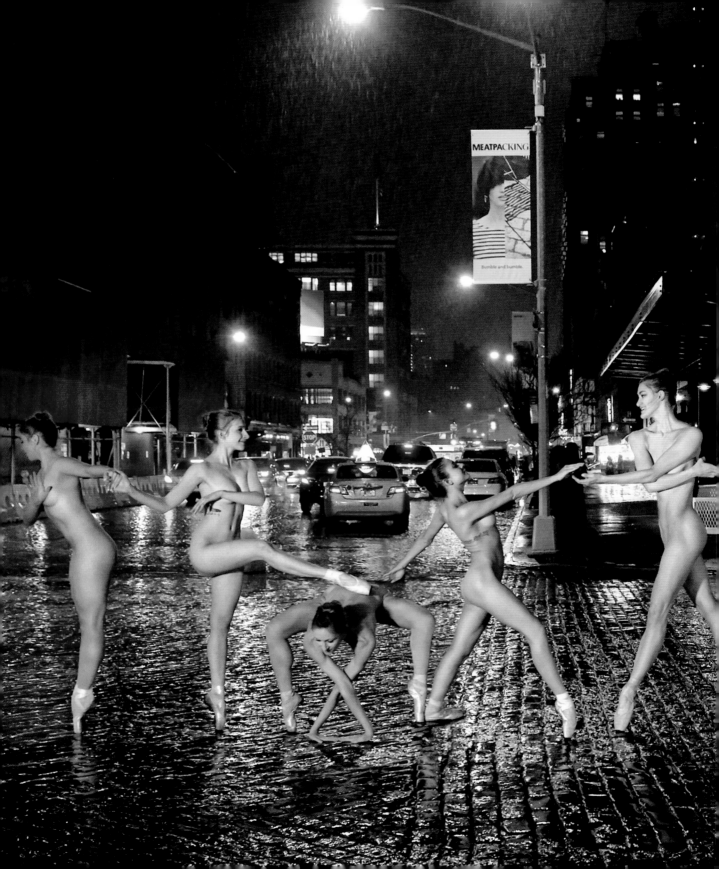

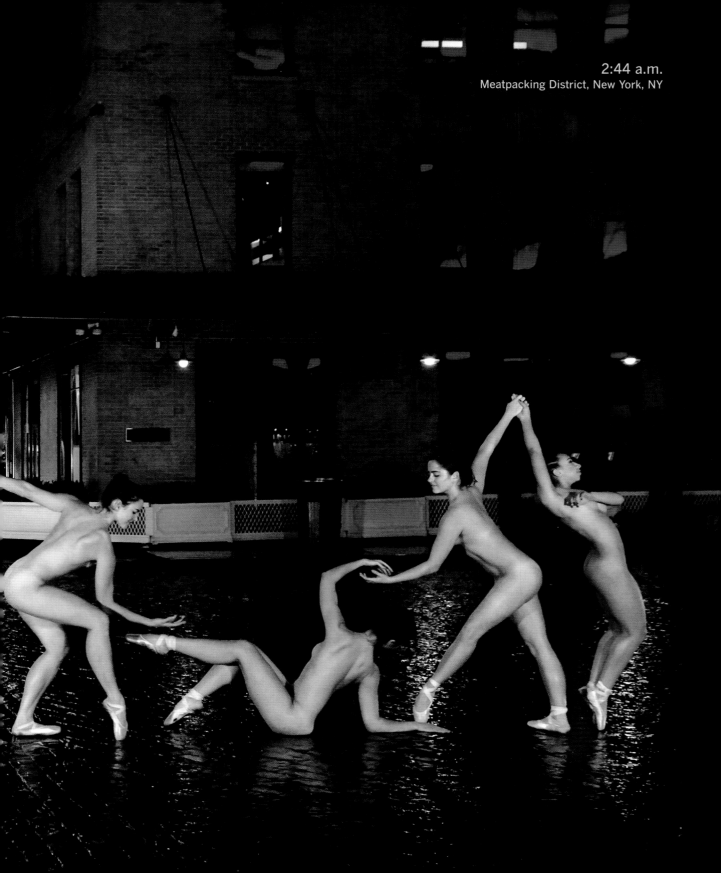

2:44 a.m.
Meatpacking District, New York, NY

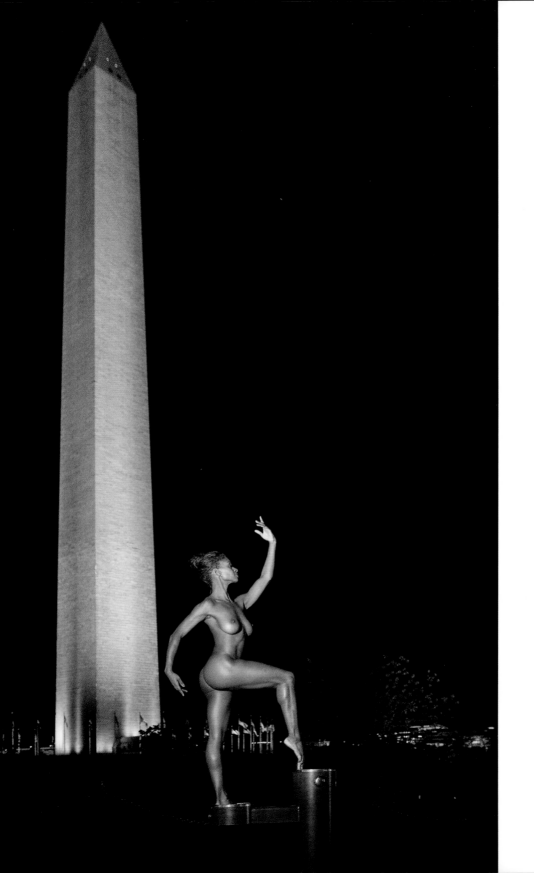

< 10:43 p.m.
Washington Monument, Washington, DC

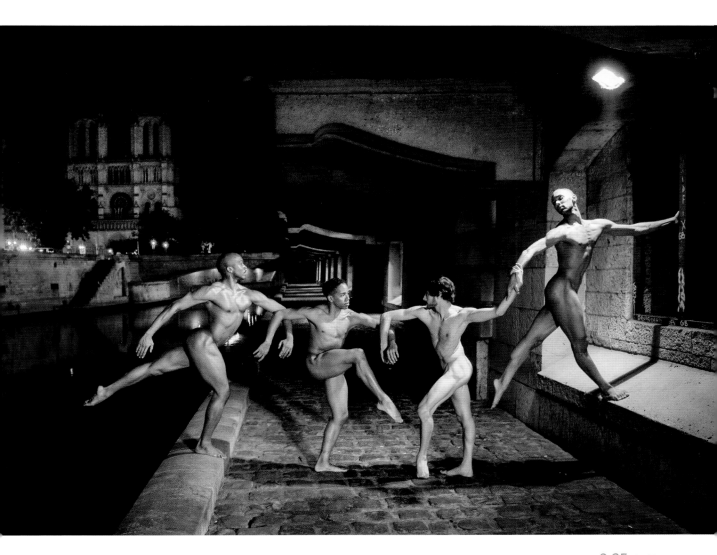

2:35 a.m.
River Seine, Paris, France

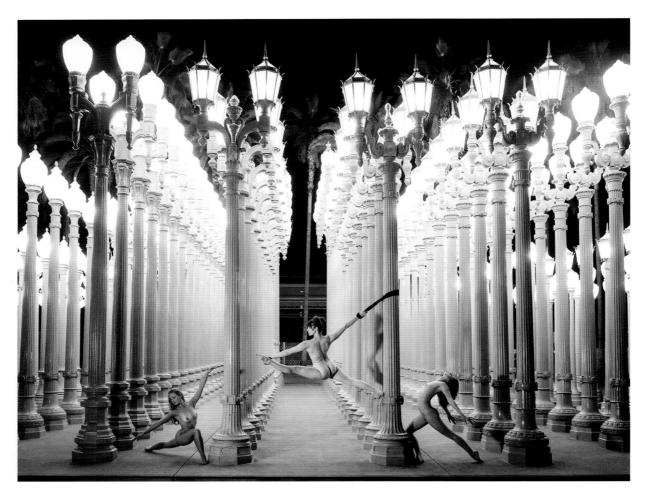

2:39 a.m.
Los Angeles County Museum of Art,
Los Angeles, CA

12:11 a.m. >
Flatiron District, New York, NY

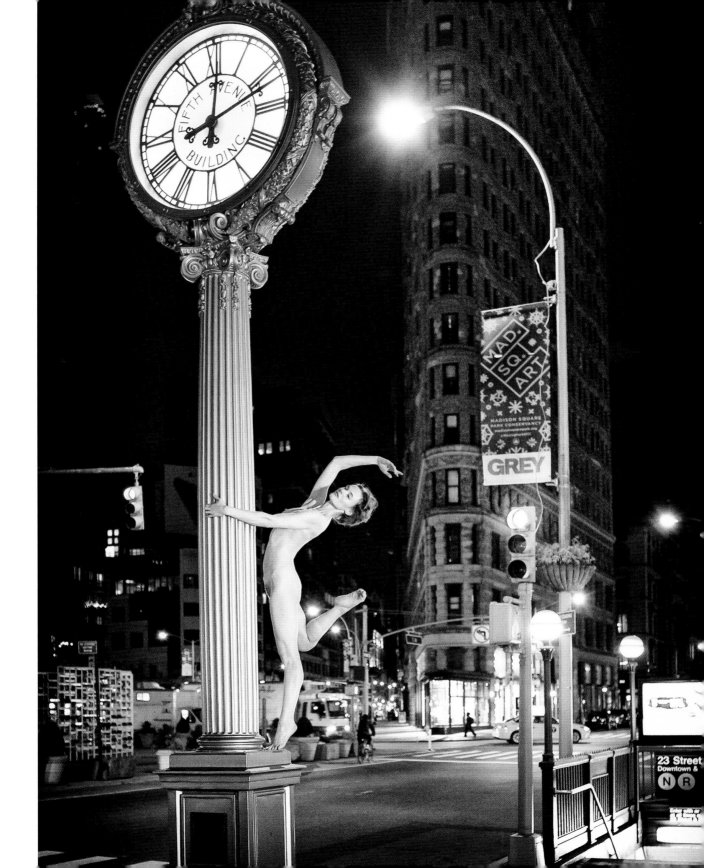

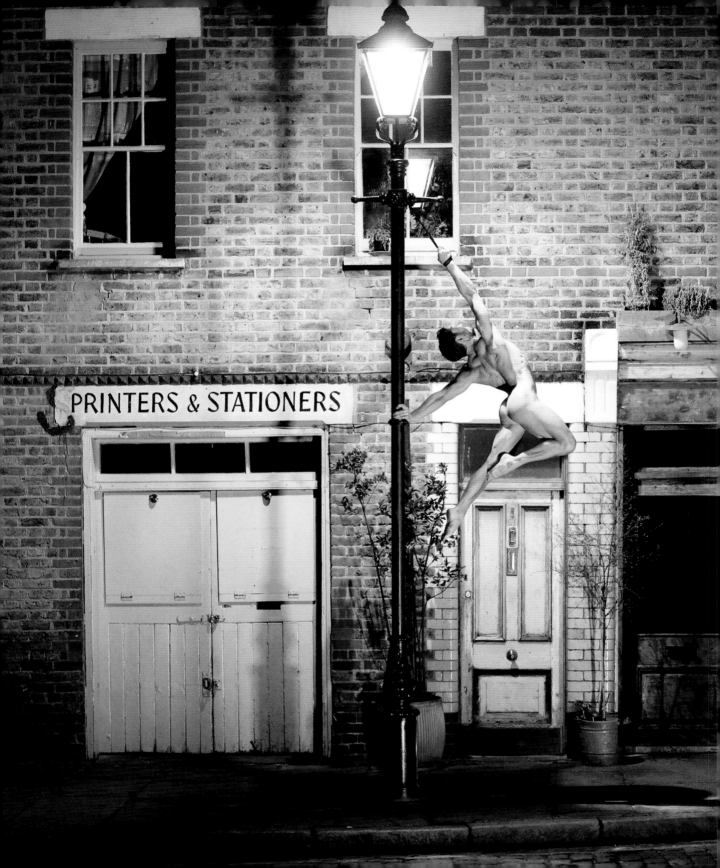

12:02 a.m.
East London, England

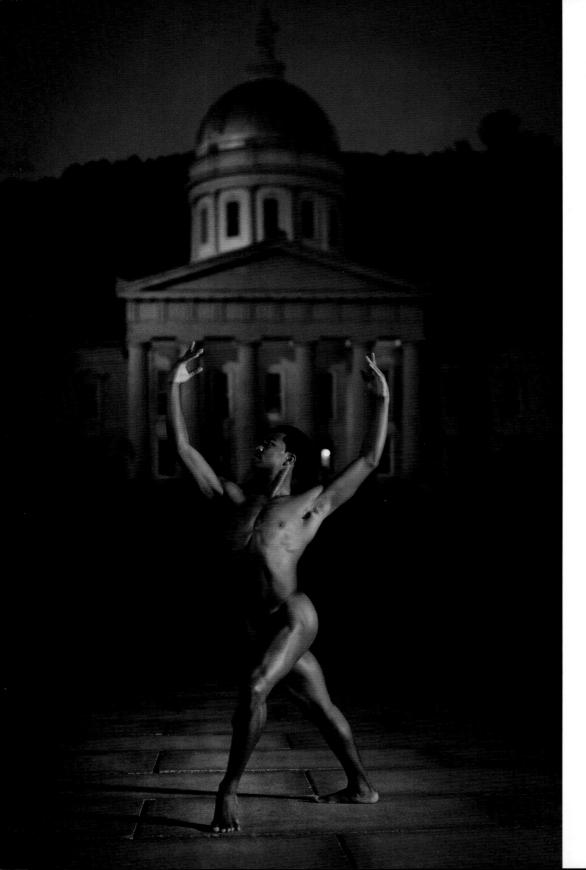

6:40 p.m.
Vermont State
House,
Montpelier, VT

3:57 a.m. >
New York
Public Library,
New York, NY

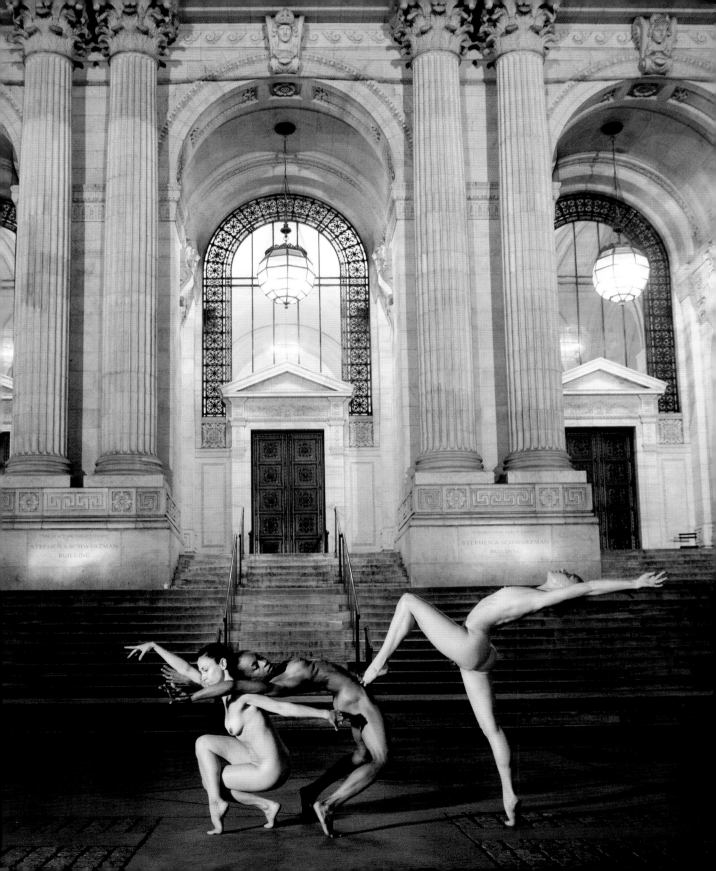

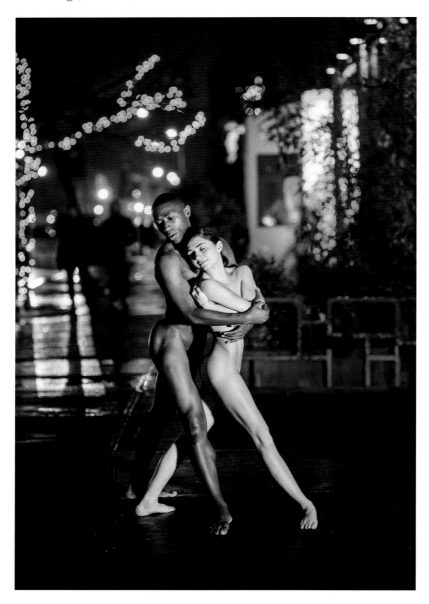

4:20 a.m. >
Times Square, New York, NY

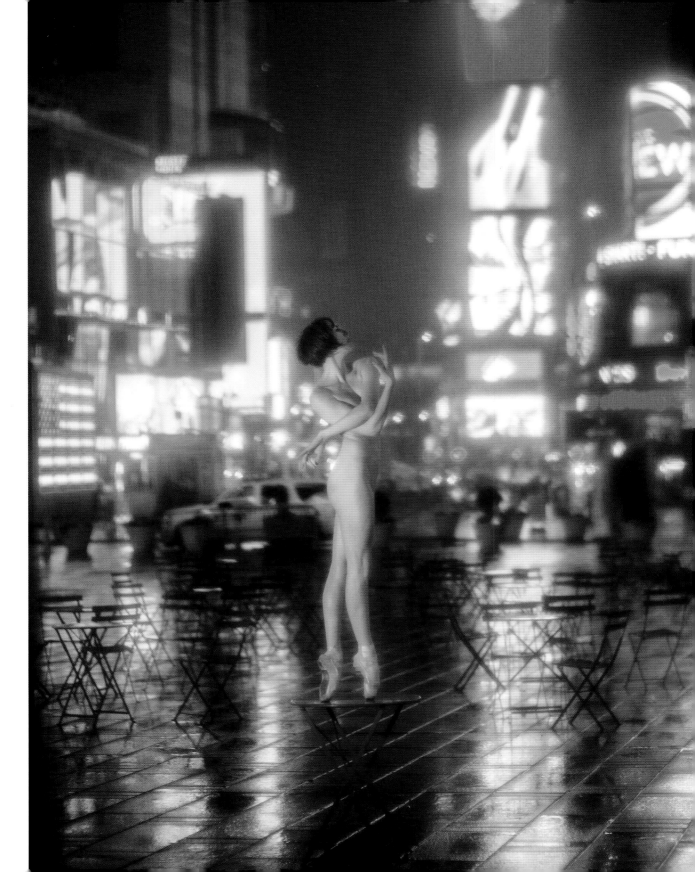

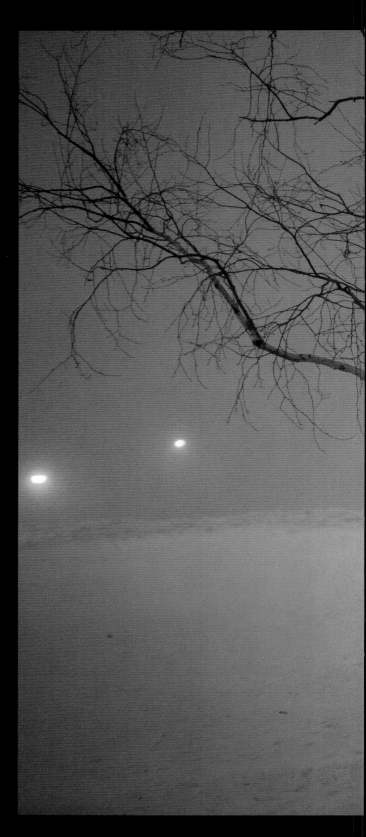

"Be the reason someone smiles today."

ANONYMOUS

7:42 p.m.
Mont Royal, Montreal, Canada

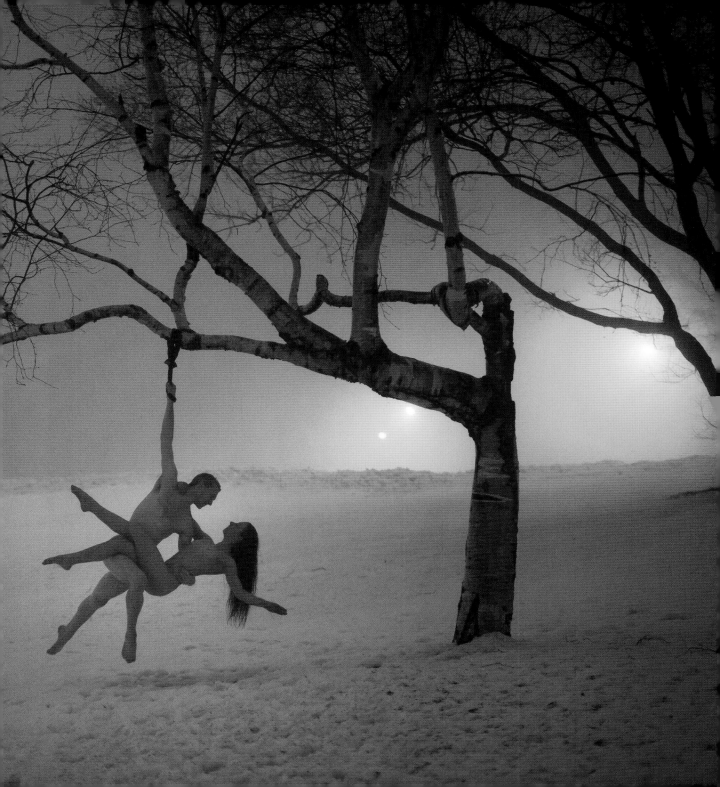

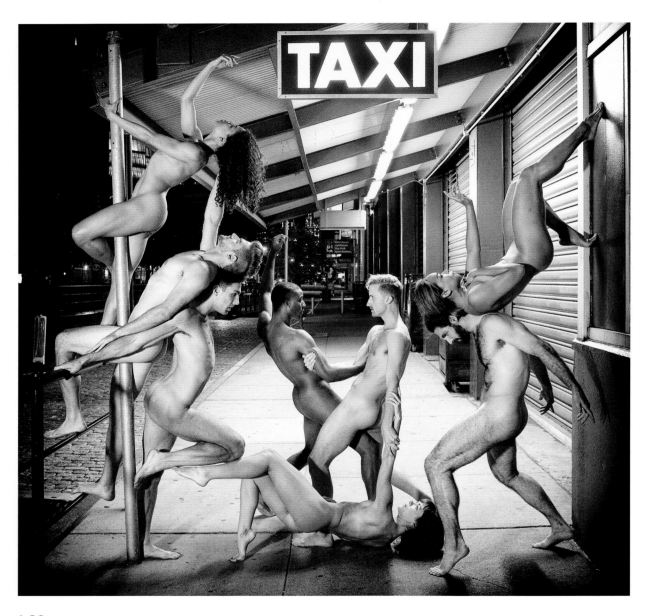

1:32 a.m.
Chelsea Piers, New York, NY

12:04 a.m. >
Venetian Causeway, Miami, FL

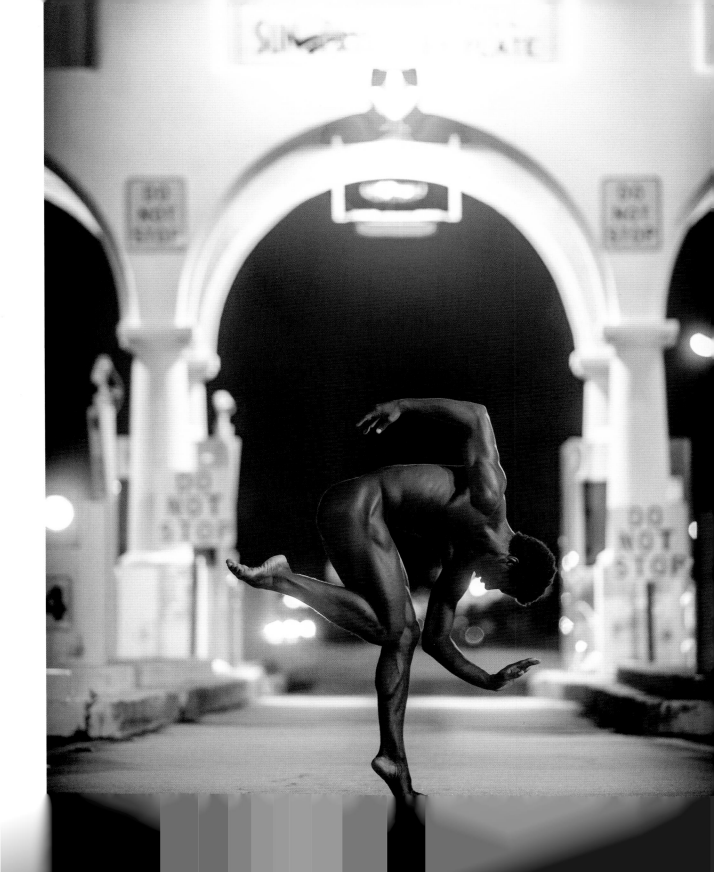

11:53 p.m.
Brooklyn Bridge, New York, NY

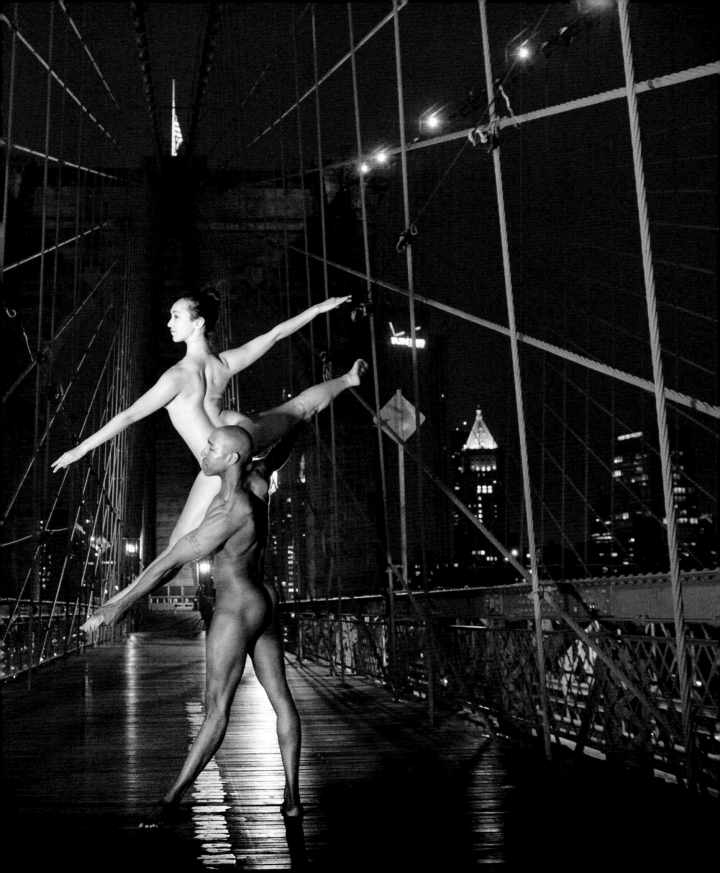

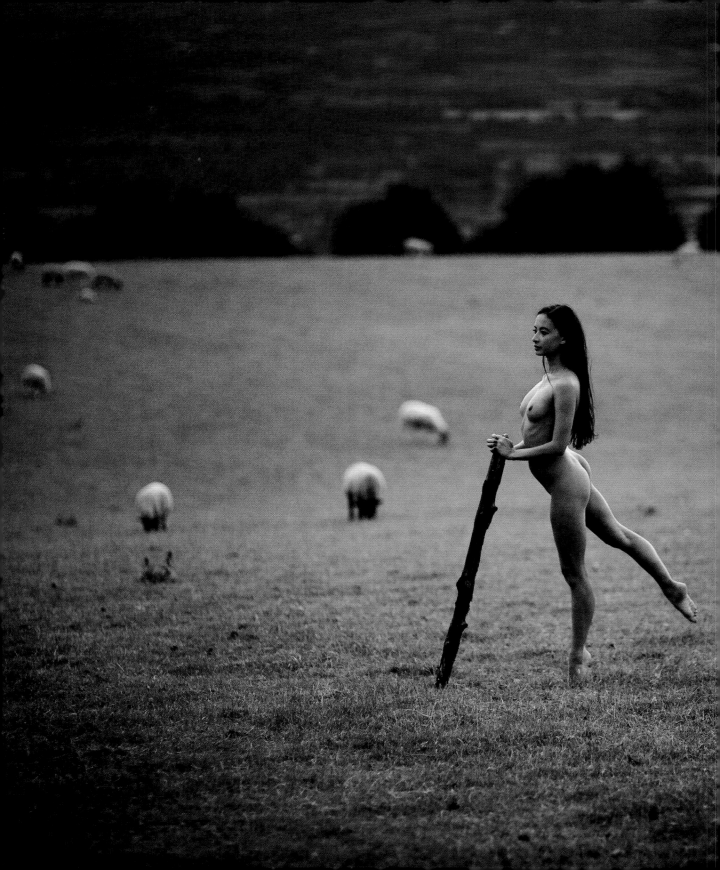

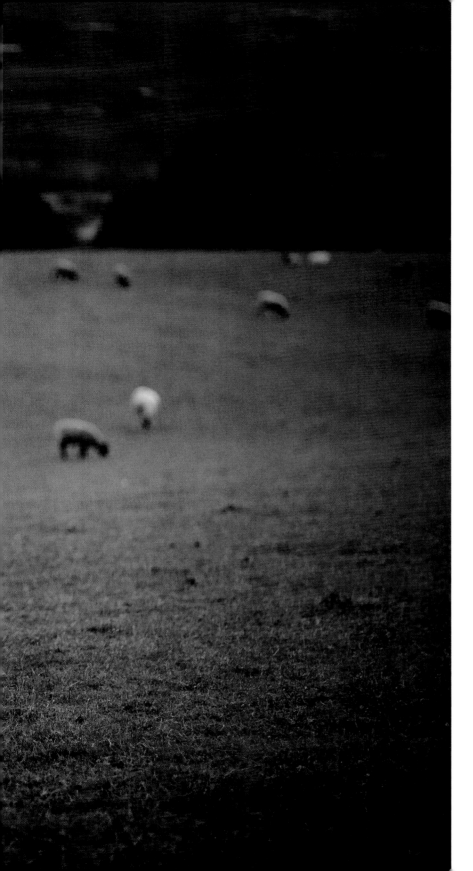

7:31 p.m.
Sheep Pasture,
The Cotswolds, England

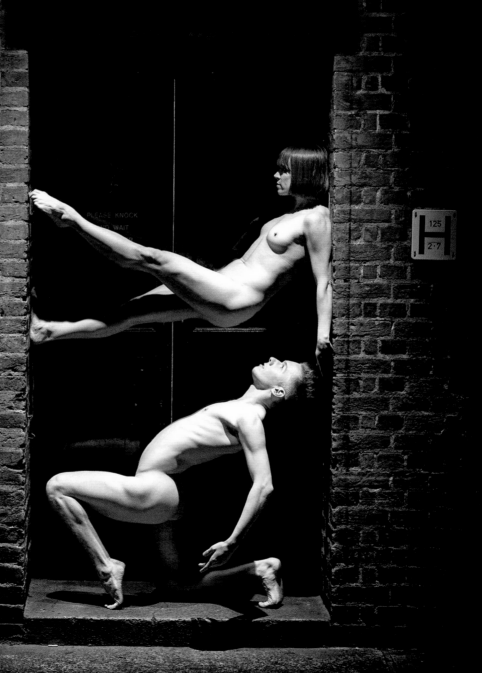

vulnerability

"To be vulnerable is to put the true you on show for the world: That's the most terrifying and rewarding thing a person can do."

Sam Baskett *(pictured bottom)*

< 1:09 a.m.
Cambridge Theatre, London, England

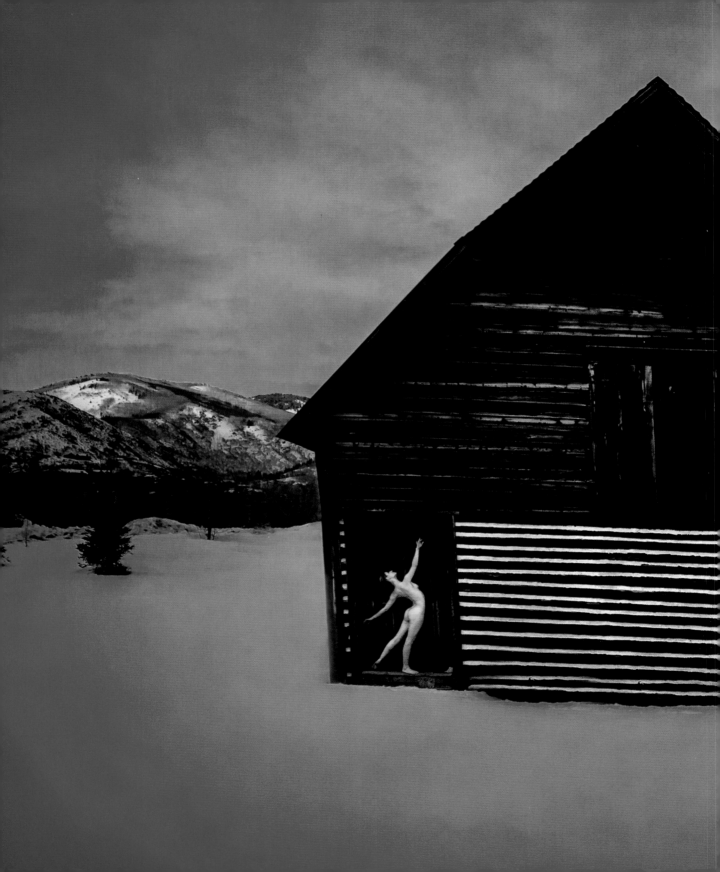

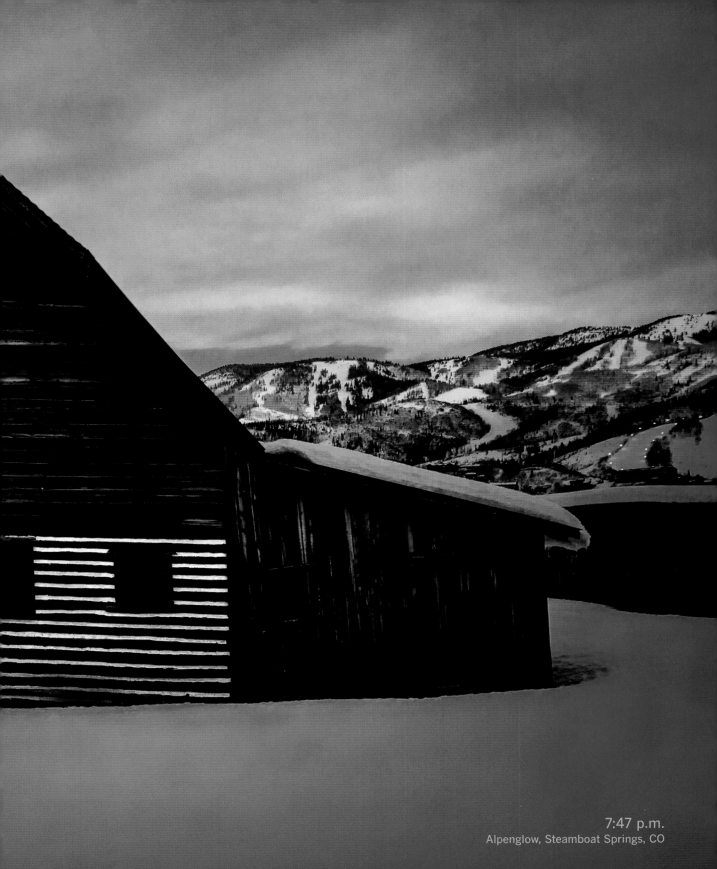

7:47 p.m.
Alpenglow, Steamboat Springs, CO

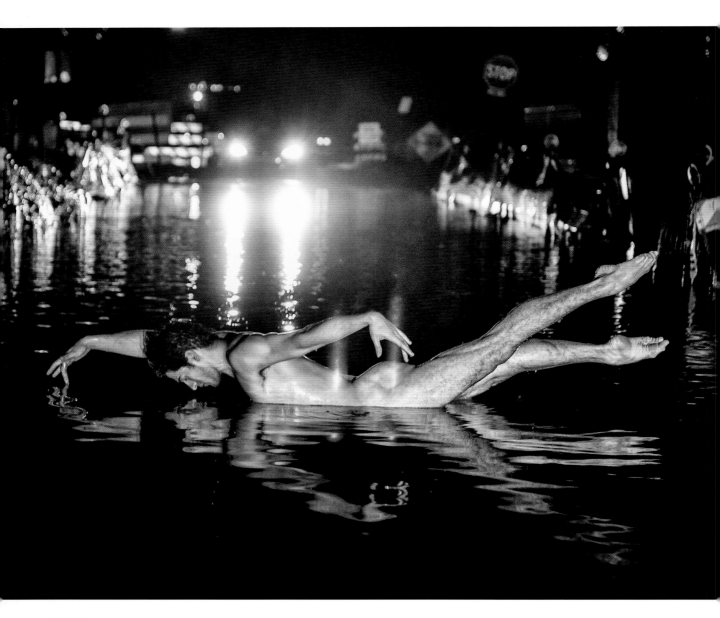

11:04 p.m.
Miami, FL

"And now that you don't need to be perfect, you can be good."

JOHN STEINBECK

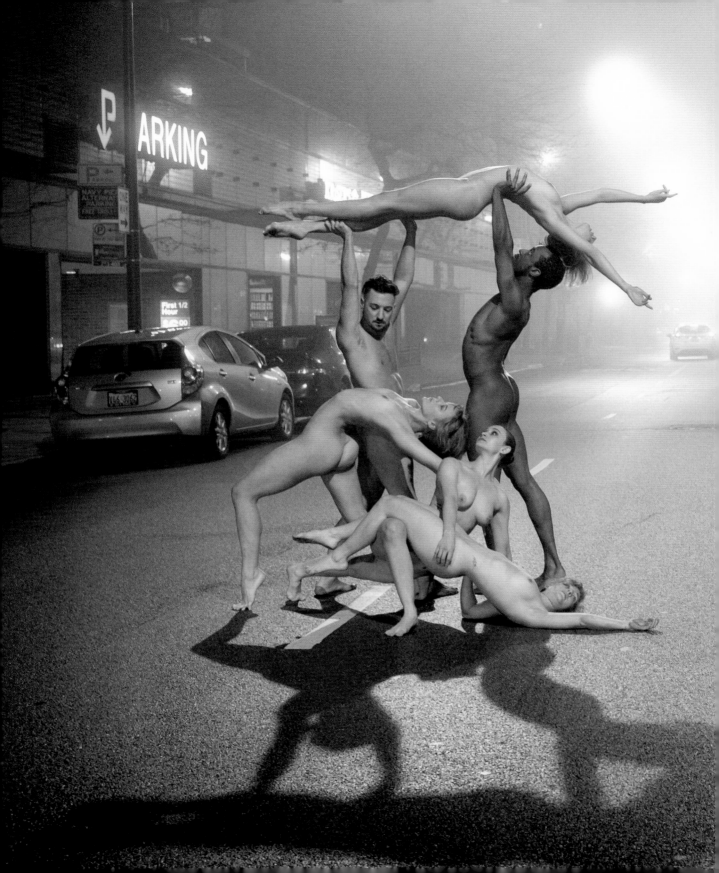

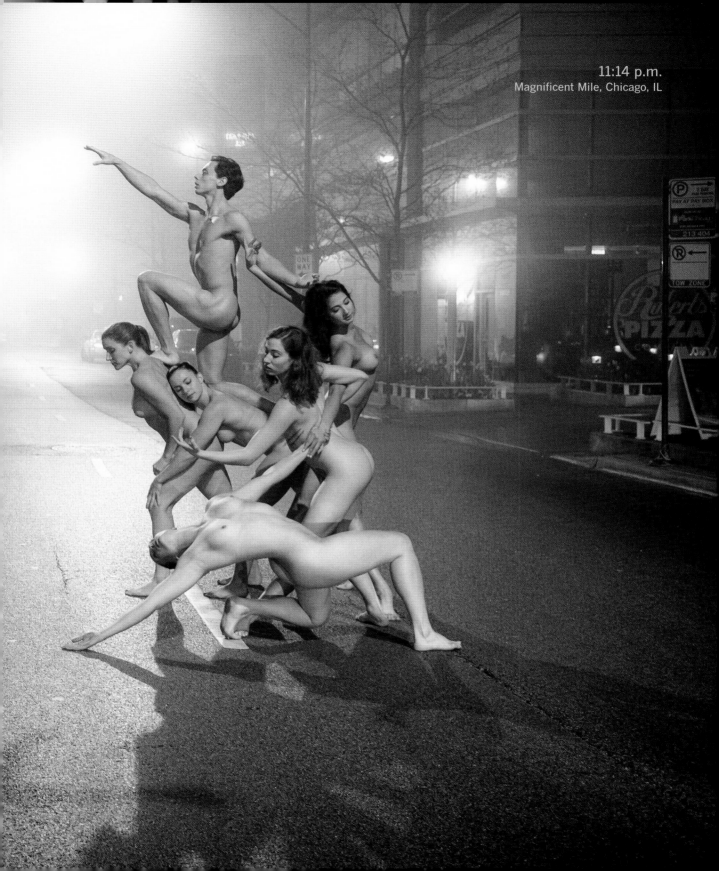

11:14 p.m.
Magnificent Mile, Chicago, IL

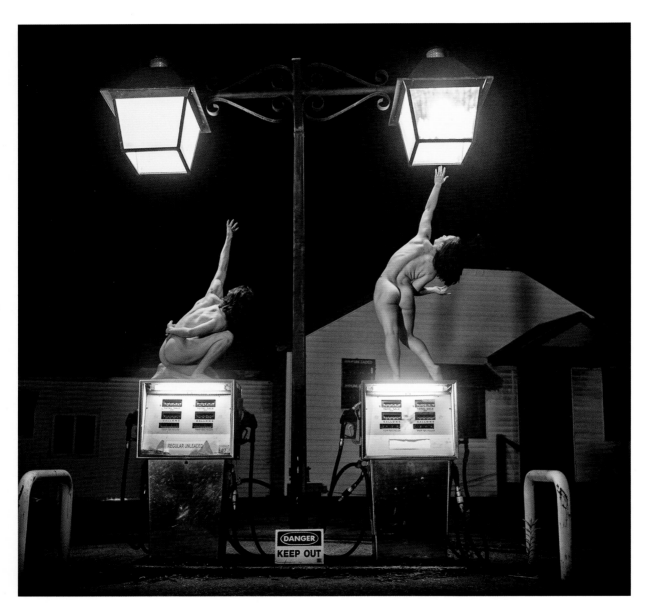

8:03 p.m.
Montpelier, VT

11:51 p.m. >
Royal Palace, Amsterdam, Netherlands

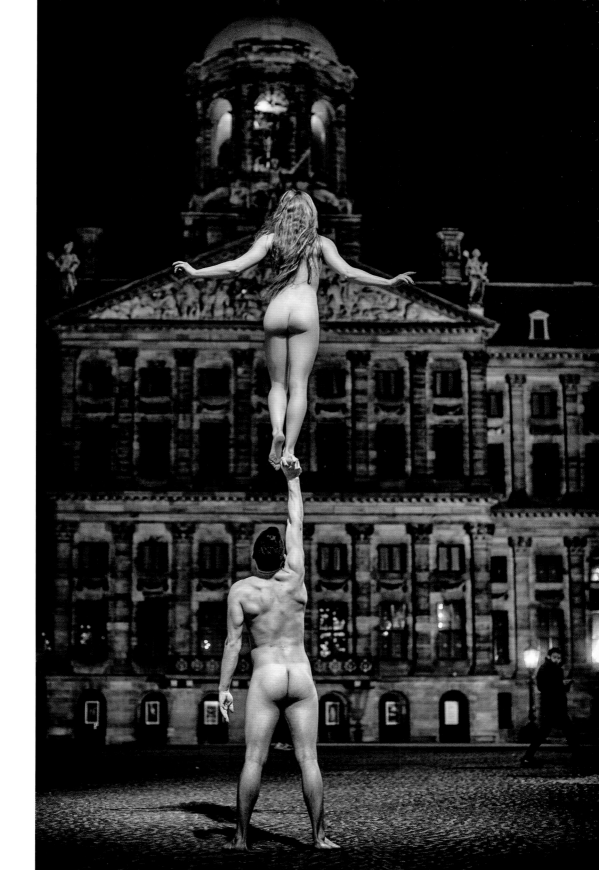

"A ship is safe in harbor, but that's not what ships are for."

WILLIAM GREENOUGH THAYER SHEDD

1:45 a.m. >
Times Square, New York, NY

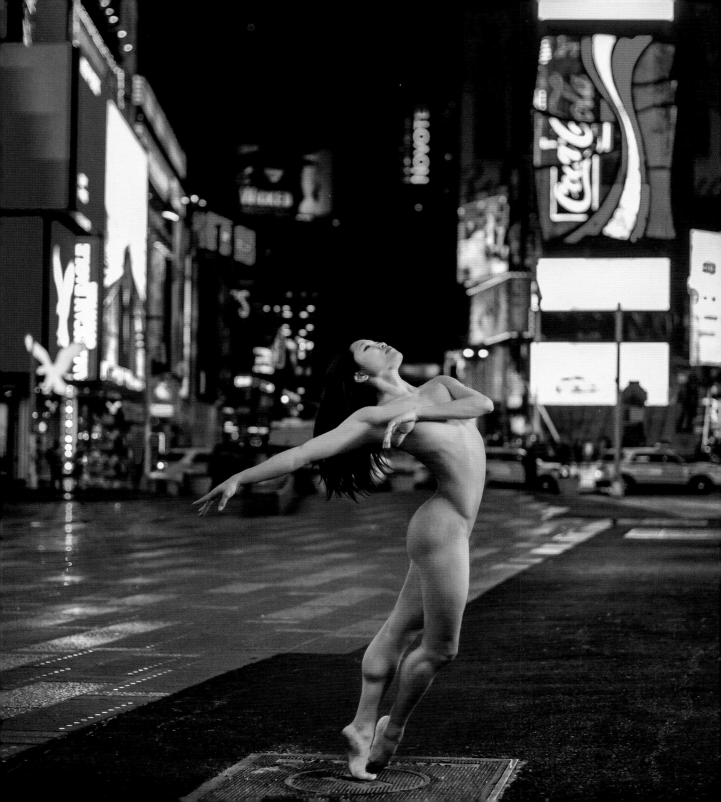

4:46 a.m.
Latin Quarter, Paris, France

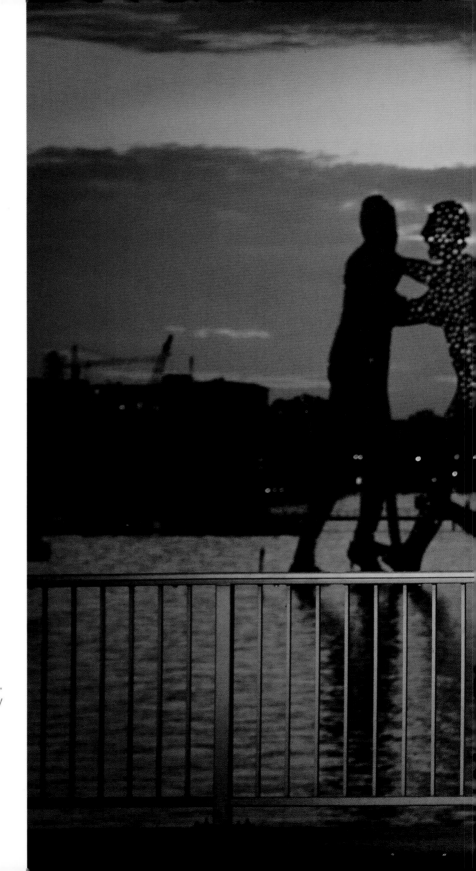

8:58 p.m.
East/West Divide, Berlin, Germany

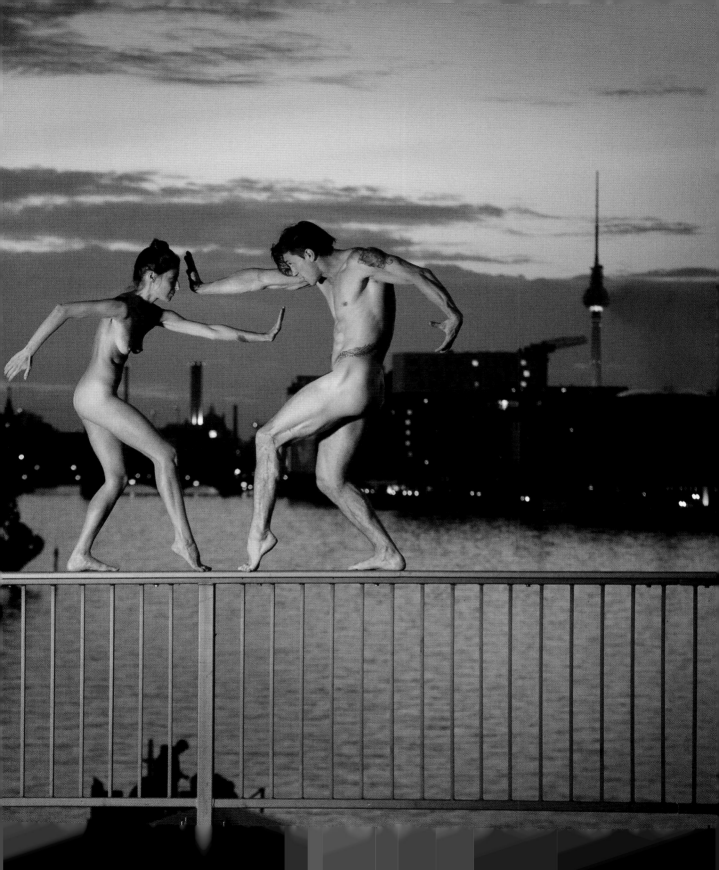

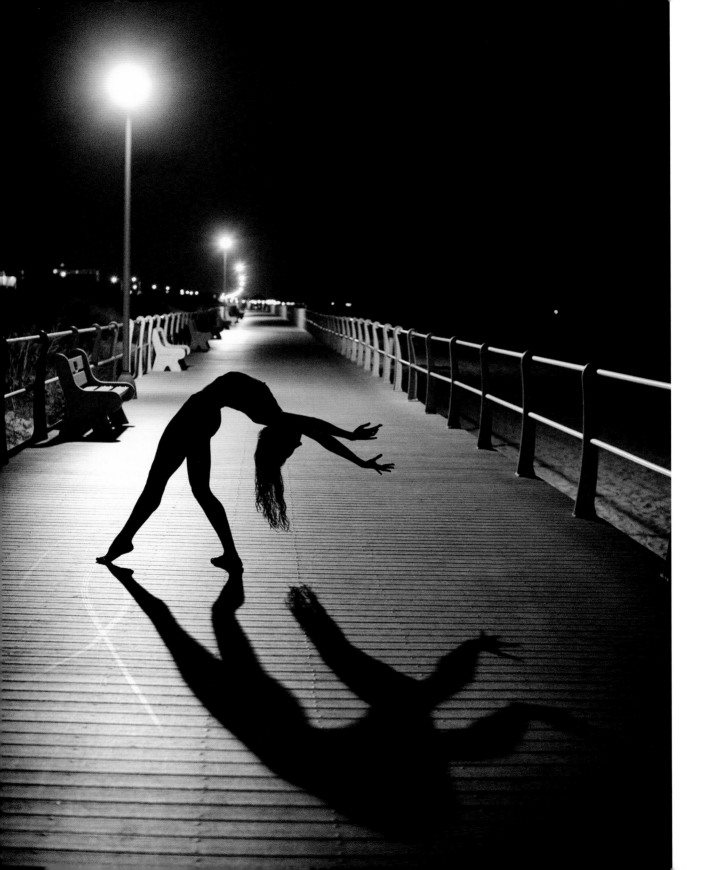

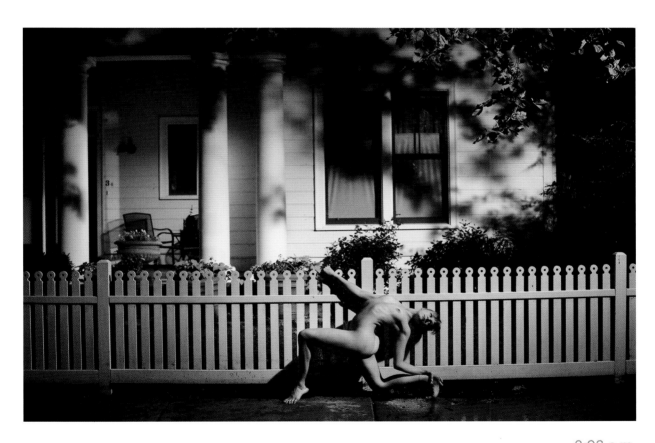

2:02 a.m.
New Town, MO

< 8:01 p.m.
Boardwalk, Spring Lake, NJ

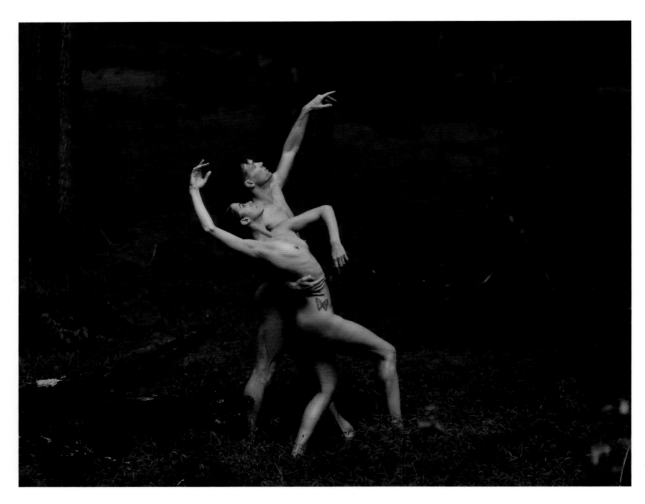

7:06 p.m.
Loch Raven Reservoir, Baltimore County, MD

10:59 p.m. >
The Met Cloisters, New York, NY

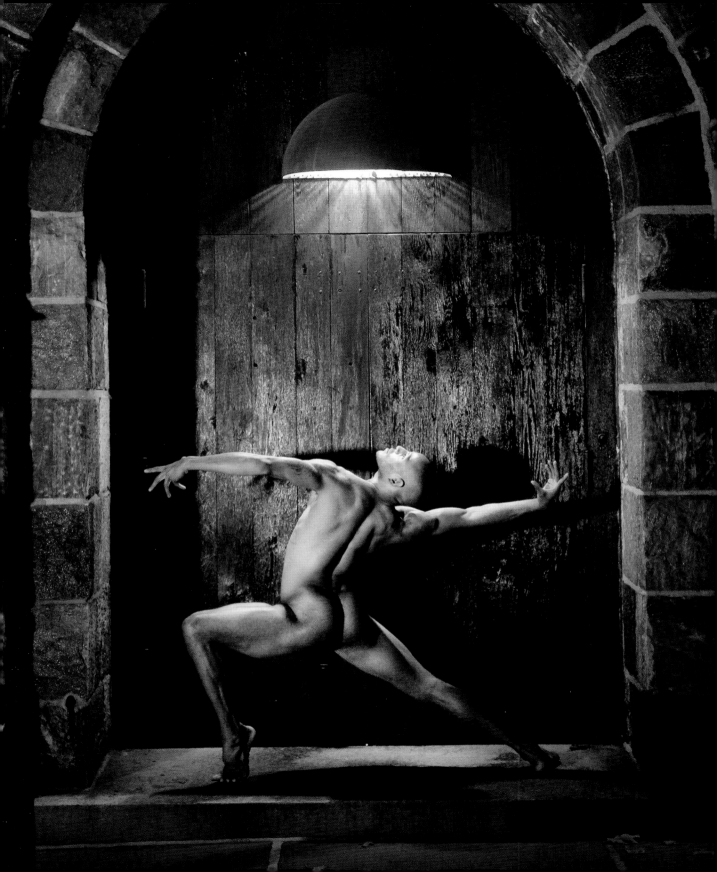

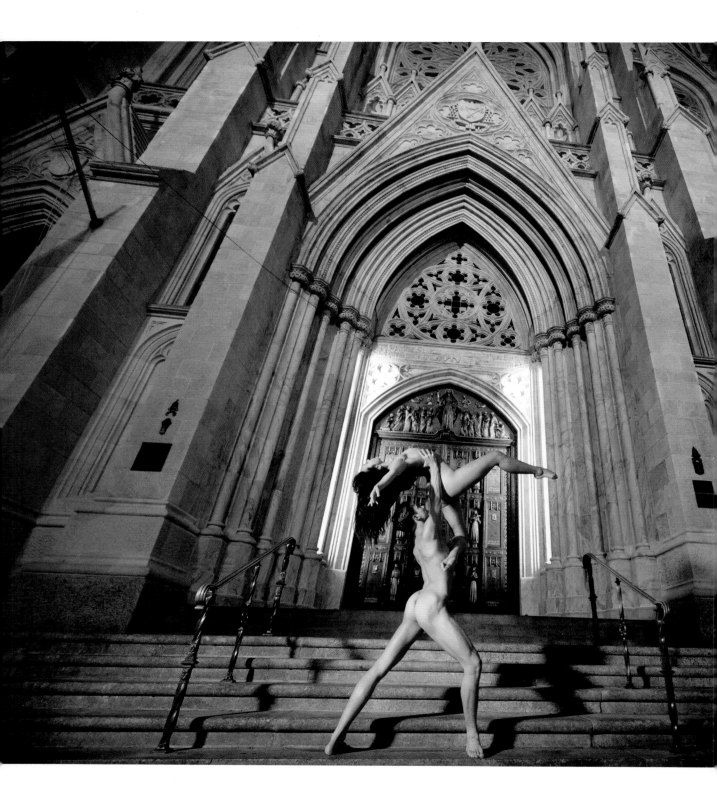

"Joy is strength."

MOTHER TERESA

10:40 p.m.
St. Patrick's Cathedral, New York, NY

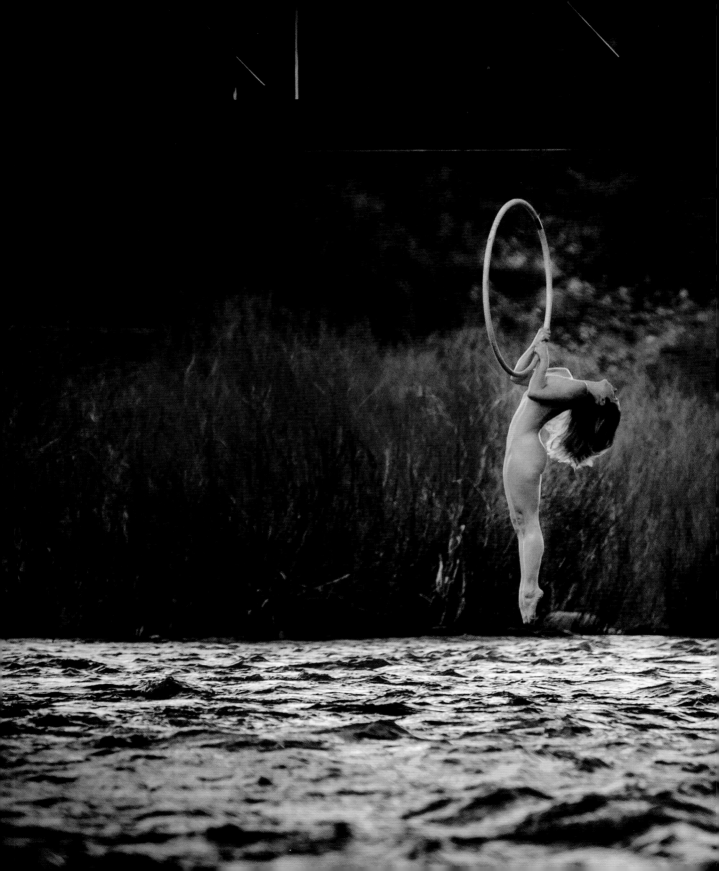

7:39 p.m.
Yampa River, Steamboat Springs, CO

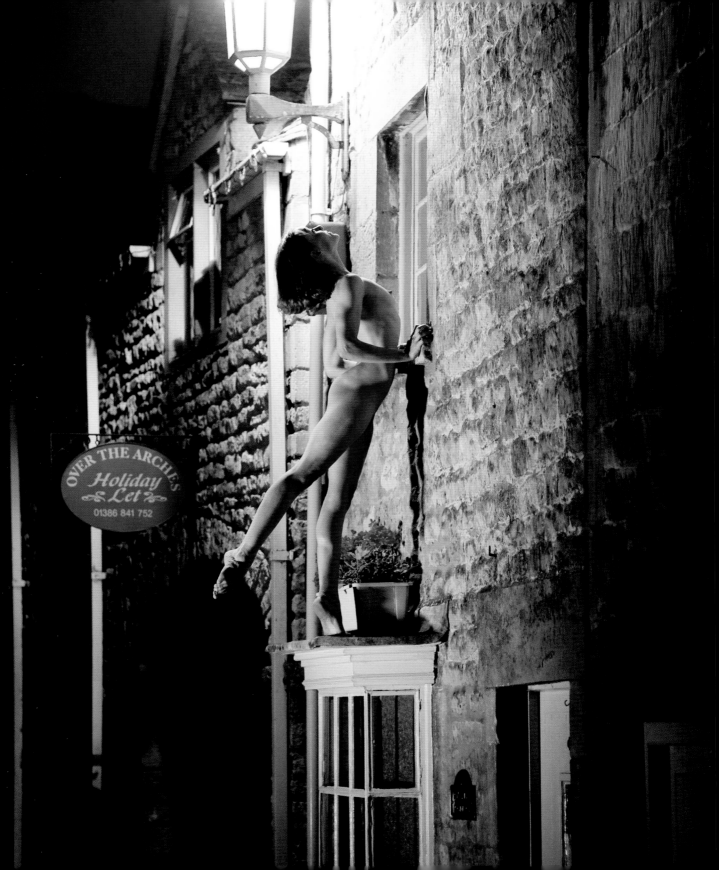

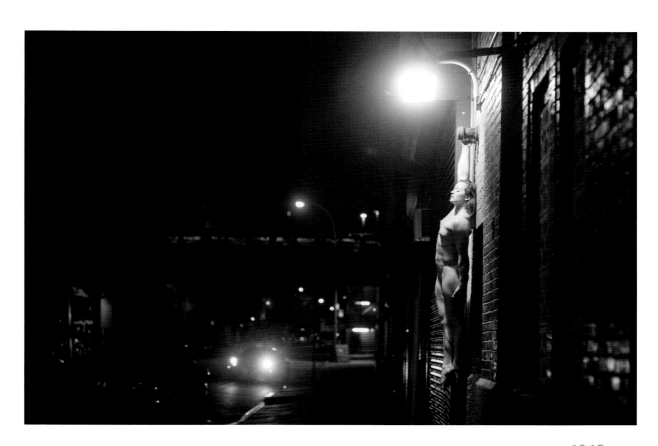

12:15 a.m.
Hell's Kitchen, New York, NY

< 8:51 p.m.
Chipping Campden, England

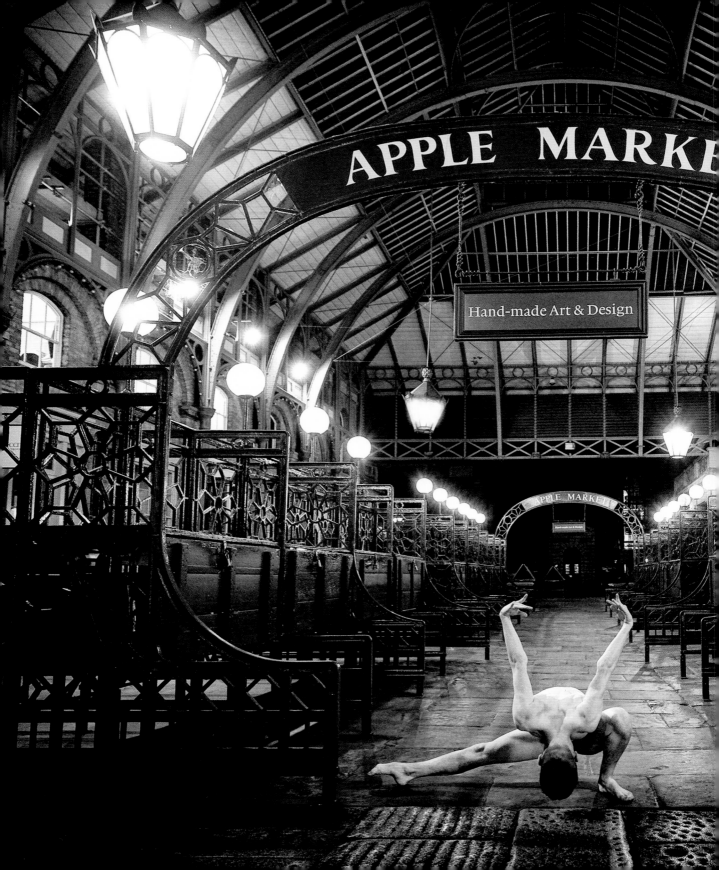

3:18 a.m.
Covent Garden, London, England

*"Whoever thinks of going to bed before twelve o'clock
is a scoundrel."*

SAMUEL JOHNSON

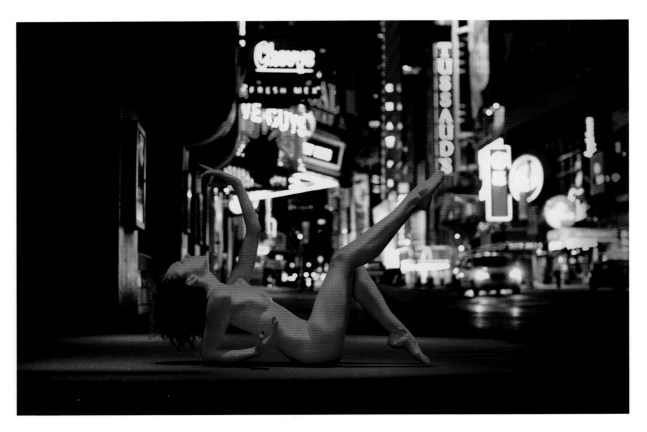

3:40 a.m.
Forty-Second Street, New York, NY

4:36 a.m. >
Red-Light District, Amsterdam, Netherlands

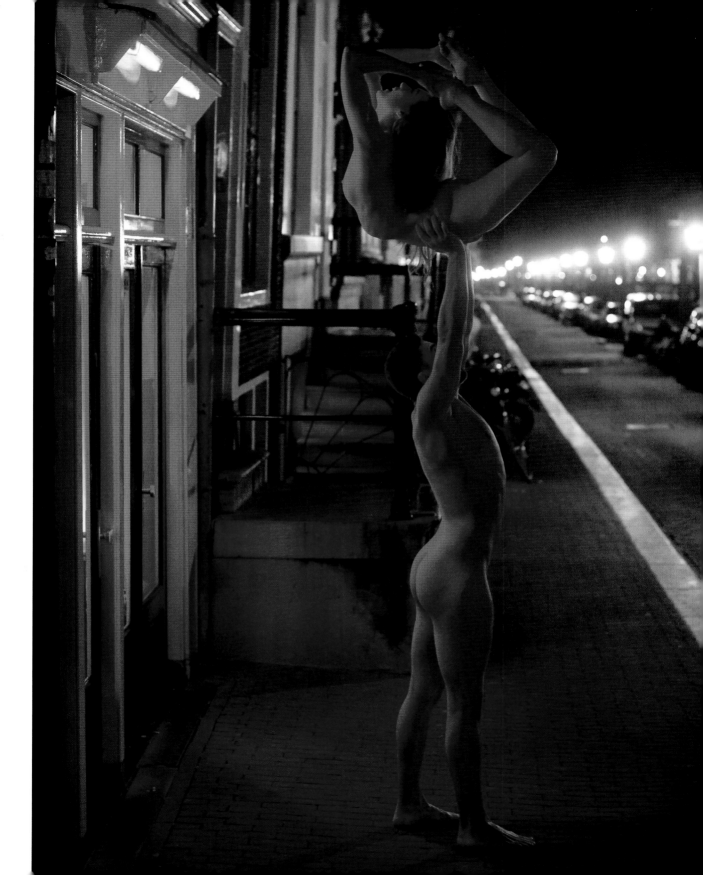

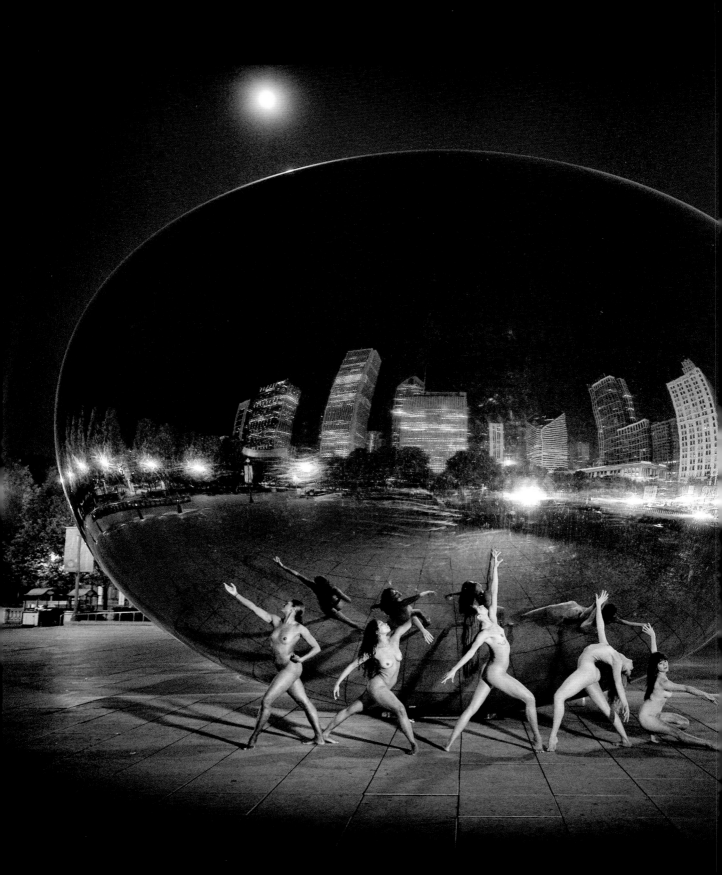

1:26 a.m.
Millennium Park, Chicago, IL

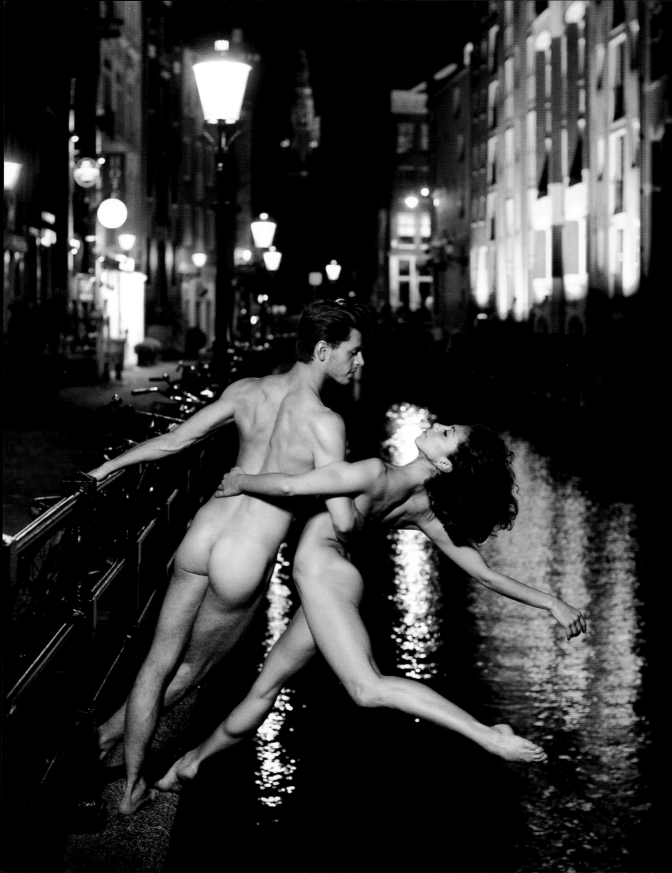

"You can't get to courage without walking through vulnerability."

BRENÉ BROWN

< 11:46 p.m.
Amsterdam, Netherlands

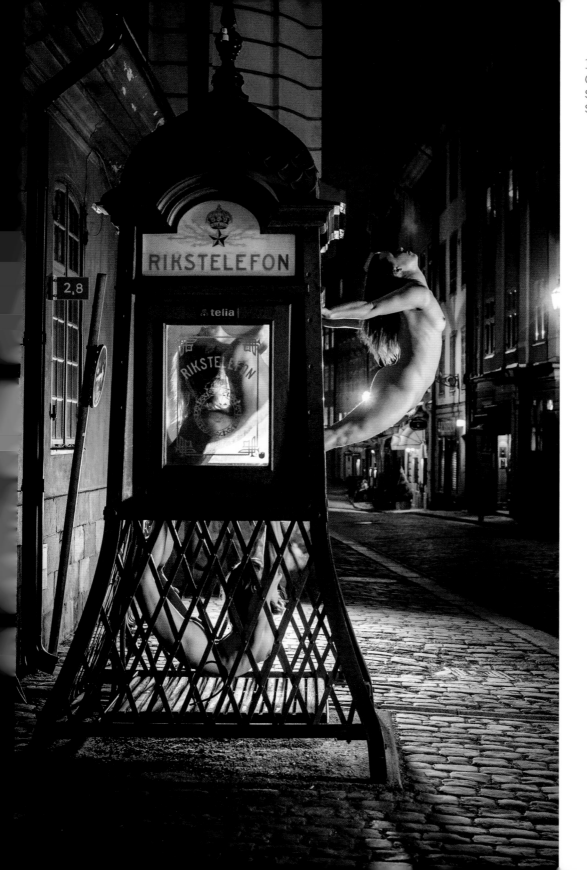

10:33 p.m.
Old Town,
Stockholm,
Sweden

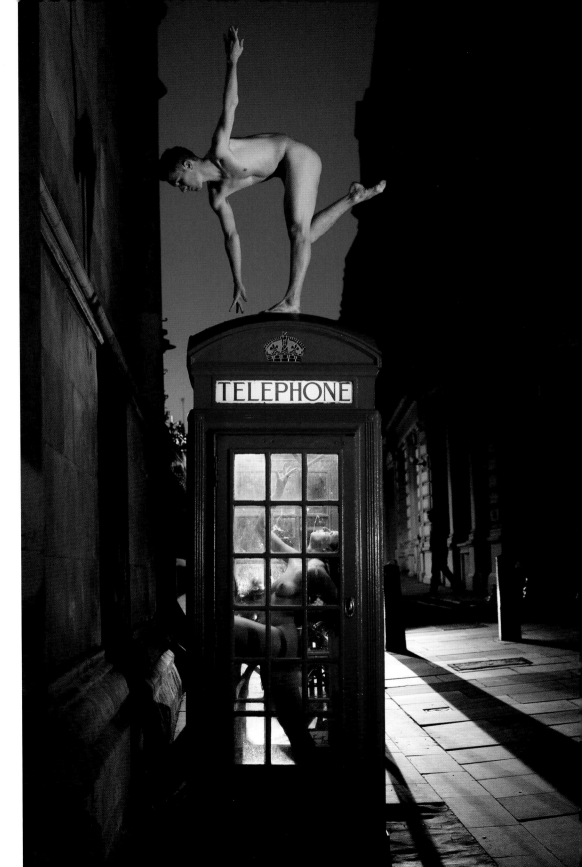

10:21 p.m.
The Strand,
London, England

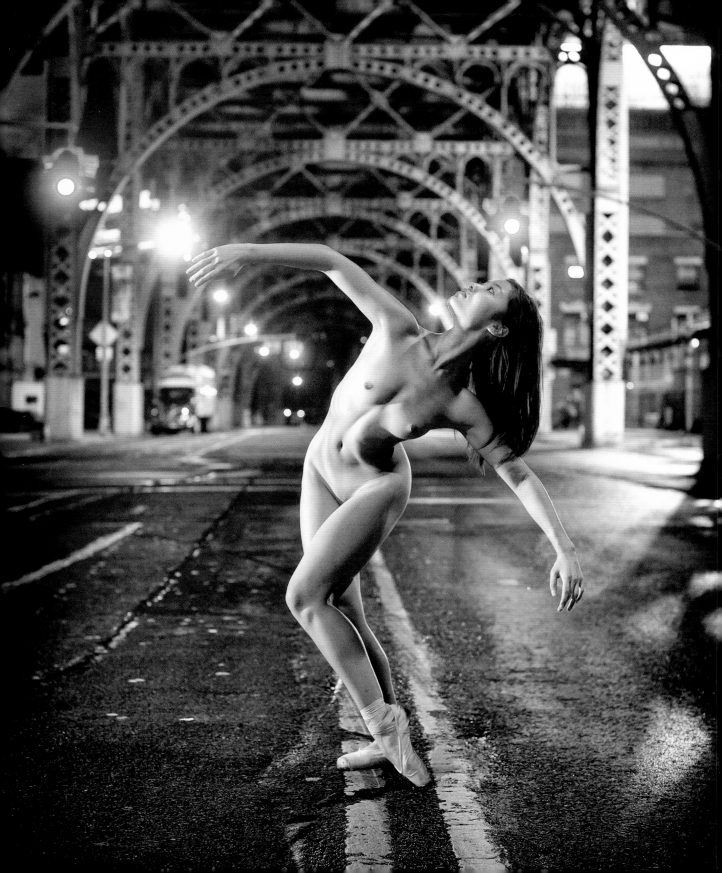

"I saw the angel in the marble and I carved to set him free."

MICHELANGELO

"Only those who will risk going too far can possibly find out how far one can go."

T. S. ELIOT

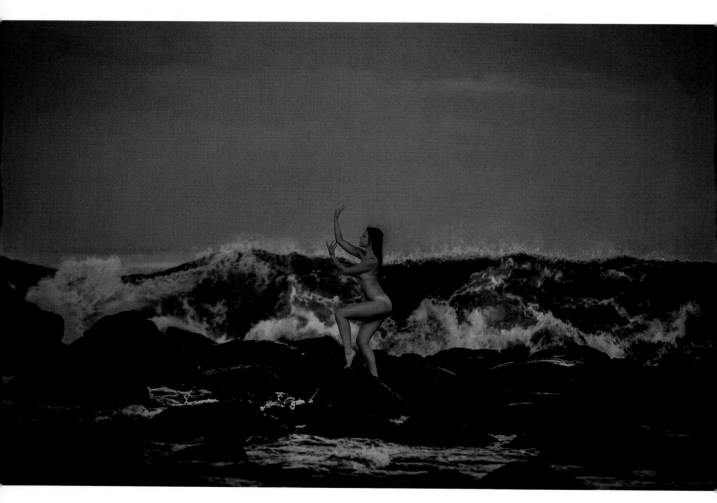

7:26 p.m.
Jersey Shore, NJ

8:34 p.m. >
Stockholm, Sweden

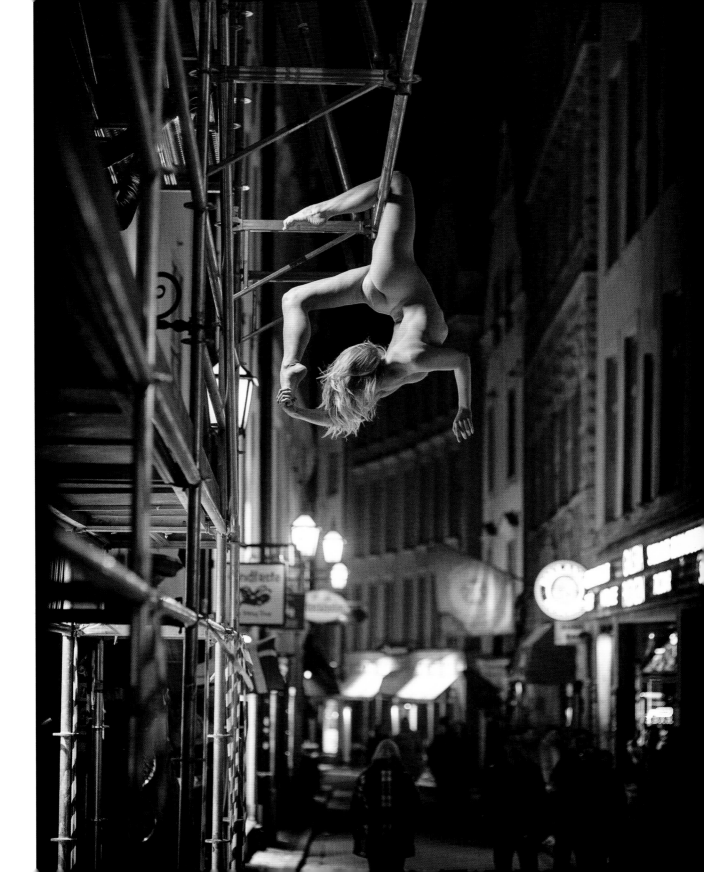

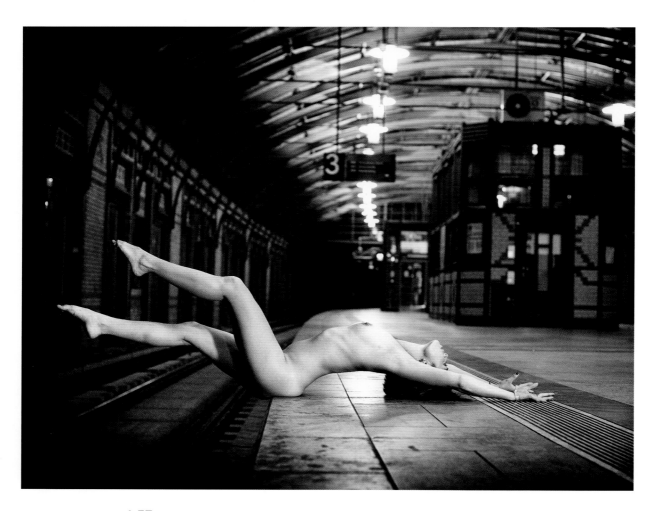

1:57 a.m.
Berlin, Germany

"Courage is being scared to death and saddling up anyway."

JOHN WAYNE

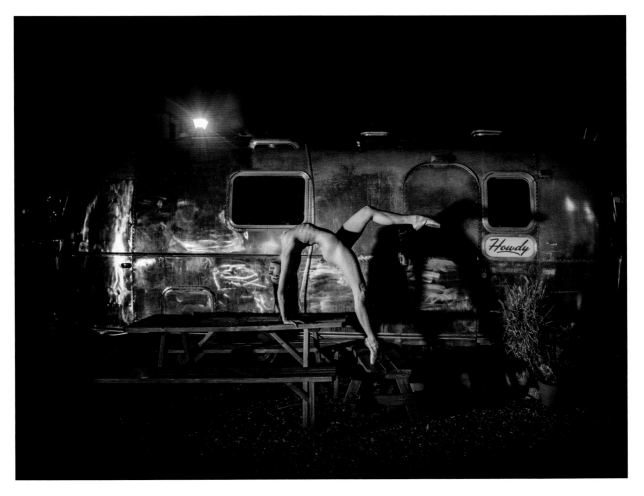

11:13 p.m.
Austin, TX

7:26 p.m.
Ocean Beach, San Francisco, CA

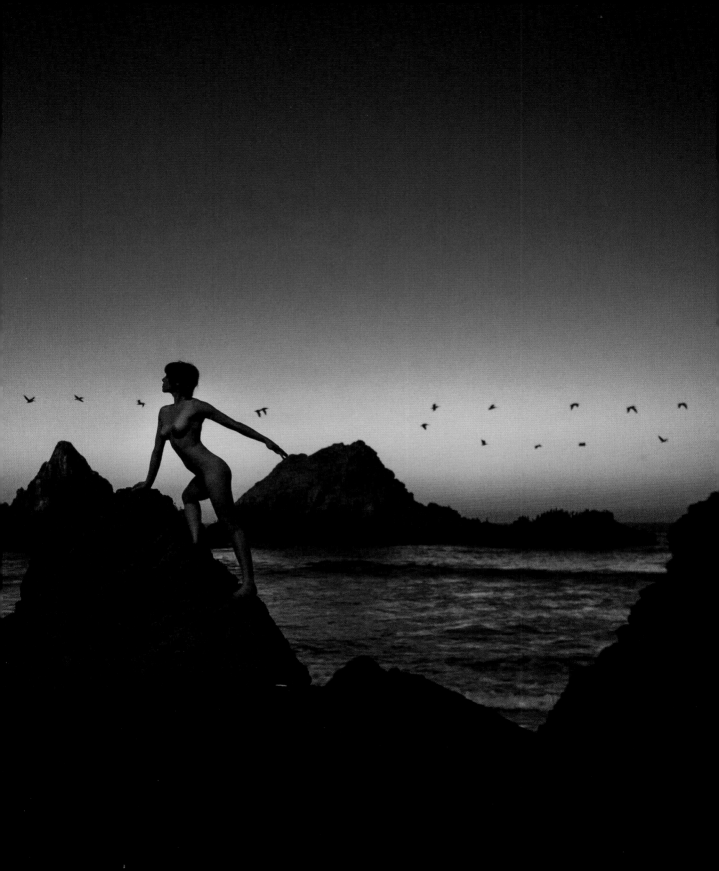

"When you reach the end of your rope, tie a knot and hang on."

ANONYMOUS

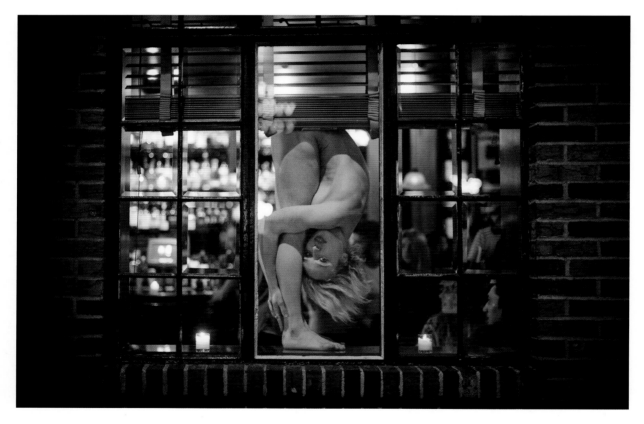

8:51 p.m.
West Village, New York, NY

12:04 a.m. >
Williamsburg, Brooklyn, NY

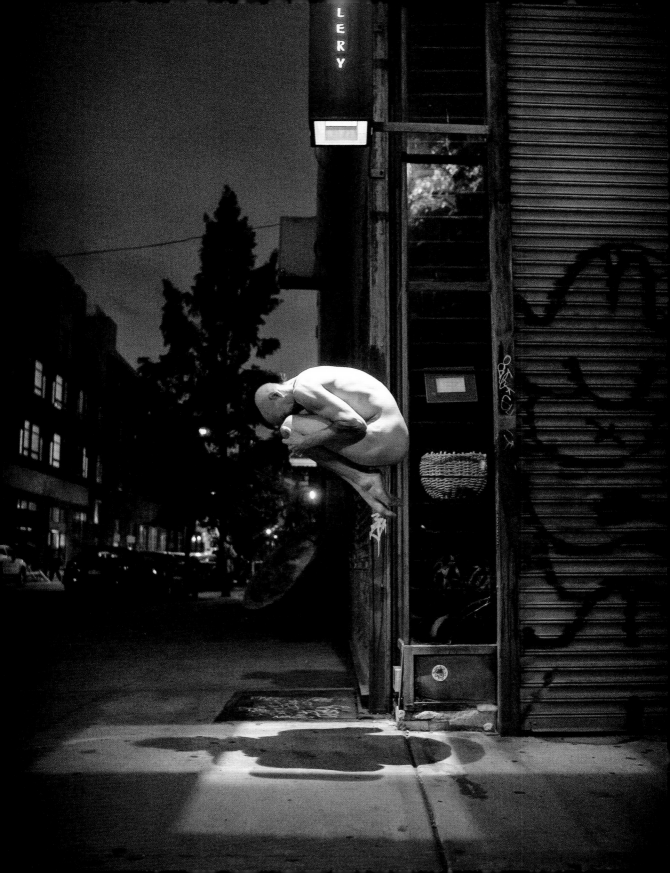

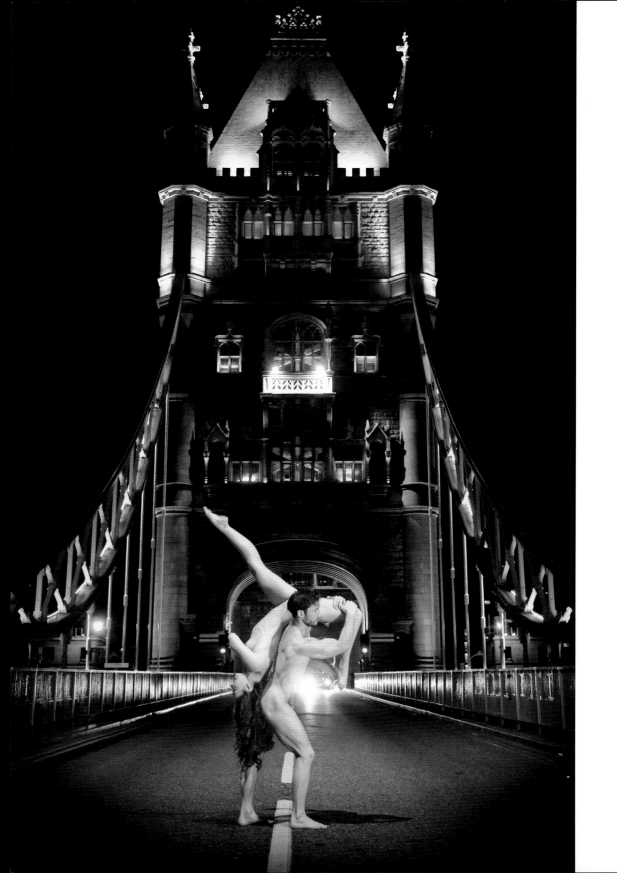

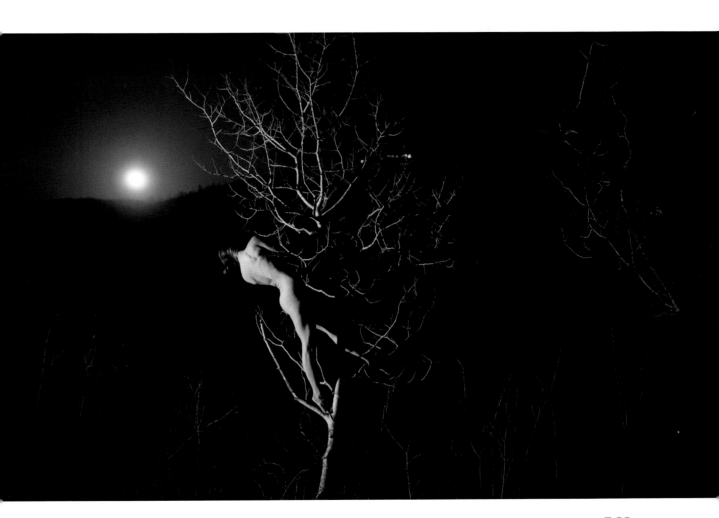

7:33 p.m.
Mount Werner, Steamboat Springs, CO

< 2:08 a.m.
Tower Bridge, London, England

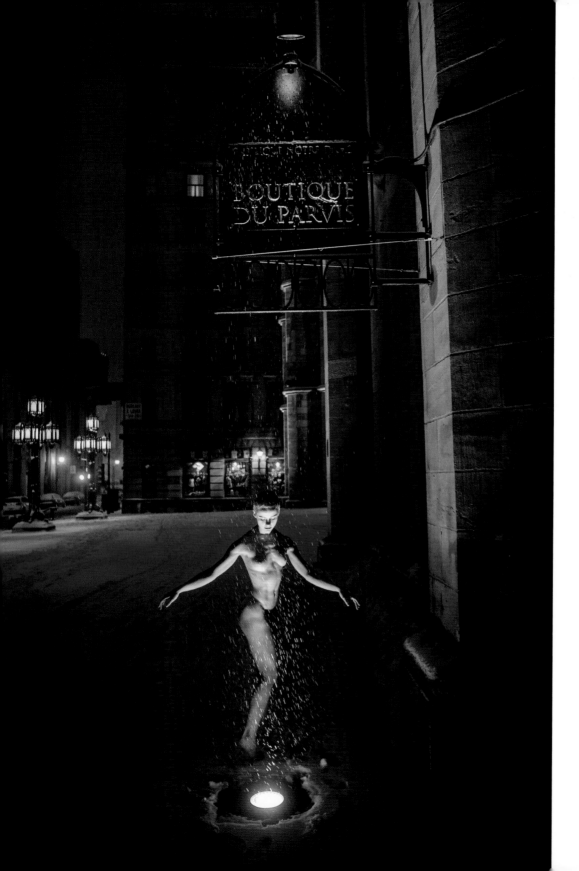

1:42 a.m. >
New York, NY

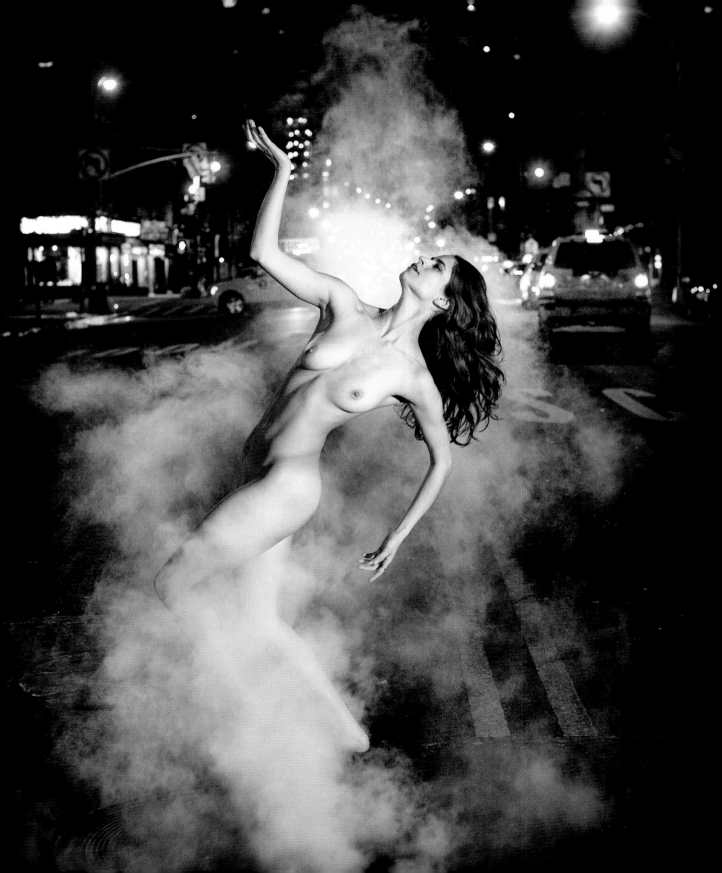

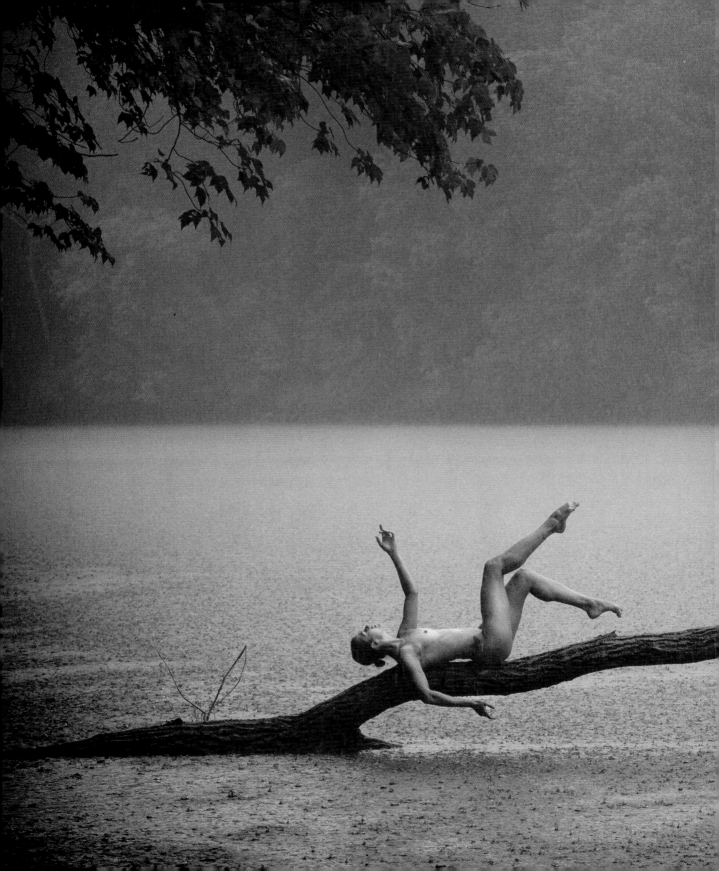

5:53 p.m.
Loch Raven Reservoir, Baltimore County, MD

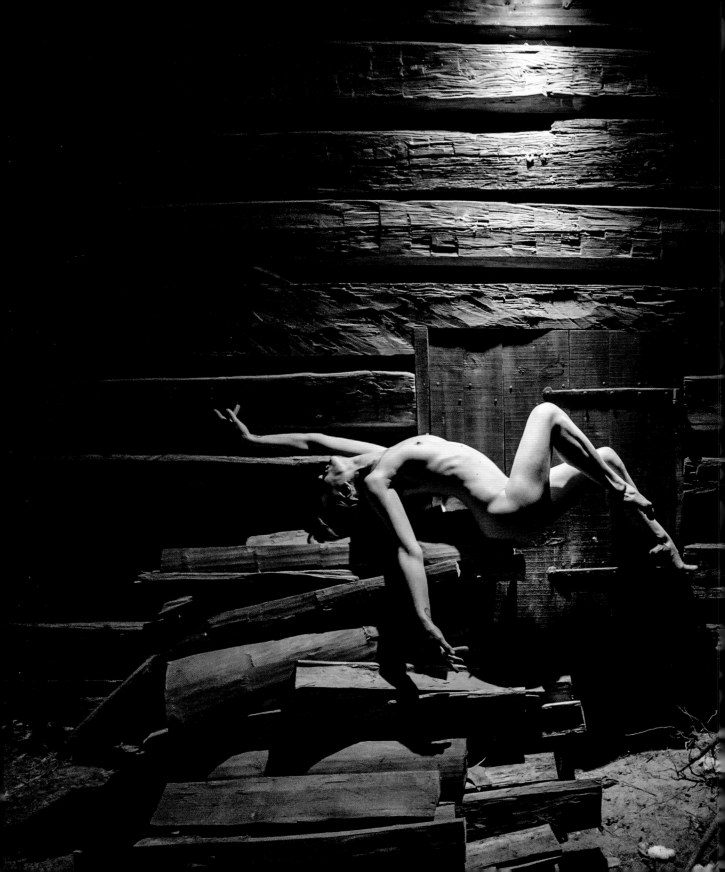

11:53 p.m.
Little Rock, AR

"The power of imagination makes us infinite."

JOHN MUIR

2:44 a.m. >
Hudson River Park Walkway, New York, NY

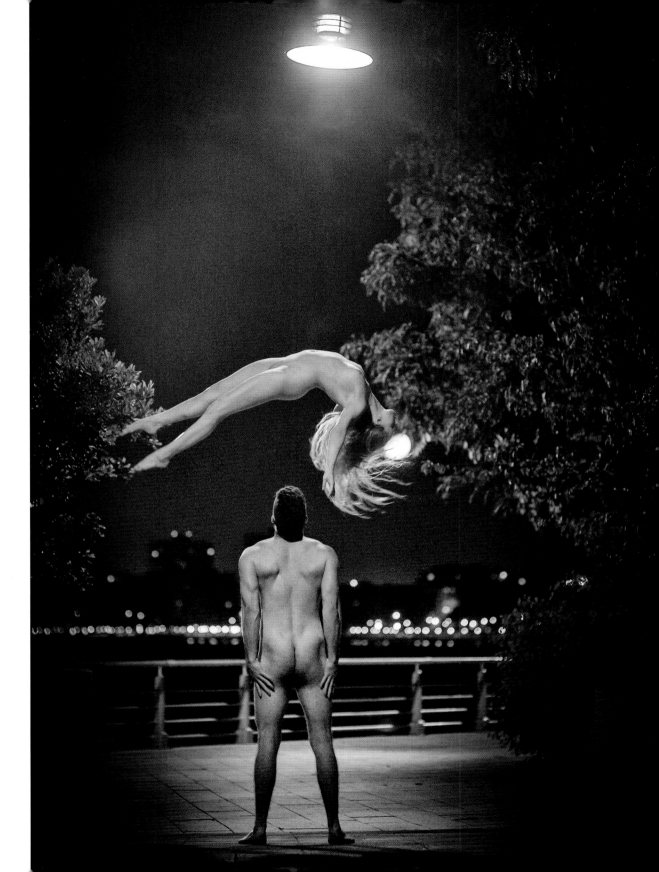

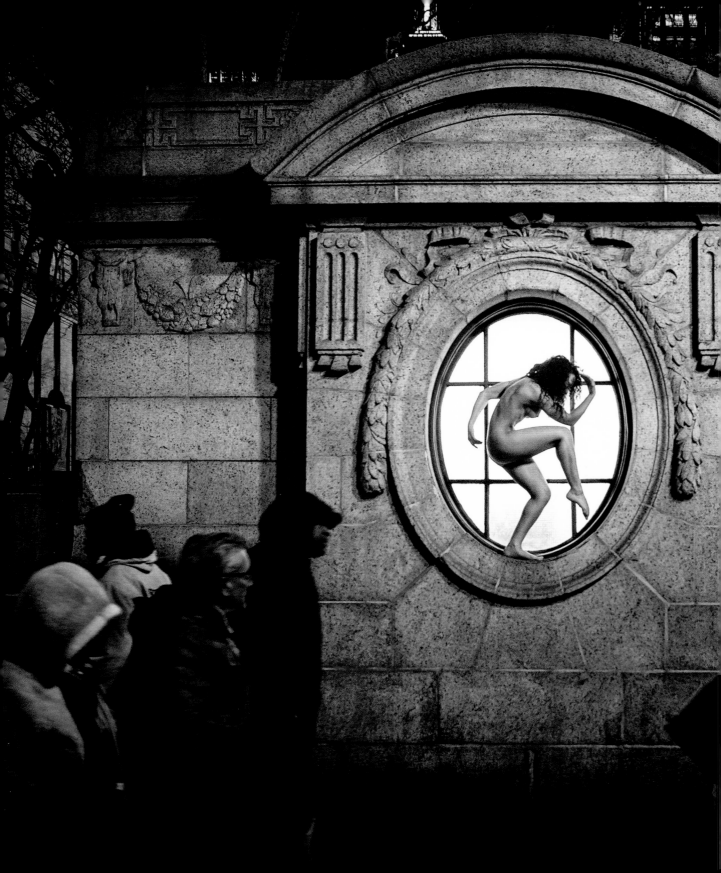

7:31 p.m.
Bryant Park, New York, NY

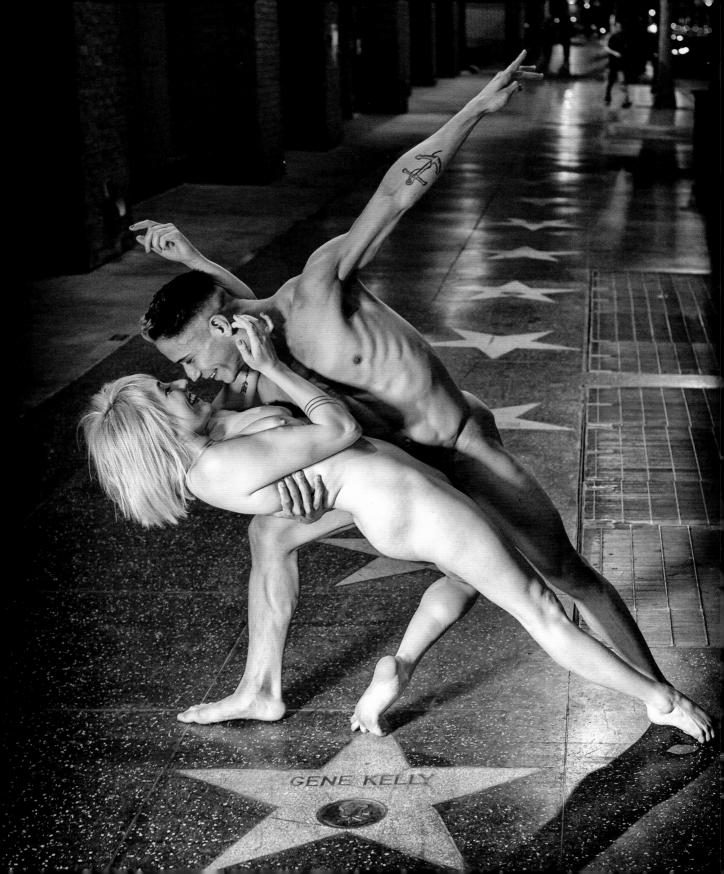

ecstasy

"Webster's defines ecstasy as 'a state of being beyond reason and self-control.' Dancing transports me from reality to a state of bliss. When I danced naked on Gene Kelly's Hollywood Star, it was even more than bliss; it was pure ecstasy."

Marissa Lupp *(pictured left)*

< 12:36 a.m.
Hollywood Walk of Fame, Los Angeles, CA

"Those who dance are considered insane by those who can't hear the music."

GEORGE CARLIN

3:02 a.m. >
Theater District, New York, NY

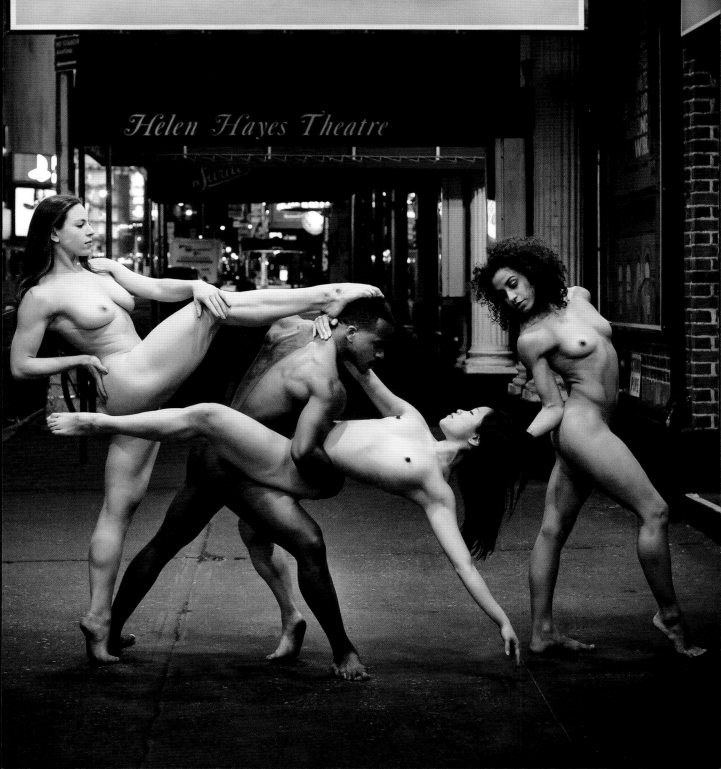

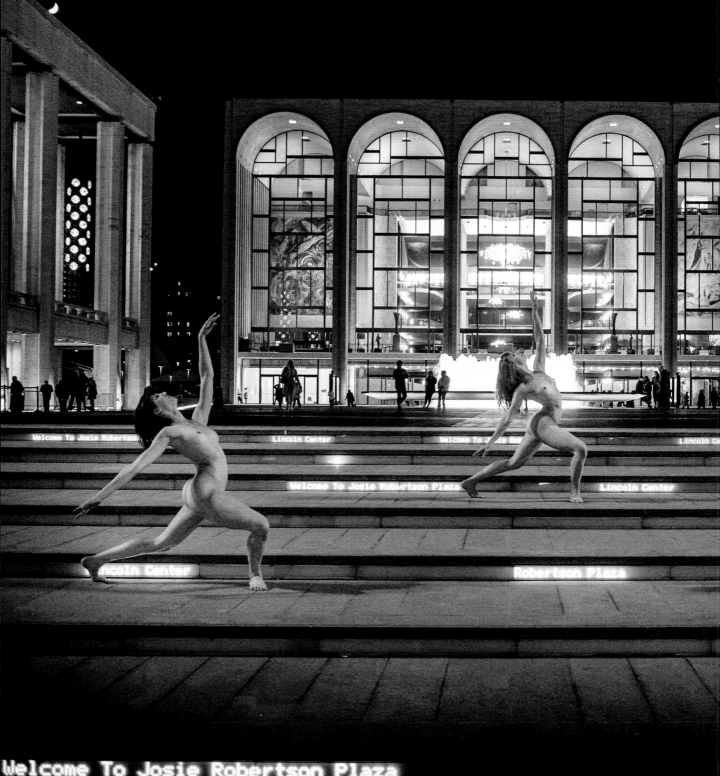

Welcome To Josie Robertson Plaza

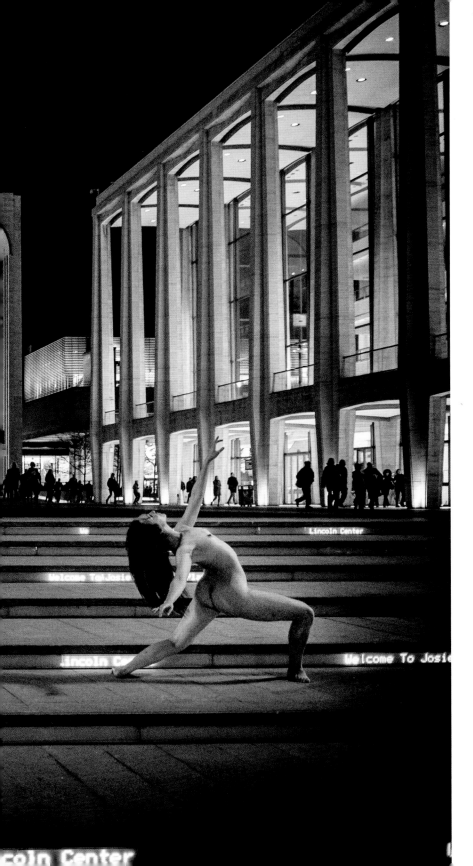

10:59 p.m.
Lincoln Center, New York, NY

"Exuberance is Beauty."

WILLIAM BLAKE

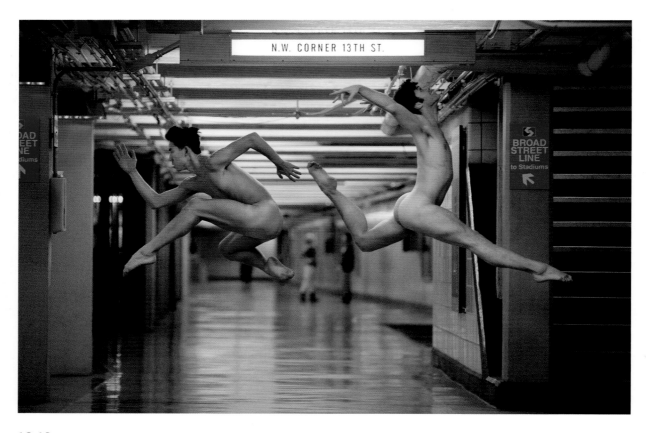

10:12 p.m.
Broad Street, Philadelphia, PA

11:06 p.m. >
Fifth Avenue, New York, NY

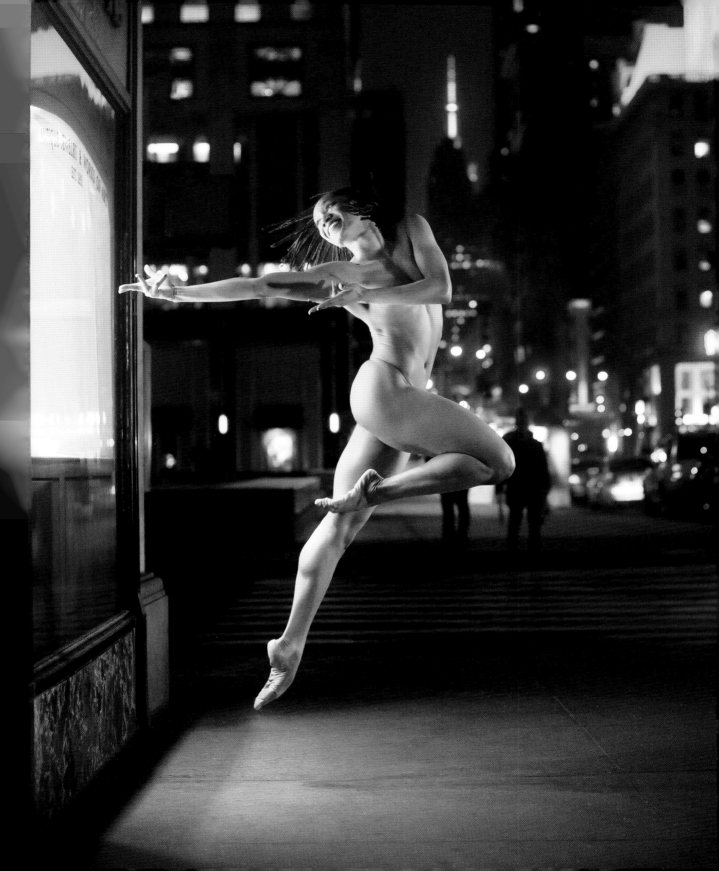

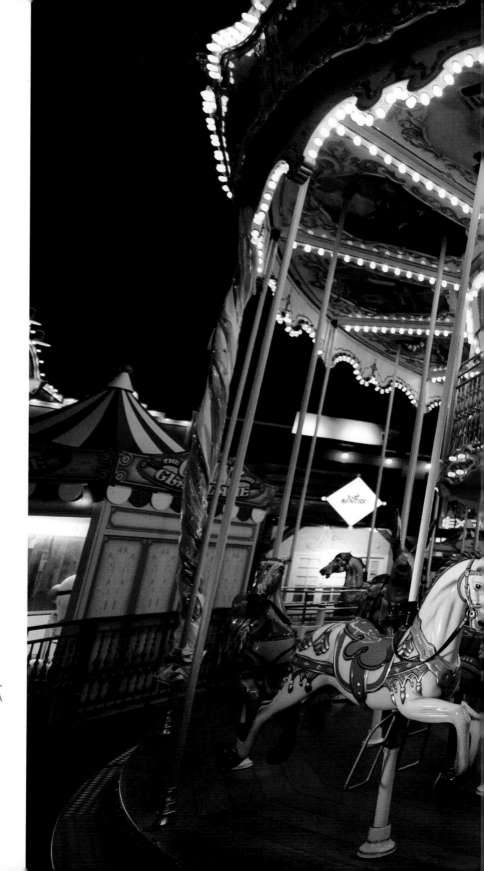

9:45 p.m.
Fisherman's Wharf, San Francisco, CA

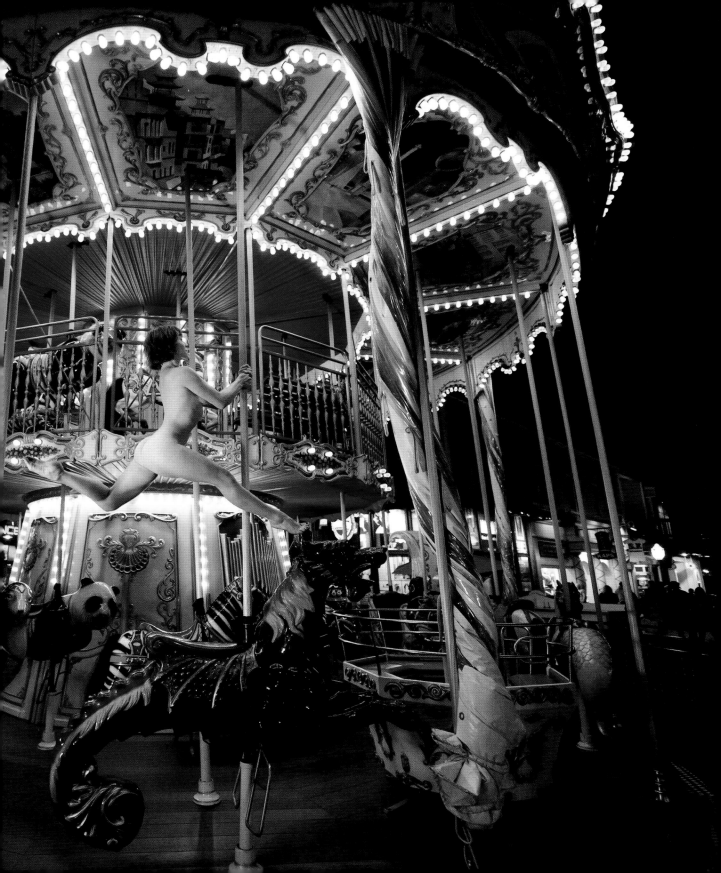

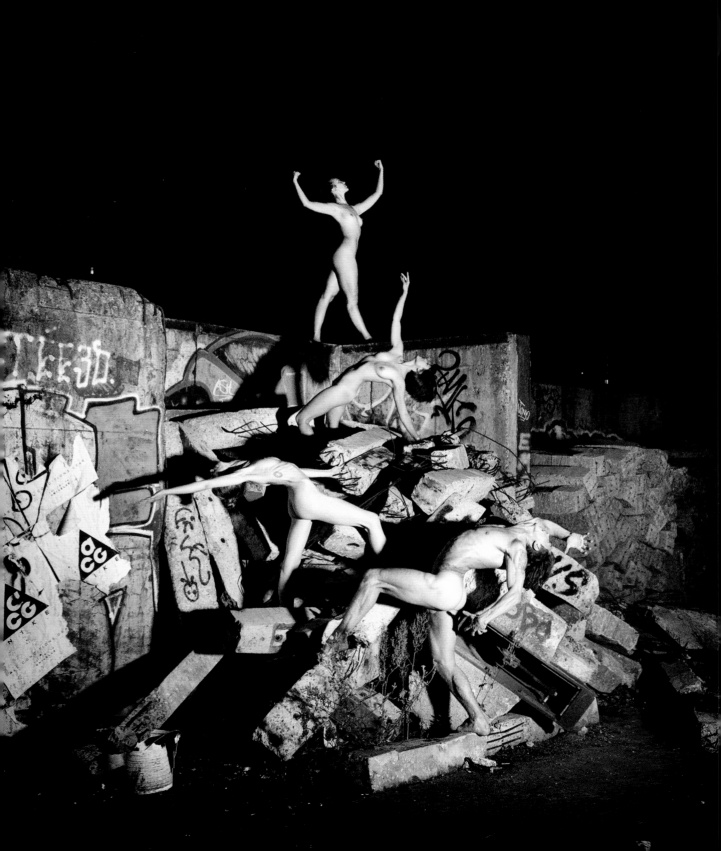

"What comes easy won't last. What lasts won't come easy."

ANONYMOUS

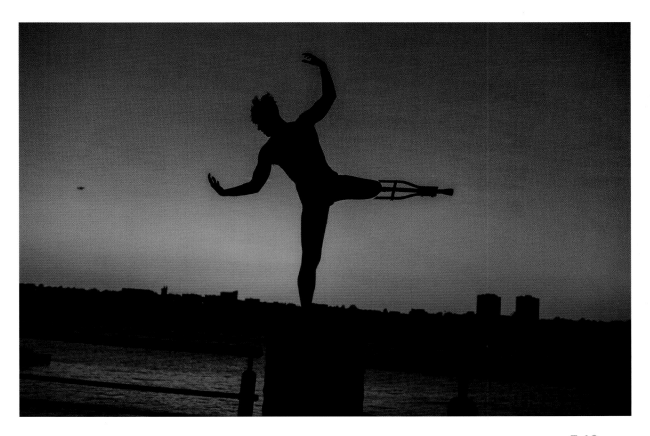

7:40 p.m.
Pier 94, New York, NY

< 9:49 p.m.
Berlin Wall, Berlin, Germany

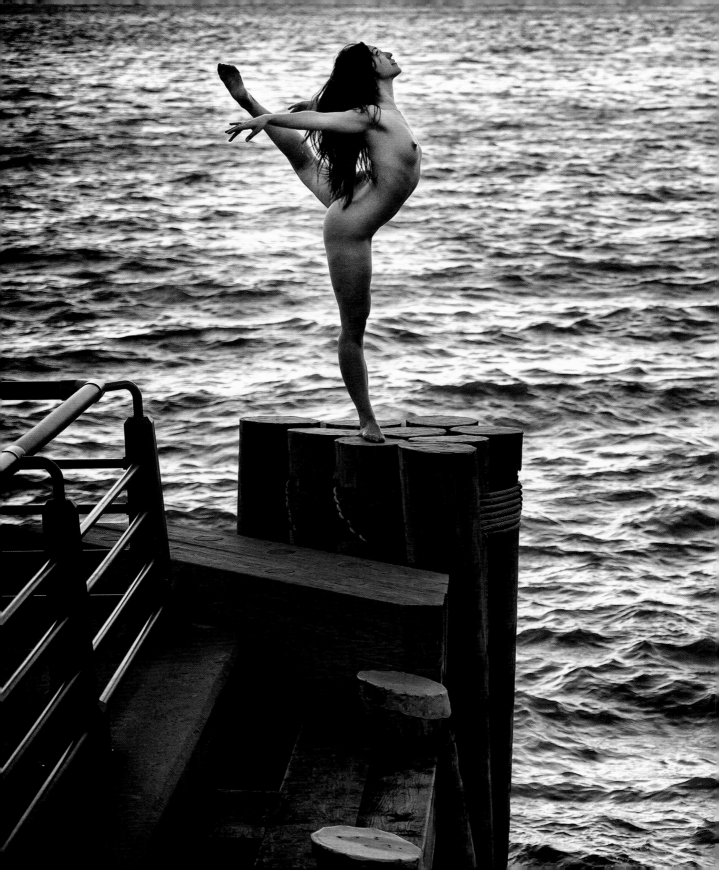

7:45 p.m.
Hudson River, New York, NY

"Life isn't about finding yourself. Life is about creating yourself."

GEORGE BERNARD SHAW

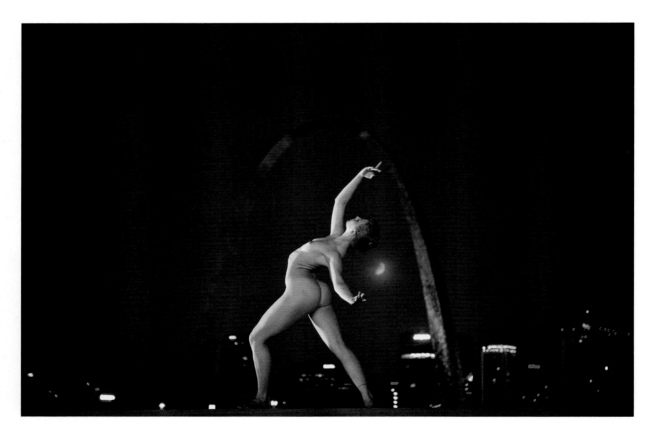

1:36 a.m.
Gateway Arch, St. Louis, MO

1:05 a.m. >
Washington Heights, New York, NY

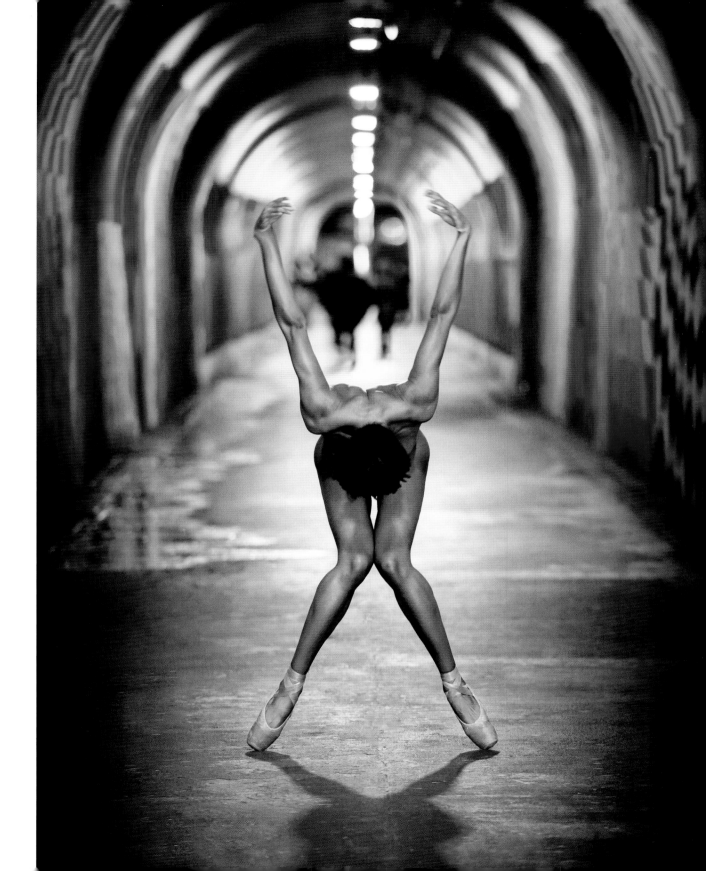

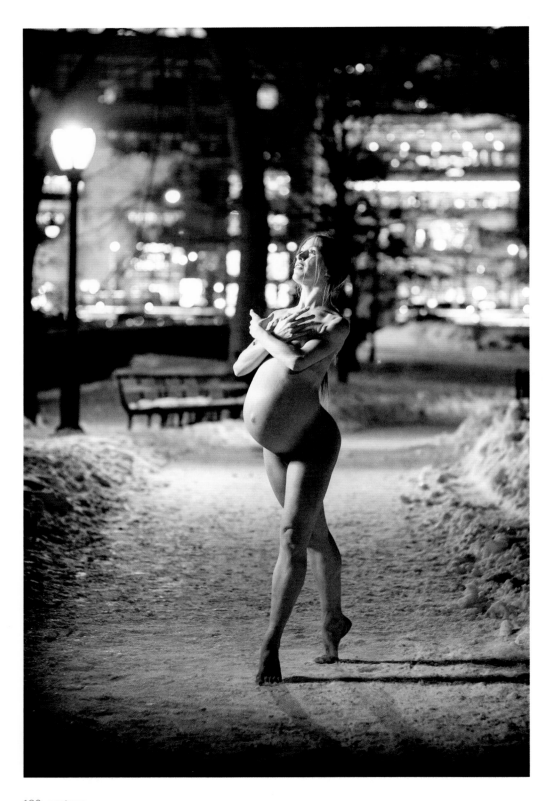

10:33 p.m.
March 2015
Central Park,
New York, NY

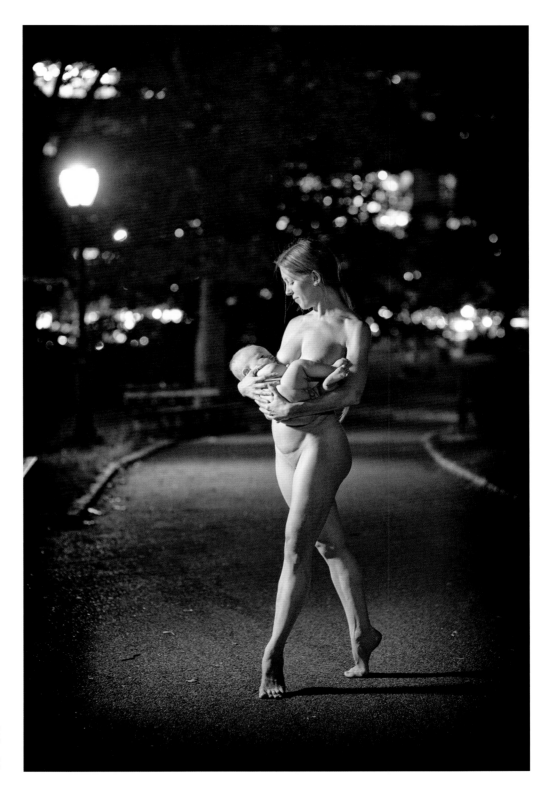

9:11 p.m.
August 2015
Central Park,
New York, NY

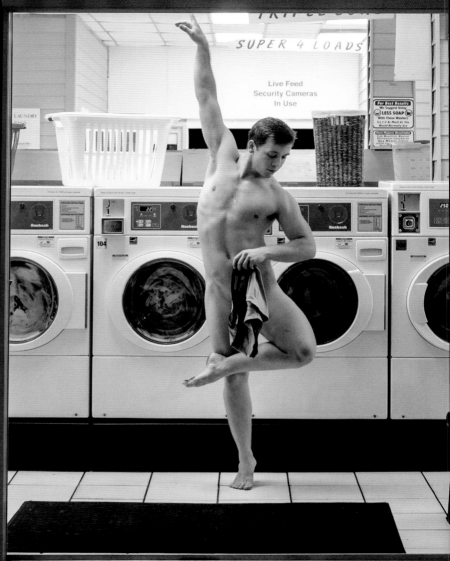

"It's better to ask forgiveness than permission."

GRACE HOPPER

7:35 p.m.
Strip Mall, Sarasota, FL

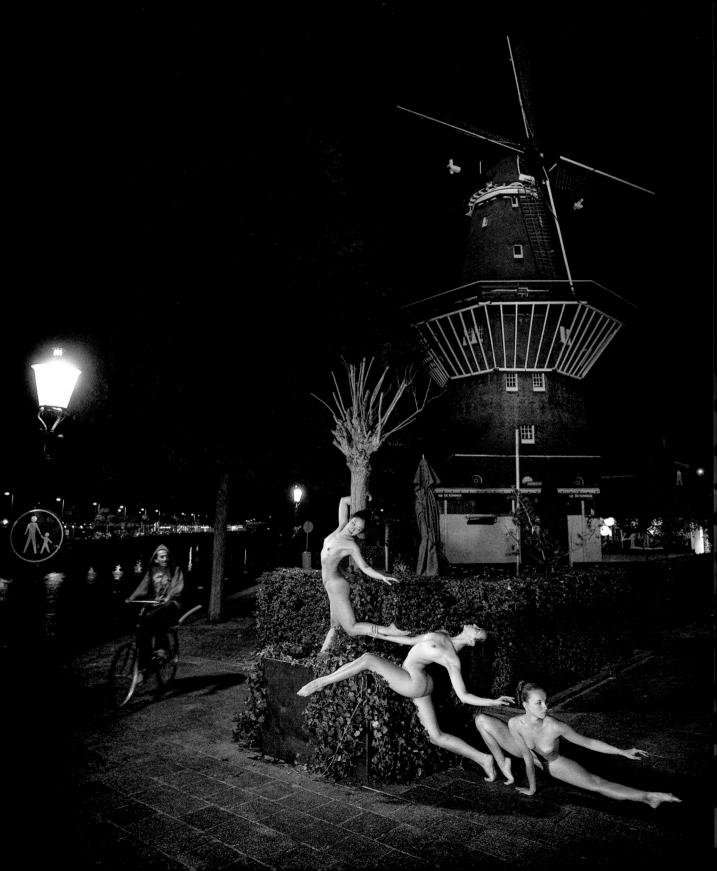

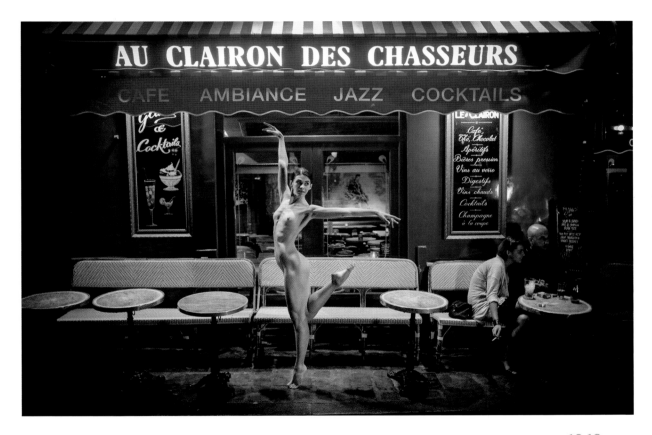

12:18 a.m.
Montmartre, Paris, France

< 2:36 a.m.
Amsterdam, Netherlands

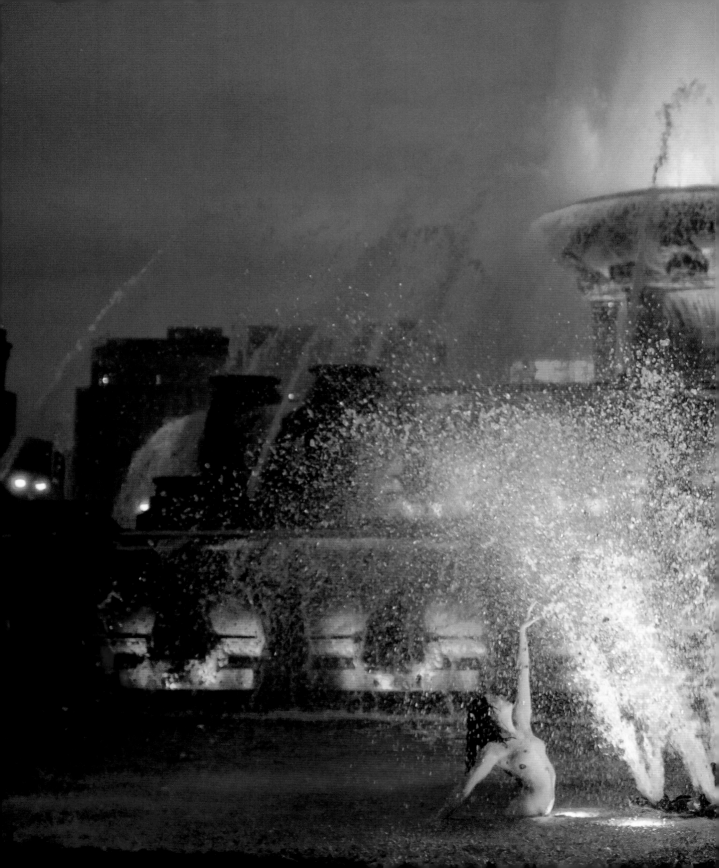

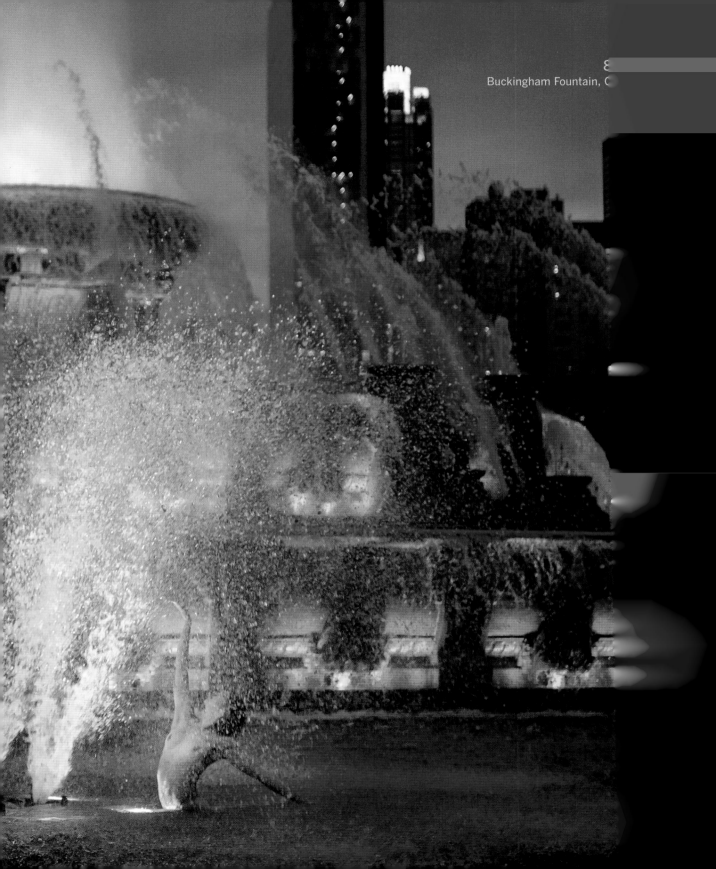

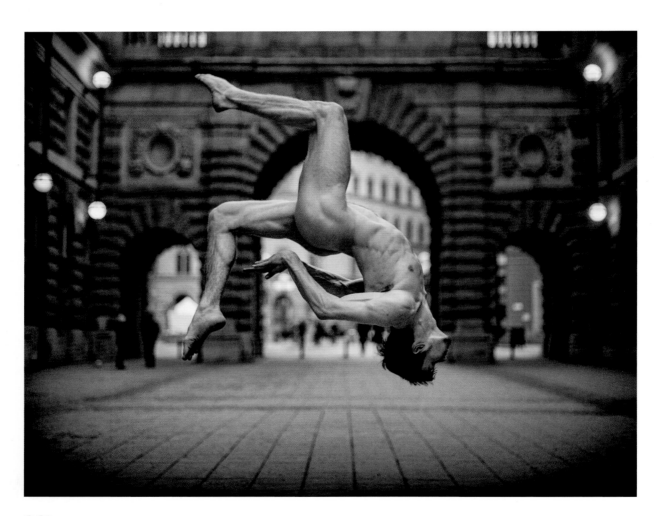

6:31 p.m.
House of Parliament, Stockholm, Sweden

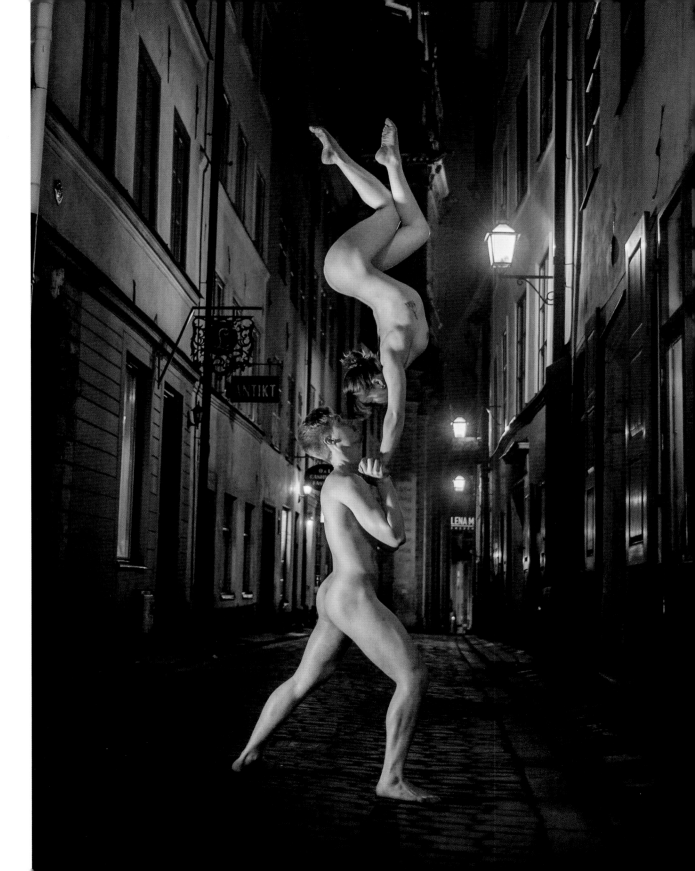

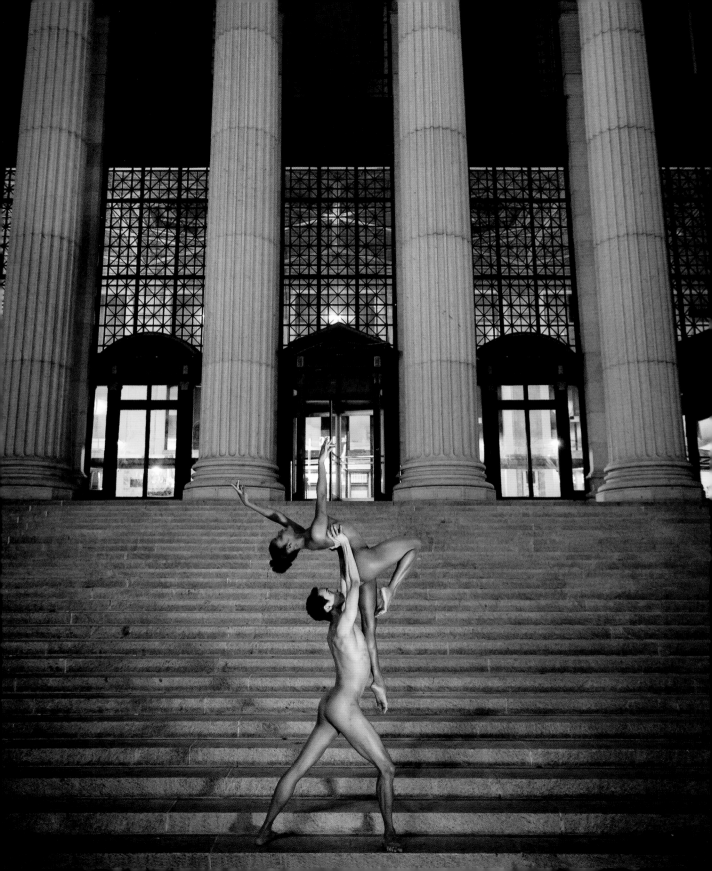

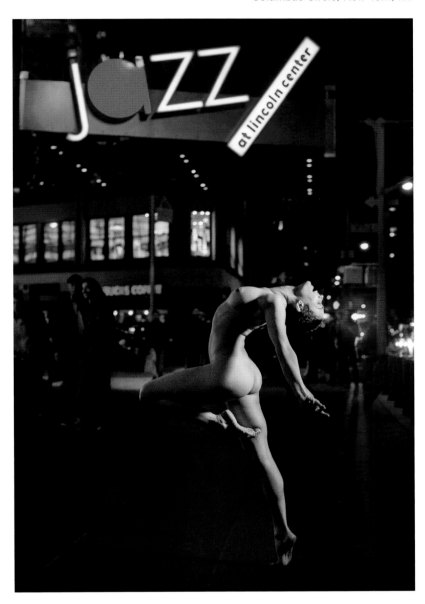

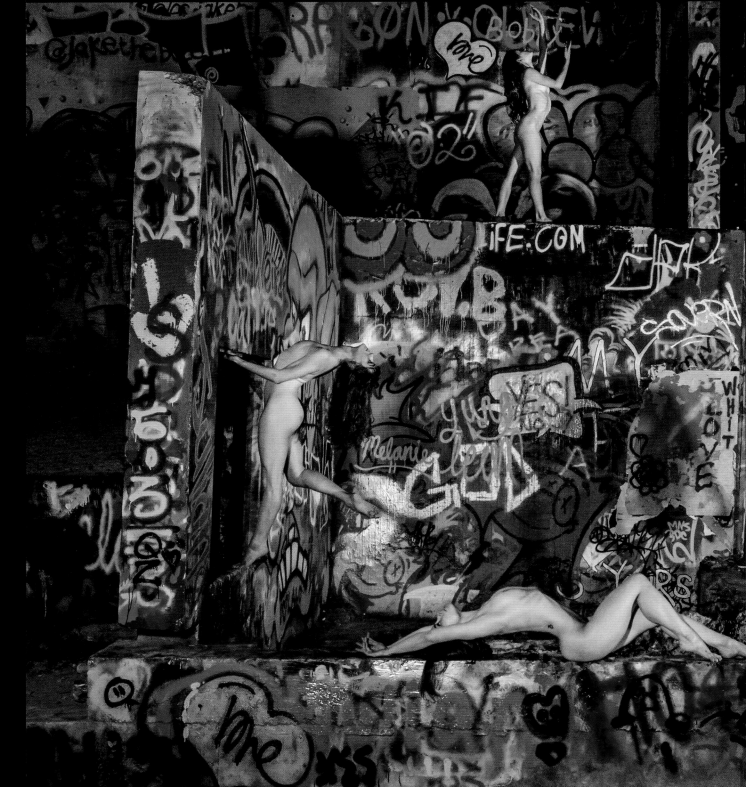

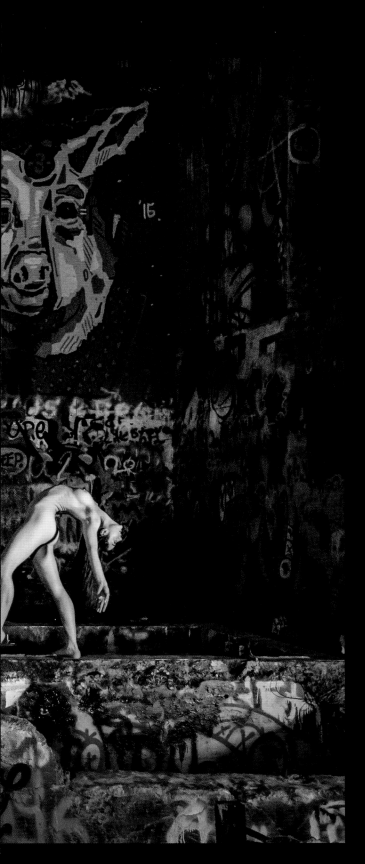

1:20 a.m.
Graffiti Park, Austin, TX

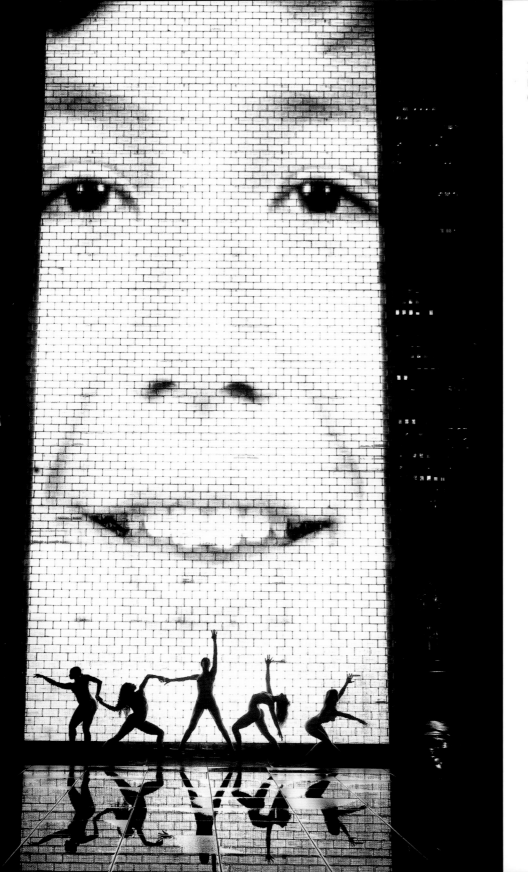

1:05 a.m.
Millennium Park,
Chicago, IL

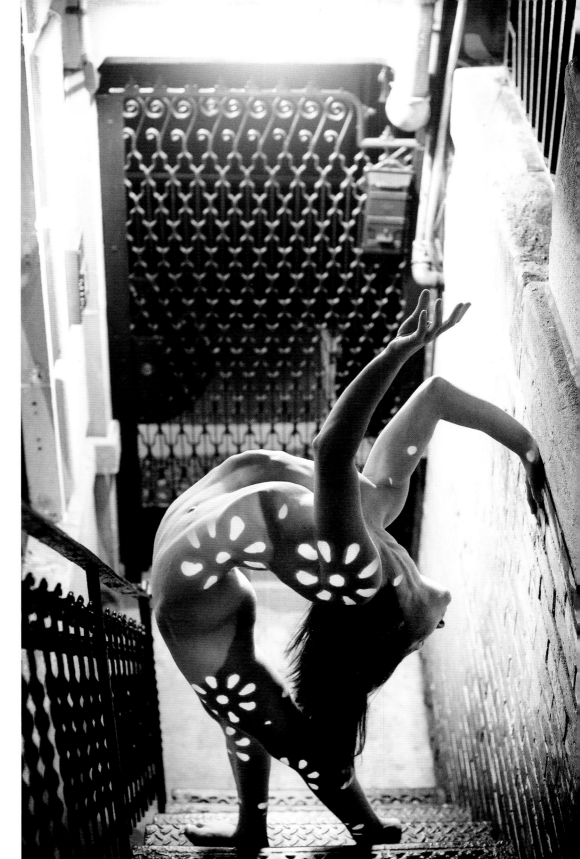

9:20 p.m.
Upper West Side,
New York, NY

*"Life isn't about waiting for the storm to pass.
It's about dancing in the rain."*

VIVIAN GREENE

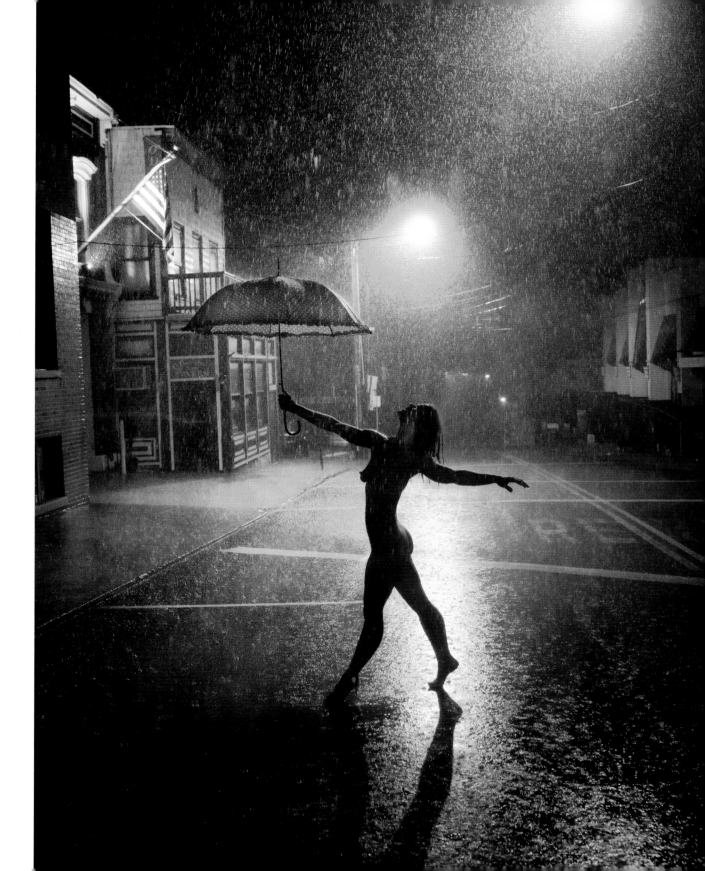

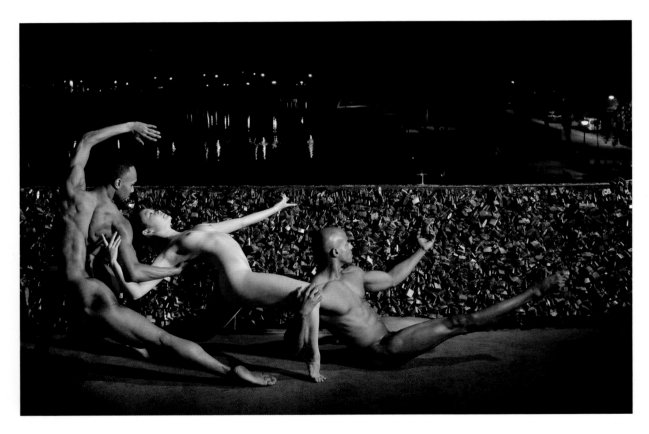

2:37 a.m.
Pont des Arts, Paris, France

1:29 a.m. >
Columbus Circle, New York, NY

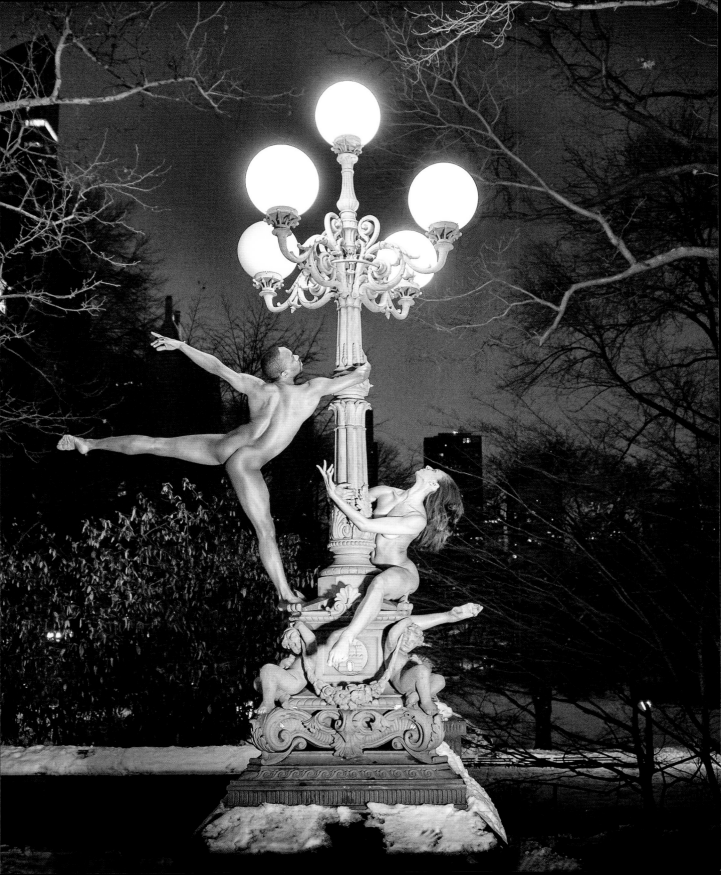

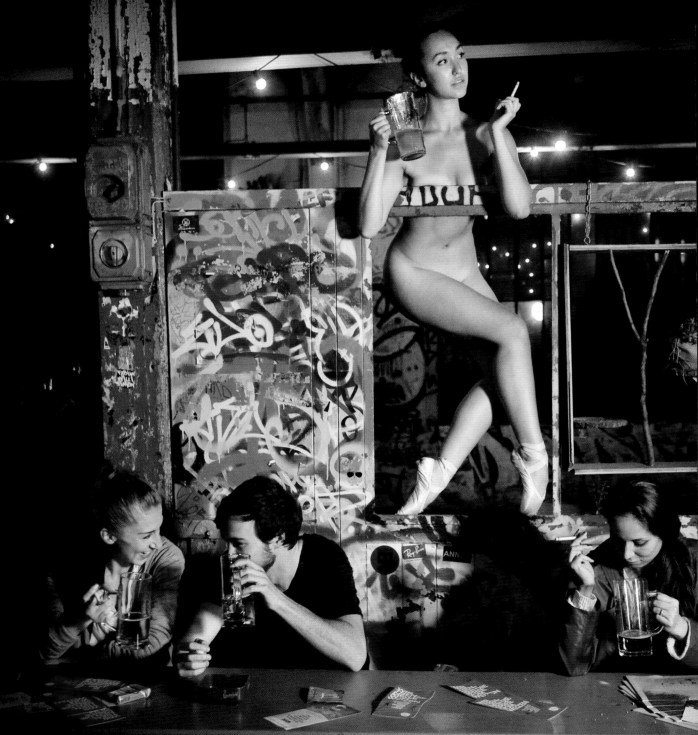

"If you obey all the rules you miss all the fun."

KATHARINE HEPBURN

12:17 a.m.
Beer Garden, Berlin, Germany

"If everything seems under control, you're not going fast enough."

MARIO ANDRETTI

8:36 p.m.
B Train Platform, New York, NY

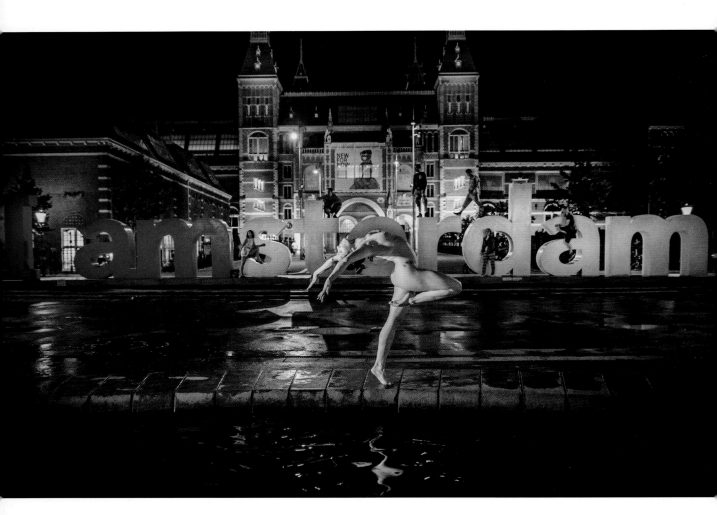

11:50 p.m.
Rijksmuseum, Amsterdam, Netherlands

3:04 a.m. >
Coffeeshop, Amsterdam, Netherlands

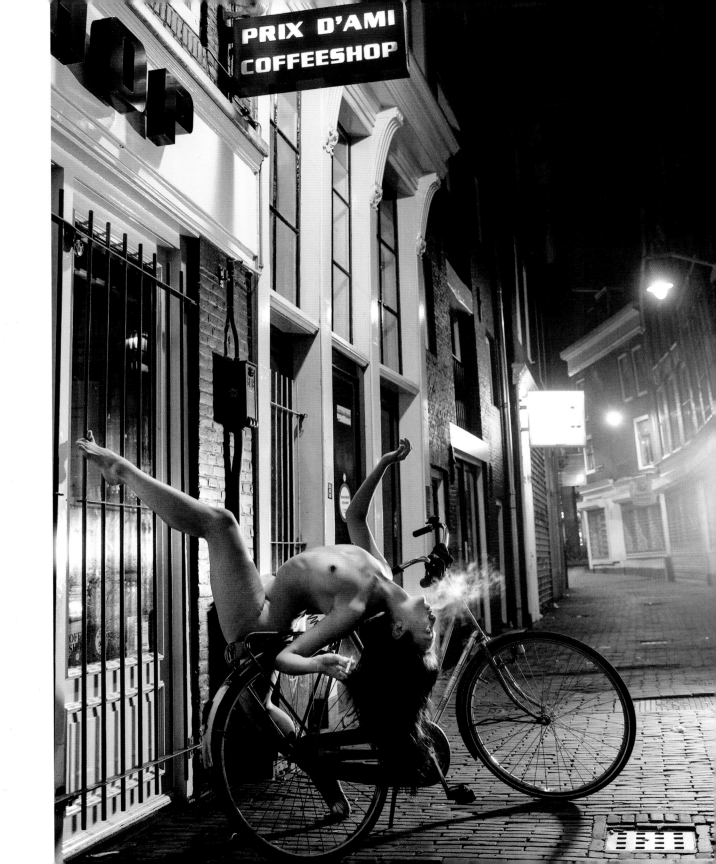

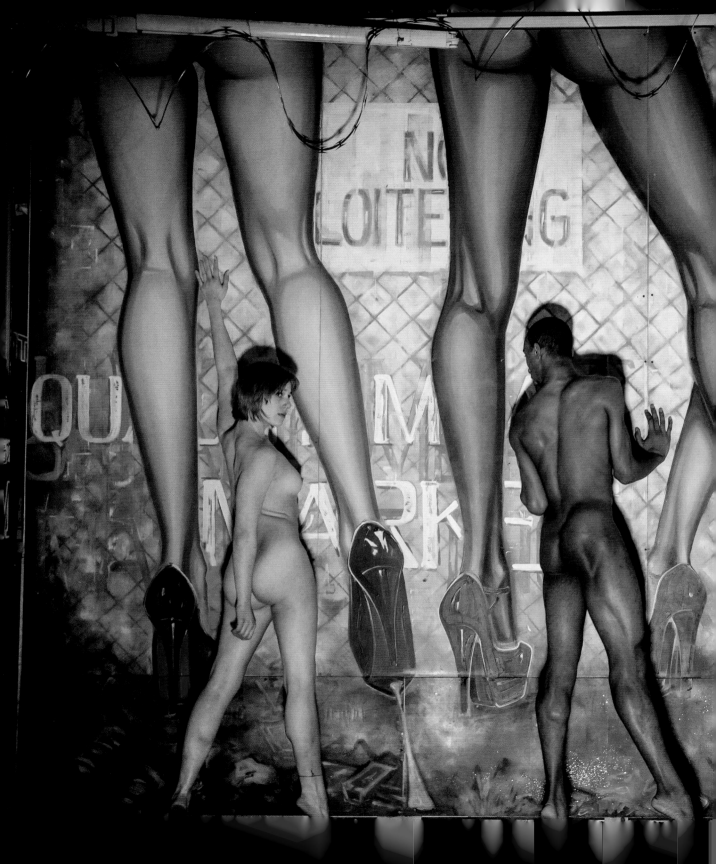

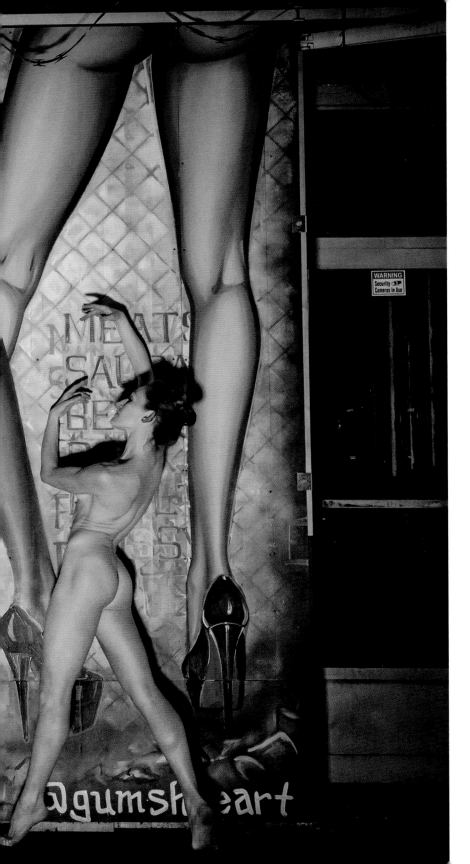

12:51 a.m.
Meatpacking District, New York, NY

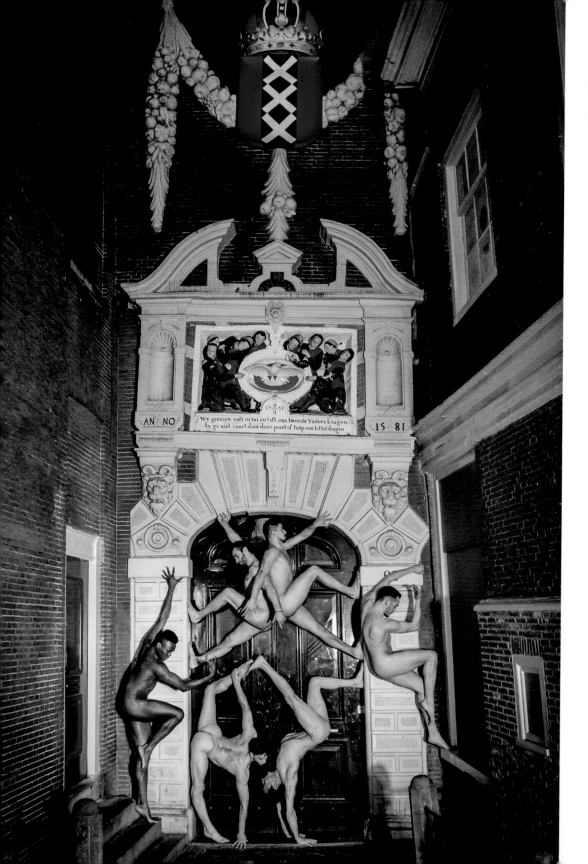

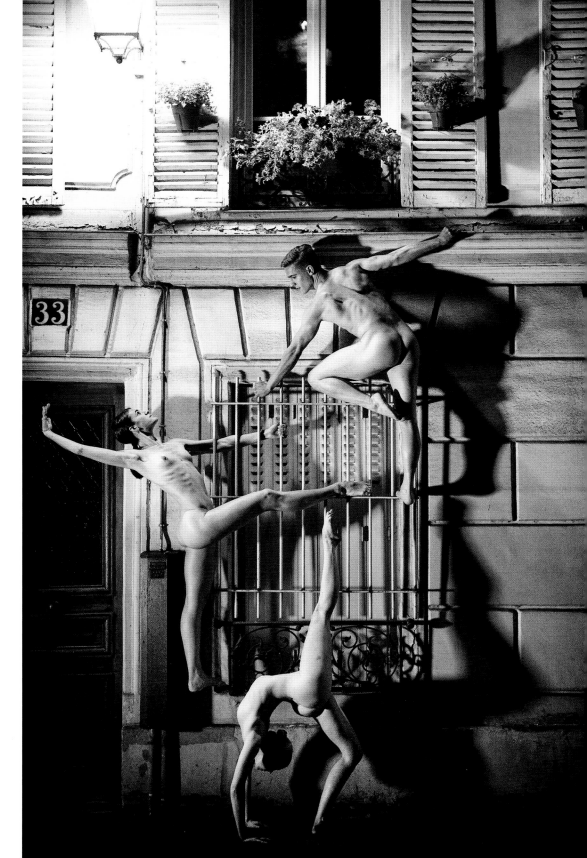

2:53 a.m.
Montmartre,
Paris, France

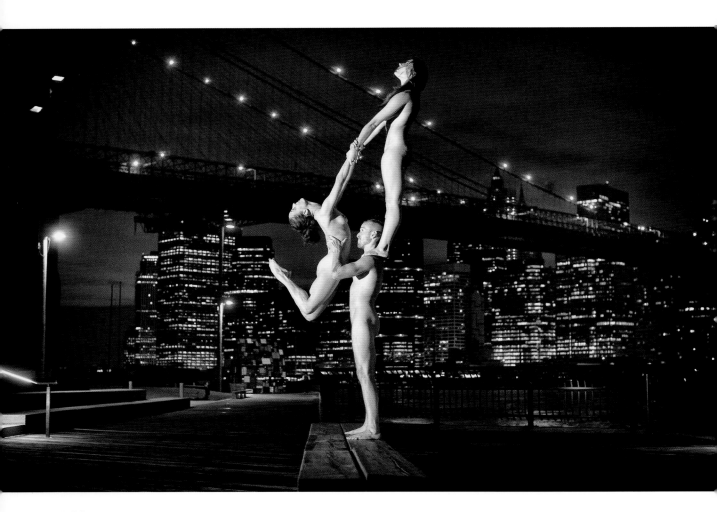

1:26 a.m.
Manhattan Bridge, New York, NY

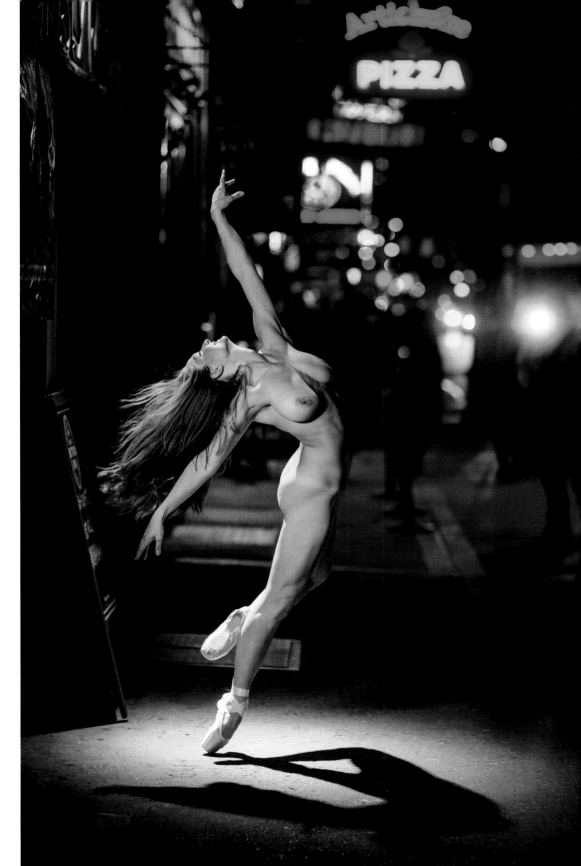

8:04 p.m.
Macdougal
Street,
New York, NY

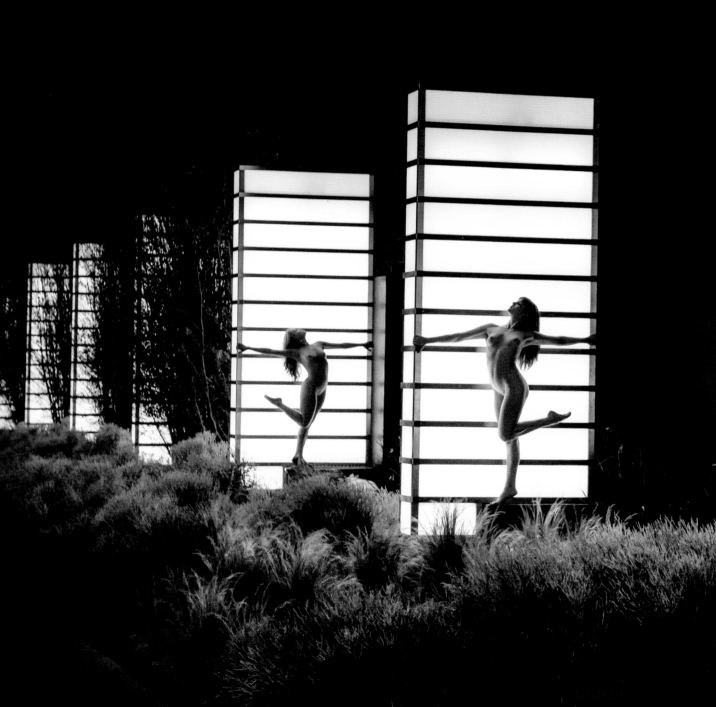

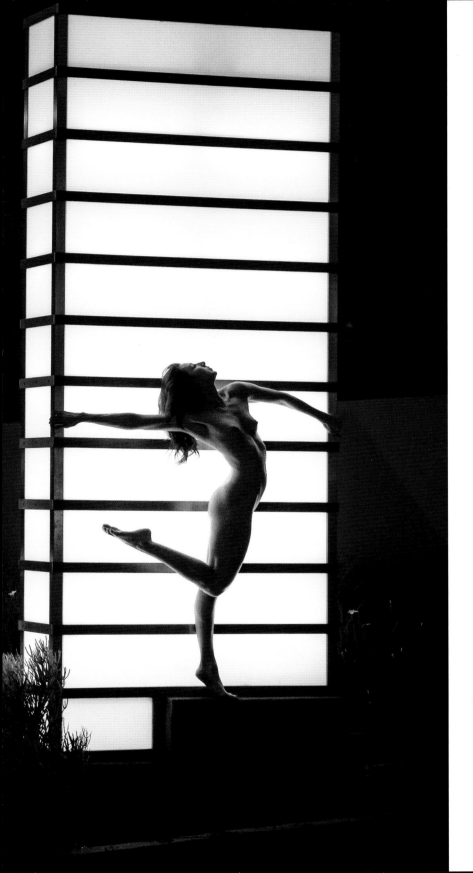

10:43 p.m.
La Brea Tar Pits, Los Angeles, CA

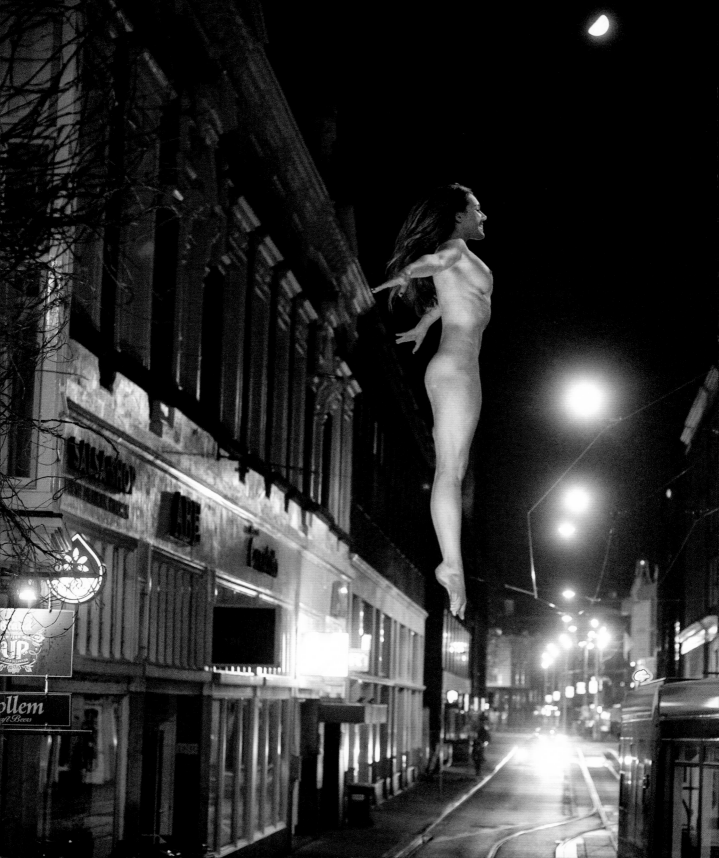

12:22 a.m.
Amsterdam, Netherlands

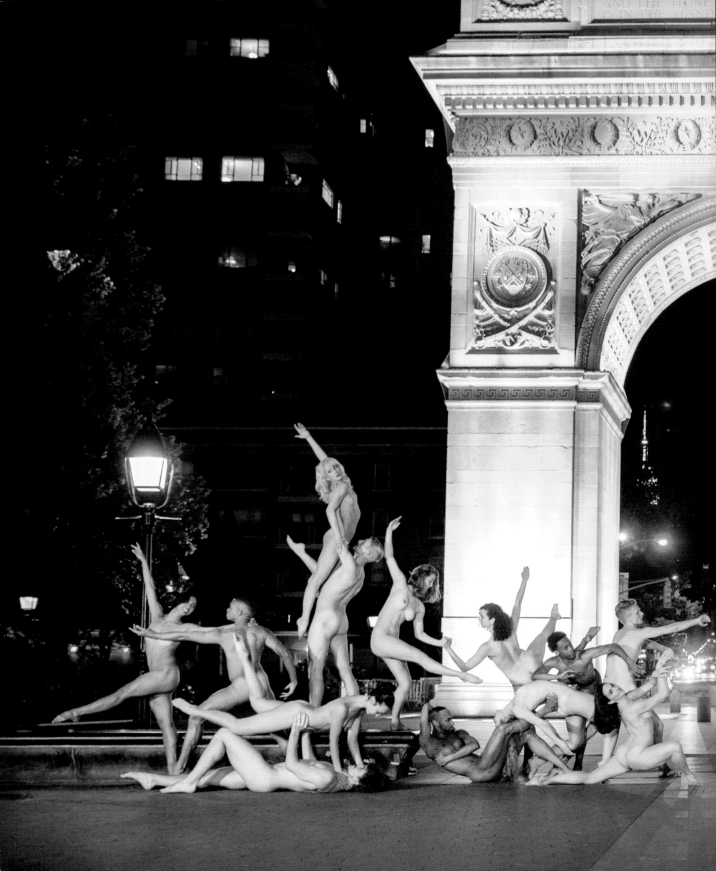

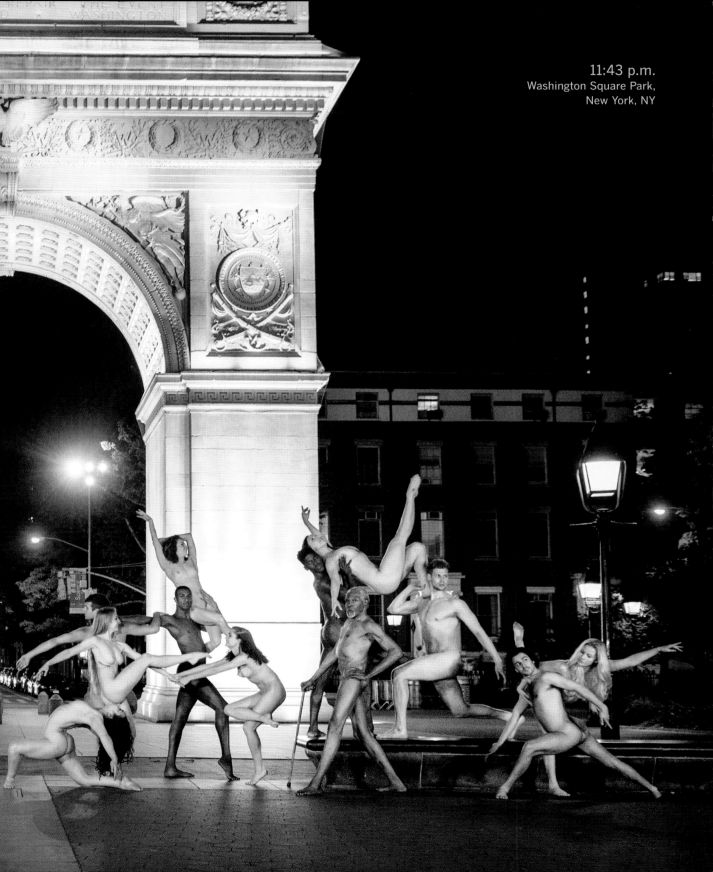

11:43 p.m.
Washington Square Park,
New York, NY

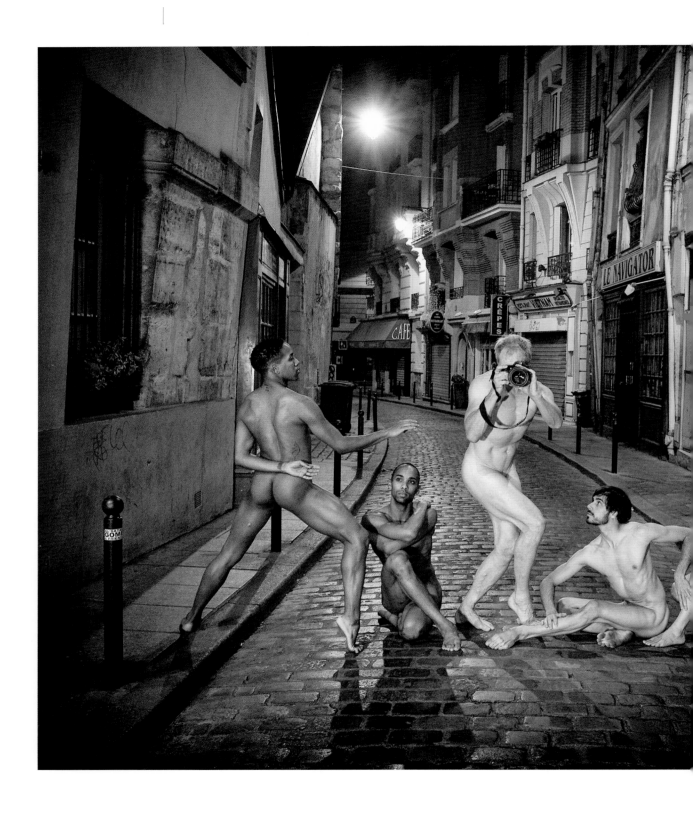

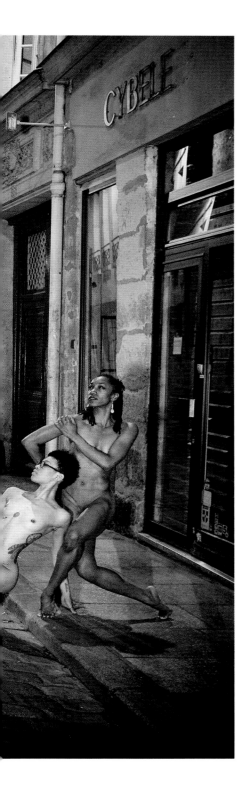

"Do something today that your future self will thank you for."

UNKNOWN

3:02 a.m.
Paris, France | Photo of Jordan Matter with dancers by Gin Pineau

behind-the-scenes stories

I worked on *Dancers After Dark* exhaustively for two years, meaning I was exhausted every week! I photographed hundreds of amazing performers in many cities and countries. It was the most rewarding creative experience of my life, and I was truly sorry to see it end. Every photograph in this book has an exciting story I will remember for years. This chapter features some of my favorites. If you enjoy these stories, you'll love the behind-the-scenes videos at dancersafterdark.com.

Cover Girl / Front cover, page 20

I met Michaela DePrince in 2013 when the Jacob's Pillow Dance Festival arranged for a shoot. She was already on a meteoric rise to the top of her profession, having starred in the award-winning dance documentary *First Position* and landed a coveted slot with Dance Theatre of Harlem.

We kept in touch over the years as I watched her career continue to blossom. She moved from Harlem to one of the most prestigious dance companies in the world, Dutch National Ballet. Her bestselling memoir, *Taking Flight,* which documents her incredible life story, was optioned for a movie by MGM.

In 2015 I got an email from Michaela that simply read, "I'll be in NYC in August. Let's shoot *Dancers After Dark.*" My first thought was, *Really?* Followed quickly by, *She needs to be my cover girl. I'll have one evening to take a cover-worthy photograph.* We met at 9:00 p.m. at Columbus Circle and started walking east. Staying true to my process, I was relying on serendipity to guide me. As we passed Seventh Avenue, the red streetlights and illumination from Times Square caught my eye. I thought it might be interesting to photograph Michaela right in the middle of a busy avenue. As I started working on lighting and composition, Michaela experimented with several poses.

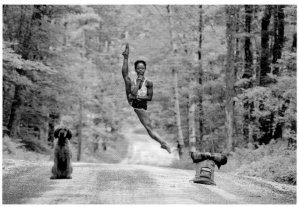
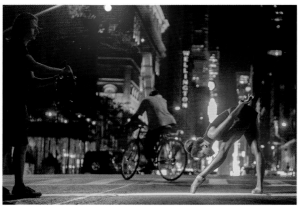

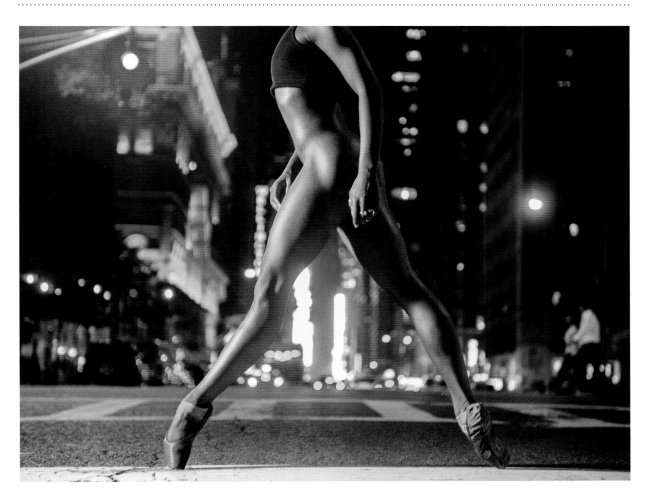

I decided to keep it simple—she would be crossing the street in pointe shoes. As I set the light, I asked Michaela to keep her shirt on. Somehow I assumed we would draw less attention if her breasts were covered. I was mistaken.

A major avenue just north of Times Square had a significant police presence and a constant stream of vehicles and pedestrians, so we shot quickly. Michaela ran into the street five times. I was looking for a magic moment. Pedestrians were essential, but they had to be just right. We came close several times.

Then, on the sixth dash into the crosswalk, serendipity arrived in the form of a man in the distance, glancing at Michaela while mirroring her stride. Her gaze was strong and determined, and her position was perfect.

"One Leg or Two?" / Page 147

I arrived in Stockholm on a red-eye flight from New York and took a moment to personally test their anti-nudity laws. I was feeling jet-lagged as I entered my hotel lobby, but my energy picked up once I saw eight incredible circus and dance performers waiting for me. As we explored Old Town that cold winter evening, my assistant, Anna Cameron, spotted some high scaffolding.

I asked trapeze specialist Enni-Maria Lymi if she would be comfortable hanging upside down like a bat. She thought for a moment and smiled. "One leg or two?" As a crowd began to gather, we practiced to make sure she felt safe. Her friends were ready to catch her, just in case.

Once it was time for the shot, we kept the light off to let her get into position without causing a scene (which turned out to be a futile effort).

Enni-Maria held her pose for forty seconds on the cold railing while the "catchers" stayed low to keep out of the shot.

I climbed the scaffolding for a higher perspective. It was done in one take!

PHOTO BY ANNA CAMERON

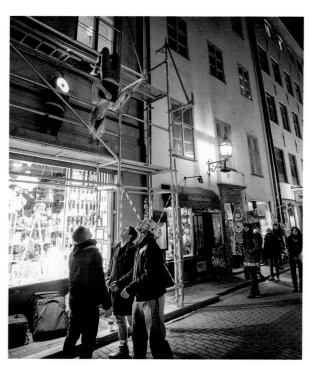

PHOTO BY ANDREW LLEWELLYN

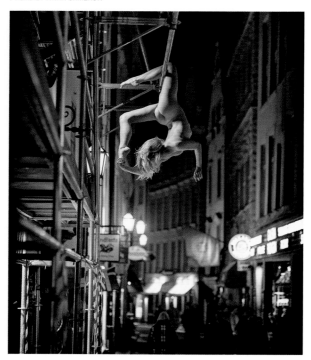

Three High / Page 54

A couple of years before I began working on this book, I photographed a three-high circus trick for a project titled *Circus Among Us*.

As I was on my way to Sweden to photograph circus performers for *Dancers After Dark*, I imagined getting a naked three-high shot. This very dangerous trick requires a lot of trust and experience, and yet the three performers available had never done it together. They practiced using scaffolding for support.

They were unsure if they could do it without the railing, but I really wanted to shoot in the middle of the street where the light and composition were perfect. When it came time to try, I started freaking out a little. Was I putting art before the safety of these performers?

It was cold and late, and the potential for error and injury was real. Yet the performers were jazzed up, so we started rehearsing. We added two dancers to the base for stability.

Having never done this trick as a team, they held the pose for an unbelievable forty-five seconds—on cold pavement while facing oncoming traffic!

Needless to say, I was ecstatic. "I can retire now!" I announced to everyone.

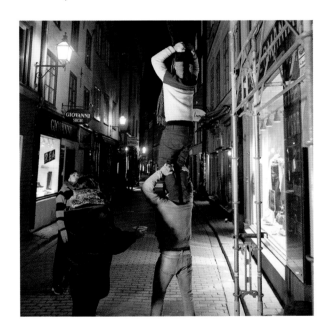

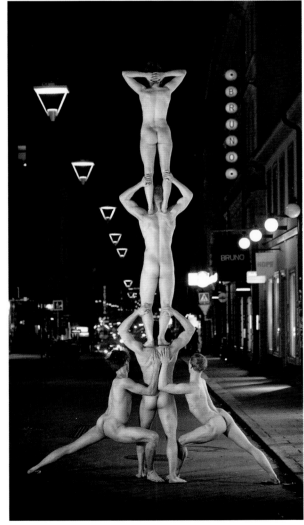

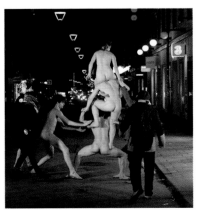

The Kindness of Strangers / Page 97

"Look at that, my phone is ringing. I'm going to turn my back and take this call."

SECURITY OFFICER, NEW YORK PUBLIC LIBRARY

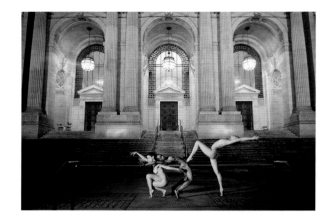

No Photoshop / Page 53

Here is one of the photos that may lead people to assume that images in this book have been digitally altered. After all, what other possible explanation could there be for this pose?

The answer is actually quite simple—selective cropping.

I set the manual focus and waited for him to come flying into the frame. He used scaffolding as a trapeze. We got only two tries before the landing hurt his heel too much to continue. Here's his final practice run.

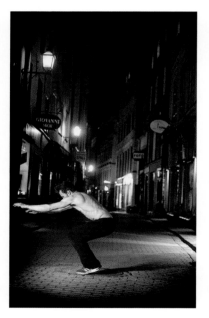
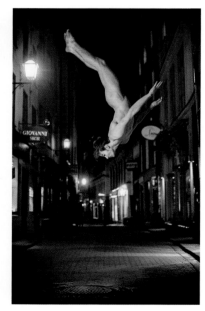

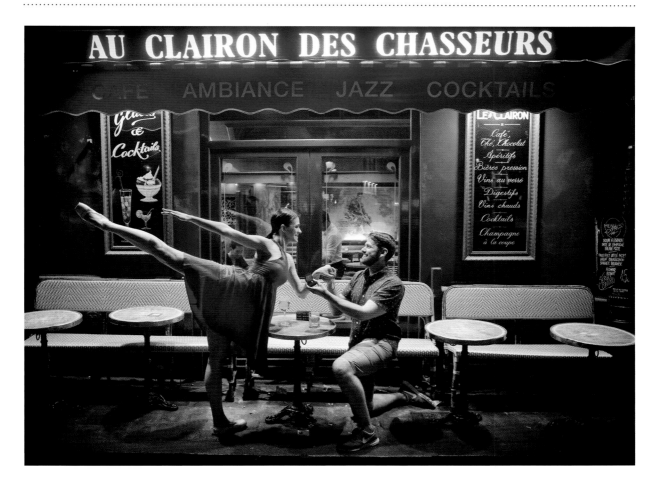

I Do! / Page 187

During an evening of shooting several amazing dancers in
Paris, we all stopped at midnight for a beer in Montmartre.
One of the dancers was Ashley Gale Munzek. Days before,
her boyfriend, Jerome Doerger, had asked me to help him
propose. So as we were all drinking, I asked Ashley to put
on a pretty dress and said I wanted to do a fun photo with
Jerome. "It's such a romantic spot, let's pretend you're getting
engaged," I said. Ashley hit her arabesque and then, on cue,
Jerome surprised her with a stunning ring!

Twenty minutes later, Ashley posed for *Dancers After Dark*
while her fiancé held the light!

Smile / Pages 216–217

I met seven circus and dance performers from the cast of the play *Pippin* at 11:00 p.m. in Amsterdam. They came ready with an idea—throw Charlotte O'Sullivan absurdly high in the air. As we walked through town, I struggled to find a street with enough light and visual interest. Then I saw the "Up" sign and the moon. Serendipity!

They assumed everyone would be in the shot, but it seemed weird to have a bunch of men looking straight up at her from the ground. Instead, I asked them to throw her so high that I could crop them all out. We tried the shot *twenty-two* times while the moon moved into the perfect position, directly in line with the lights.

Then someone shouted that the tram was coming, and I rushed to do it one more time. As Charlotte was climbing into their arms, I yelled for her to smile.

I didn't stop smiling for twenty minutes!

PHOTO BY STEPHEN BROWER

The Shortest Shoot / Page 14

JORDAN: "You can balance on a wine bottle, *en pointe*, without breaking it?"

KITTY CONLON: "Usually."

The entire shoot lasted three seconds.

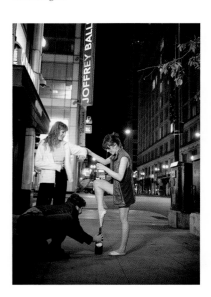 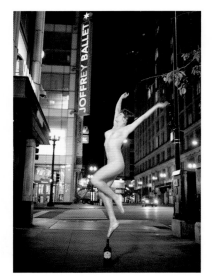 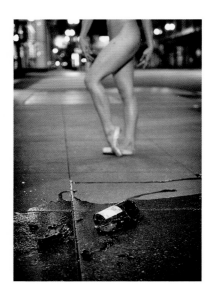

The Longest Shoot / Page vi

These dancers and I all met each other for the first time at 9:00 p.m. at the School of Visual Arts in Manhattan. I chose these dancers based on photos they had emailed me. I wanted one group image that could encompass a variety of ethnicities found in the dance world, but other than that I had no plan. By 9:15 p.m. they were rehearsing intimately, as if they'd been friends for years.

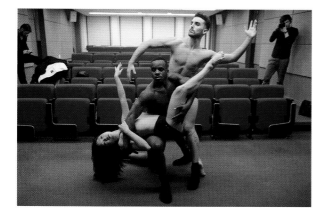

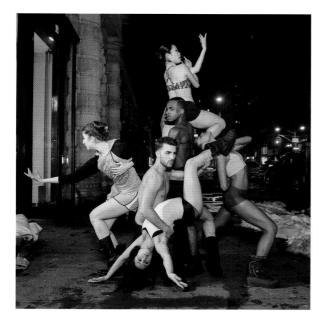

By midnight we had the beginnings of a pose and decided to find a location. We descended into the cold winter night, and I began looking for something special. I stumbled around, trying unsuccessfully to use a Manhattan landmark.

They kept each other warm and waited patiently. I kept looking for *two hours*.

At 2:00 a.m. I crossed Sixth Avenue on my way to another spot, when I realized the location was right in front of me. We immediately started practicing. Their bodies were cold and tight, and they would frequently run into the subway station to warm up.

A group shot in the street is extremely difficult because everyone has to hit their mark within fifteen seconds. We didn't know how many chances we'd get before the police caught us, so we rehearsed on the sidewalk, trying to make it perfect.

By 2:30 a.m. the cold was really setting in, and it was now or never. They rushed into the street and hit their marks.

The first shot looked good but there were many adjustments to be made. We kept reviewing it over and over again, wanting to get it just right.

The dancers were numb and shaking, but they went enthusiastically into the street seven more times. I shot more than four hundred photos before we were all satisfied. The last frame was taken at 3:10 a.m.

We had been working on this one image for over six hours! We were drained and frozen solid, but we all left smiling.

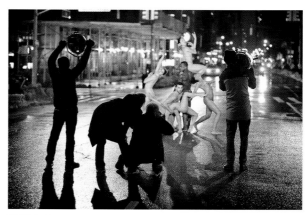

PHOTO BY CHARLIE NAEBECK

"Jesus Loves You"

Two years ago I took this *Dancers Among Us* photo in front of City Hall in Philadelphia.

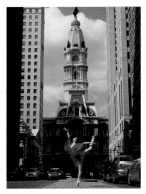

I loved the location and wanted to repeat it for *Dancers After Dark*, so I went back to the median with a single dancer. It was the most public shot I had taken at that time, and the adrenaline bug bit me.

When I returned to Philly the following year, the project had evolved and I wanted to try the location again, this time with two men.

What followed was possibly the most bizarre moment of my career. A man came running toward us, waving one arm and carrying a dog.

He started dancing and laughing. "I'm gonna do it too! It's beautiful! I'm gonna get naked!!" I suggested that it wasn't a great idea, but once he ripped off his clothes, I had to get the shot.

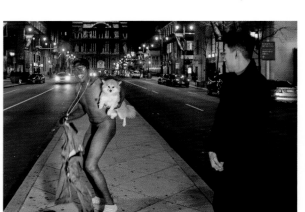

The following day I returned for a third time and brought a ballerina, Sarah Biren. I wanted her arms to match the arch of City Hall. Broad Street is a major thoroughfare, and police cars were passing by frequently. When the coast looked clear, we shot in quick spurts for seven minutes.

As I was basking in the excitement of finally getting the shot I'd been looking for, a woman pulled up and stopped traffic so she could deliver this message: "Sweetheart, you are beautiful but keep yourself covered. Jesus loves you. Your body is a temple."

"Thank you, but I'm Jewish," Sarah replied with a smile.

"Oh . . . shalom!" she said, and drove off.

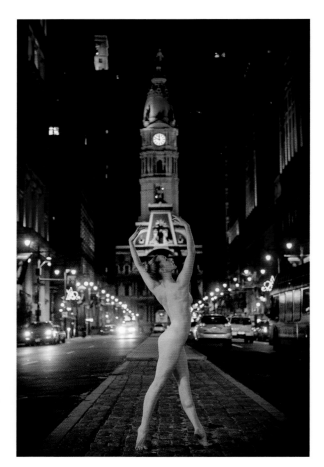

A Leg Up / Page 177

In *Dancers Among Us,* I told the inspiring story of Evan Ruggiero, a courageous young tap dancer whose battle with bone cancer left him with one leg but didn't stop him from achieving his dream of professional dance.

Three years later, we met again. I was surprised, excited, and a little apprehensive when he contacted me about *Dancers After Dark*. I wasn't sure how I'd photograph his uncovered prosthetic in a way that portrayed him as an inspiration rather than a victim.

Evan immediately assuaged my concerns. It was dusk on a warm spring night. He arrived with shorts and a smile. He strolled unselfconsciously along the crowded Hudson River Park Walkway. Nothing was going to make him feel like a victim; that was eminently clear. The sunset promised to be a beautiful one, so I suggested a silhouette. Could he stand on a narrow platform overlooking the river and extend his prosthetic? I was concerned about his safety, but he wasn't. He walked right out to the edge and started practicing positions.

When it was time to shoot, Evan dropped his shorts, let out a joyous laugh, and kicked his prosthetic leg high in the air. "I hope it doesn't fly into the river," he joked. A police officer stopped by, ready for an altercation. He took one look at Evan's smiling face and, speaking for all of us, gave him a thumbs-up.

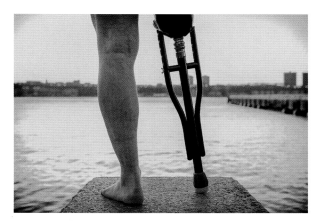

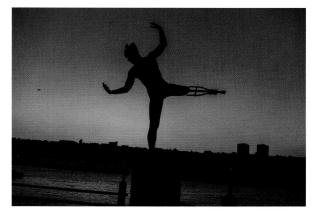

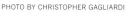
PHOTO BY CHRISTOPHER GAGLIARDI

No Trespassing / Page 138–139

Ten minutes into setting up this photo, the head of security at Millennium Park in Chicago boomed at us from across the plaza.

"You need to leave *right now!* This park is *closed!*"

He approached us rapidly, waving his hands. He got right in my face, stared me down, smiled and whispered, "You need a little more time?"

"Yes," I whispered back. "Maybe three more minutes." "You got it," he said.

Then, as he walked away, he screamed one more time, "Like I said, *no trespassing!* I'm coming back in three minutes and you better be gone!"

Nice to Meet You

Kristina Bentz and I arranged the time and date of our photo shoot through email. We met on a corner in Manhattan, and I briefly explained the process.

"Before you get naked, let's practice the shot clothed." She stared at me, confused. "Naked?"

My Turn / Pages 220–221

At 3:00 a.m. on my final night in Paris, Alvin Ailey dancer Sean Aaron Carmon asked me, "Jordan, have *you* posed yet?" Twenty minutes later I was naked. Filmmaker Gin Pineau took the photo while a large group of Parisians enthusiastically encouraged us from a café.

Gin captured my excitement on video, and I finally understood the incredible adrenaline rush the dancers had described over the years.

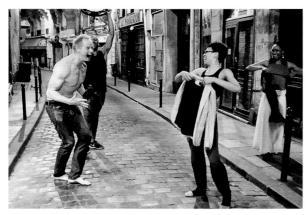

VIDEO STILL BY GIN PINEAU

A Day at the Office / Pages 50–51, 119, 136, 169

It was a cold winter evening, so I decided to meet four dancers in the heavily populated but very warm Penn Station in midtown Manhattan. We all arrived at 10:00 p.m. I was in no rush to freeze, so I suggested we rehearse for a while in the station. As we began to discuss poses, I spotted the iconic departures board hovering above our heads and was simultaneously gripped by both fear and excitement.

"Anyone want to pose in here?" I asked the group. Jourdan Epstein immediately volunteered. We had never met before, and I was struck by her confidence and enthusiasm.

Security guards were stationed right next to the sign, the main floor was littered with video surveillance cameras, and the place was packed with all types of people waiting for their track to be announced. I tried to find an angle where Jourdan could be slightly less exposed.

Unfortunately, it was obvious she had to be right under the sign—the most public spot in the entire building. We practiced the pose and waited for the right moment. The departure of a popular train was announced, clearing the floor a bit.

The security guards walked away, and the time was suddenly upon us. Jourdan ran into place, dropped her jacket, and hit the pose. I shot sixty-five photos in sixteen seconds. I yelled, "Done!" before security could return.

I sat on the floor and reviewed the images. A police officer approached me.

"Excuse me, sir," he said, frowning.

Here it comes, I thought. "Yes, officer?"

"You're not allowed to sit on the floor," he told me as he walked away.

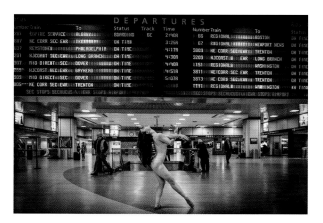

BEHIND-THE-SCENES PHOTOS BY CHARLIE NAEBECK

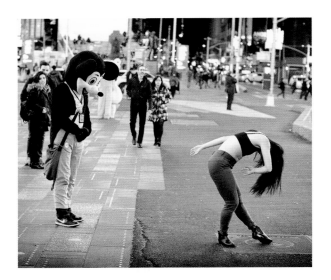

Fortunately he didn't see the image illuminating my laptop. The success of our first adventure energized the group.

I was feeling indestructible, so we left the station and walked straight to the busiest place on earth: Times Square. An equally fearless dancer, Amelia Low, started rehearsing for another ill-advised, crazy, thrilling shot. But first we had to contend with some unwanted attention.

We waited. And rehearsed. And waited. Finally, at 1:45 a.m., the coast was momentarily clear. Amelia hit her mark and I shot for twenty seconds. That's all it took. The dancers were on fire!

It was time for Maleek Washington and Jennifer Florentino to get in on the action. It was too late to travel far, so we started looking at the Broadway theaters near Times Square. I found a cheeky sign that could add some humor to the shot, and I suggested we try a playfully sexy pose with all four of them. The beauty and mixed ethnicities

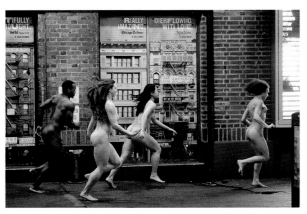

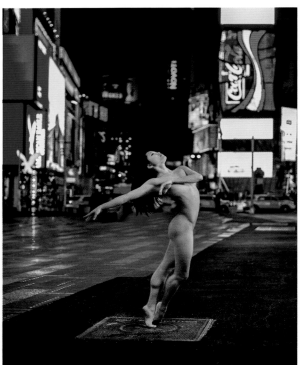

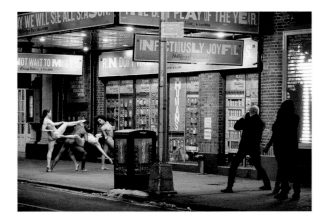

of the performers inspired me, but everyone was freezing and exhausted, so I worried we wouldn't have the time to construct a killer pose. It turns out my concern was unnecessary—artists this good don't need much time. We arrived at the theater at 2:30 a.m., and by 2:50 a.m. they were running into position.

We shot on and off for ten minutes, adjusting limbs to cover genitals. I think Maleek owes me a beer for documenting this moment in his life.

It had been an incredibly productive and magical night. We took the obligatory selfie and said good-bye. The evening was complete.

Except, it wasn't.

I walked toward my car with Carrie Walsh. She had come to the shoot just for fun and to help with composition and lighting, but had never considered participating herself. We were both giddy, having just experienced an incredible five-hour adventure. It was 3:30 a.m. When we passed a dramatic red light shining on Forty-Second Street, I turned to her and smiled.

"Do you want to do it?"

She hesitated.

"That's okay," I said. "Another time. Maybe when it's warmer."

We kept walking, now in silence. She was thinking.

"Fuck it. Yes. Let's do it."

I've had many evenings shooting *Dancers After Dark* when, despite our best efforts, we did not produce a single photo for this book. And then there's an occasional night like this, when everything and everyone clicks, and the enthusiasm is palpable. To make it even more miraculous, Charlie Naebeck, a phenomenal photographer, was there to document the entire experience. It was a truly extraordinary day at the office.

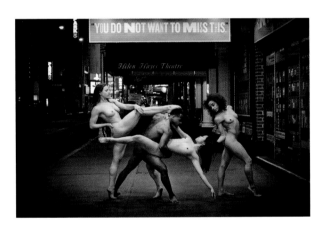

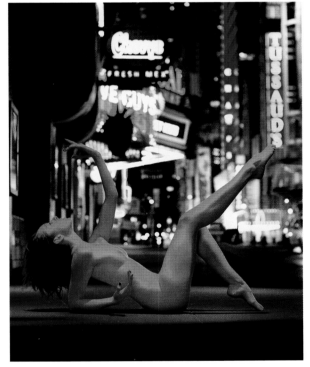

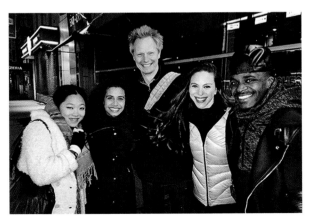

Club Cumming / Page x

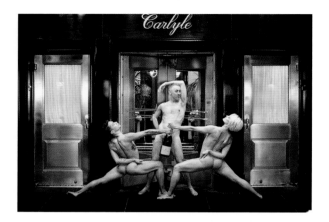

I've photographed celebrities, but I've never asked one to disrobe. That changed when I met *The Good Wife* star Alan Cumming in his dressing room one winter evening after his star turn in the Broadway revival of *Cabaret*. Alan was holding court for a large group of guests, a regular event labeled "Club Cumming" by the *New York Times* that was quickly becoming Broadway legend. Alan had been kind enough to give me a blurb for *Dancers Among Us*, so he was familiar with my work. Emboldened by the fully stocked bar and encouraged by my wife, I swung for the fences.

"I'm doing another book, and this time I'd like you to be in it," I said, when we had a moment alone.

"Sure," he replied enthusiastically, without hesitating. Alan has the kind of infectious energy that can make a single syllable bounce off the walls. It's impossible to be tired around him (which came in quite handy months later).

"Well, you should probably see it first," I said, and handed him a photo of a nude dancer in Times Square.

I waited for him to say, "No way." What possible benefit could he see in this? He looked at it for about an eighth of a second.

"Beautiful. Let's do it! Everybody," he shouted, "let's dance." And that was that.

After months of waiting, hoping, checking in, and waiting some more to schedule a shoot, I finally got the call the following spring. His assistant, Jimmy, said that Alan would shoot with me after his solo show at the Carlyle Hotel, just two nights after hosting the Tony Awards. I was to meet

him at 11:00 p.m. at his apartment downtown. Jimmy asked me to find a private location and said that I'd have about thirty minutes. Understandably, Alan would be exhausted.

I don't usually scout locations, but I did for Alan. I arrived hours early, scouring every inch of his neighborhood. By 11:00 p.m. I had several quiet spots chosen. The lighting was pre-set, and my assistant stood in for Alan, rehearsing poses. I was determined to make this quick and efficient.

Bzzzzzzz. A text message popped up on my phone. "Is this you, Jordan? I am still at the Carlyle. Sorry. Loads of guests tonight. Do you want to come here?"

The optimist in me thought, *At least he's not canceling.* The pragmatist thought, *Now what?*

I grabbed a cab and sped uptown. I scouted the neighborhood quickly and saw a couple of good locations in Central Park.

Alan sent another text, "How goes it?" which I interpreted to mean, "Get your ass over here before I fall asleep." I rushed to the hotel, noticing the attractive facade as I entered the building.

I arrived in his suite at midnight. A gin and tonic was waiting for me, as were several members of his extremely attractive band. This was definitely the cool kids' party.

Everyone was having a blast, laughing and joking around. Alan leaned back in his chair. "So, Jordan, what do you have in mind?"

The laughing stopped. They all looked my way, excited to hear my divine inspiration.

"Uhhh, well, there's this sculpture in Central Park, and you could drape over it, maybe? Or there's a beautiful fountain outside the Met. You could stand in the water and pose?"

Not exactly divine inspiration. I didn't like the ideas, and neither did they.

The conversation drifted, but I wasn't worried. Of the many lessons I've learned from performers, agility is at the top of the list. The great ones have an uncanny ability to mold their performances to the energy around them, to sense an audience's expectations and make adjustments. My process is similar, developed over many years of trial and error. I rely heavily on spontaneity. I trust myself to bend with the wind, and in moments like this, I expect serendipity to come to my rescue.

And it did.

"My friend suggested we shoot in front of the hotel," Alan said, jolting me away from my thoughts.

"Yes!" Suddenly, I was jazzed up. "The facade is gorgeous, and the Carlyle sign is directly above. You could stand in the revolving door."

"Love it," he said. I guess he wasn't so concerned with privacy, after all.

Relief overtook me, but just for a moment. "What would you do?" I asked.

He showed me his famous pose from *Cabaret*, which is full frontal.

"I love the pose," I said, "but how do we cover your junk?"

Alan grabbed an unopened magnum of Veuve Clicquot and held it in front of his groin. "This should about cover it," he said with a sly smile.

Everyone laughed. We were close. The room was filling with excitement.

It needed another element, but it was just out of my grasp. "If you're holding the bottle, then you can't do the pose." I was thinking aloud.

A band member stood up, walked over to Alan, and held the bottle for him. Again, everyone laughed.

Then it hit me. Divine inspiration. "Yes! We need two dancers holding the bottle, a man and a woman, one on each side. That's so decadent, so *Cabaret*!"

It was 1:00 a.m. on a Tuesday night. We all got on our cell phones and started texting dancers this surreal message: "Get out of bed and come get naked with Alan Cumming at the Carlyle Hotel."

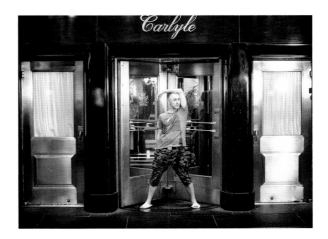

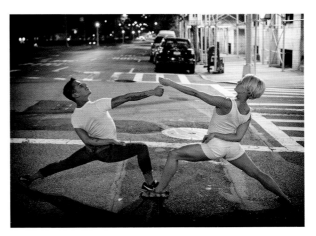

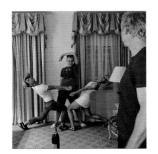

At 2:00 a.m. two beautiful, groggy dancers arrived at the suite. I tried to construct the pose, but the enthusiasm in the room was just too high.

Alan was ready, so we all rushed downstairs to the location and started to rehearse.

A large, intimidating security guard came out and pointed to a video camera recording our every move. He wouldn't leave. Alan whispered to me, "You have to go. He thinks you're paparazzi."

I took the dancers around the corner and had two minutes to practice their pose.

I got a text from Alan. "Where are U? Come back right now."

We rushed back to see Alan disrobing. "Wait!" I laughed. "Give me a minute." I tried to compose the shot and set the lighting, but there was no time. Alan and the dancers ripped off their clothing and ran to the revolving door. They got into position and hit their pose as I frantically shouted directions, improvising along the way.

"Arch back more. Extend your arms. Twist the bottle. Alan, smirk at the camera. Hold it. . . . Hold it. . . . *Hoooold!* Two more. . . . Done!"

The shot took eleven seconds. Months later, Alan made our photograph the cover of his album. I'm willing to bet it was the shortest cover shoot in the history of the music industry!

The Turning Point / Pages 170–171

For the first year of shooting *Dancers After Dark,* I stayed in the shadows, looking for private locations away from the public eye. Then, on a spring evening in 2015, everything changed. I had three ballerinas in my car as I drove past Lincoln Center on my way to another hidden location. The illuminated steps and iconic facade caught my attention, and I double-parked right in front. I knew it could be a beautiful photograph.

We all sat quietly as I contemplated this idea. The theater crowd was just exiting the Metropolitan Opera House, and security guards were patrolling the square.

"This is nuts," I said. "Maybe we'll come back later, or another night. This is too scary." The ballerinas were silent as I started to pull away. "But sometimes when you're scared . . ." I mused aloud.

"Yup," they replied.

I turned around. "Oh, you want to do this?" They all smiled. My heart started pounding. This was uncharted territory. I got out of the car and paced around, while the security guards and I watched each other. The dancers and I figured out a pose. I went back to the steps to see if we could really pull it off—but I got freaked out about the risk and decided to call it off. That's when I saw three naked ballerinas stuffed into the small backseat of my Prius. Obviously they were not feeling my apprehension.

I waited until the guards were distracted, pulled open the car door, and said, "GO!" They ran into position and hit their poses beautifully. Just one problem—the lights on the stairs had gone off.

The illuminated stairs were key to the shot. The dancers held their pose as a crowd gathered and we waited for the stairs to light up again. Security started walking quickly toward us. I was shouting, "Hold it, hold it. . . ." Finally the lights returned. I took a burst of twenty-six shots and yelled, "DONE!"

They jumped back into the car. I hit the accelerator, and as we sped away the security guard smiled and gave us a thumbs-up!

Postscript: The next evening, one of the ballerinas went alone to *The King and I* at Lincoln Center. She stopped by the fountain to buckle her shoe when the same security guard approached her. Unaware of the coincidence, he smiled and asked her out for drinks.

"Thanks," she said, "but you've already seen me naked." His mouth hung open as she walked away.

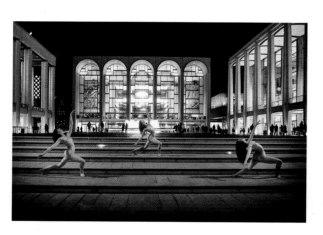
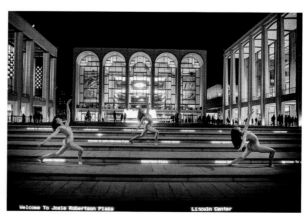

Spring in Montreal / Pages 100–101

In April of 2016 I flew to Montreal and experienced a Canadian spring: blustery wind, heavy snow, and freezing rain. Over two cold, wet, blissful nights, I photographed fearless circus performers testing their limits. Never was this more evident than sunset on Mont Royal. It was so cold and rainy that I had to shoot through my car window.

As we drove around looking for a location, I discovered this beautiful birch tree disappearing into the fog.

I asked aerialists Lindsay and Dominic to hang from the tree branch. This was much easier said than done. The wind kept spinning them in circles, and the cold made Dominic's hand so numb that he could only hold the strap for a few seconds before returning to the warmth of the car.

I was concerned that the light would disappear before I got the shot, but instead, something magical began to happen. As it got darker, the streetlamps created a colorful glow unlike anything I had ever seen before. I urged them to run out again and again, as each time the color became more intense.

Finally, when they could take it no more, I pleaded for one last attempt.

Smiling the entire time, they gave me a magical image under the most intense conditions. Moments later, the brilliant color was gone.

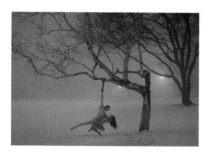
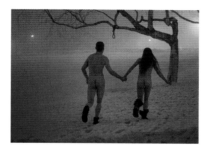
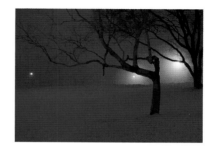

The First Photo

In July 2014 I was in my Manhattan studio when I received this message from Lauren Joy Herley, a circus performer I had photographed several times: "Tonight could work well for a shoot around 12:00 a.m., after my show. I don't know if it will be raining but that could be pretty, with wet hair, maybe nude, doing some organic positions."

I called my wife, who was several states away in Baltimore, and explained, "A contortionist in *Pippin* has suggested doing a nude shoot near my studio late tonight. I think it might be cool but I haven't really done nudes before, not sure what the point is, and I'm happy to skip it if you feel uncomfortable."

She didn't hesitate. "If you think it's worthwhile, definitely do it. You never know what it could lead to," she said.

Lauren arrived after midnight and we found a streetlight. The concept came to life through her extraordinary talent,

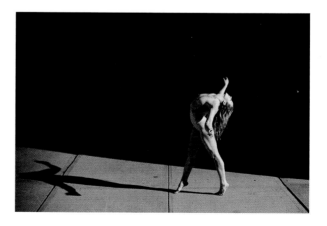

and *Dancers After Dark* was born. Without the incredible trust and encouragement of my amazing wife, it never would have happened.

The Final Photo / Pages 218–219

What began with a spontaneous shoot in an alley behind my studio evolved into a two-year obsession. By May of 2016 I had photographed more than 300 performers in over 400 locations around Europe and North America. Though I still loved every single shoot, it was finally time to be finished. Publishing deadlines were looming.

Two days before my final deadline, I got this email from friend and photographer Charlie Naebeck: *What if you invite some of the dancers who posed for the book to join you tomorrow night for one final shoot? That would be a really awesome way to celebrate the project.*

Charlie was right; I had to go out with a bang. I emailed some dancers and they called their friends. The next evening, twenty-five beautiful performers arrived in Washington Square Park at 10:00 p.m. The largest group I had ever photographed for anything was fourteen dancers, and they were clothed!

I had been looking forward to this all day, but now that the moment had arrived, I was very anxious. Usually challenges excite me, but this felt different. I had no idea

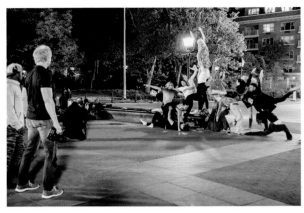

PHOTO BY STARK PHOTO PRODUCTIONS

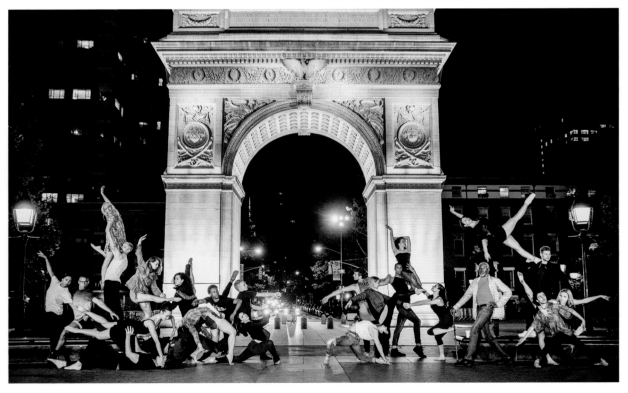

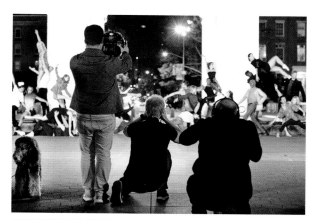

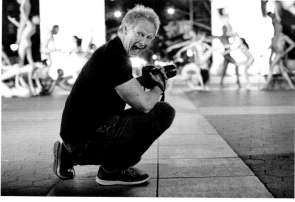

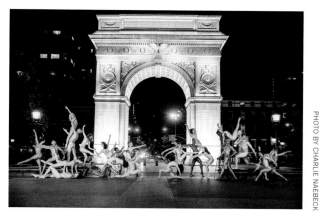

what to do. What's more, Susan Bolotin, the Big Kahuna from Workman Publishing, was there, along with a videographer, two photographers, a bunch of assistants, and every dog walker in downtown Manhattan. Failure would not go unnoticed.

I hemmed and hawed for a while, making small talk and passing out coffee. Then around 10:45 p.m., Charlie walked up to me and said with a huge smile, "Go big or go home, brother." That was the kick in the butt I needed. I yelled out to get everyone's attention. "All right, let's start with one dancer and build from there."

Everyone got into the act. People broke off into groups, and dancers were choreographing each other. The creative energy was frenetic and inspiring. By 11:45 p.m., it was time to shoot. The idea was so ambitious that excitement was palpable throughout the park. A big crowd of people had gathered behind me, and everyone went silent as I called out, "On three, drop your clothes and run into position. One . . . two . . . THREE!"

They stayed in position for forty-three seconds, but it felt like an hour. When I yelled, "BREAK!" the park erupted into spontaneous applause for what these brave and talented dancers had just accomplished. I reviewed the photos and announced that we got it! The shot, the evening, and the project were done!

Five minutes later the police arrived, closing down a park we had all assumed stayed open all night. My streak of zero arrests remained intact!

The party lasted until 4:00 a.m., but the memories will last a lifetime.

the dancers

I am utterly humbled by the trust I received from each dancer I photographed for this project—not just for their willingness to get naked in public, but for their readiness to do so without any guarantee of the final outcome. The images listed below are the result of a collaborative effort between photographer and subject, created through a process of spontaneity. At best, I can take half the credit for the photographs in this book, and even that is a stretch.

...

Dancers pictured, in order of appearance

COVER: Michaela DePrince
PAGE VI: Savannah Lee, Simone Bouffard, Antonio Cangiano, Maleek Washington, Amelia Low, Lande
PAGE VIII: Kai Tomioka
PAGE X: Ray Matsamura, Alan Cumming, Lisa Kuhnen
PAGE 3: Sean Aaron Carmon, Renee Lee
PAGE 4: Rachael Hanlon, Quinton Weathers
PAGE 5: Ashley Murphy, Corey Landolt
PAGES 6–7: Job Bautista
PAGES 8–9: Anne Sandefur
PAGES 10–11: Gabriel Hyman
PAGES 12–13: David McManamon
PAGE 14: Kitty Conlon
PAGE 16: Nikeva Stapleton, Adam Perry
PAGE 17: Taylor Massa
PAGES 18–19: Gustavo Nunez
PAGE 20: Michaela DePrince
PAGE 22: Toni White
PAGE 23: Sascha Bachmann

PAGE 24: Jason Macdonald
PAGE 25: Chalvar Monteiro
PAGES 26–27: Kristian Brooks, Paige Jacobus, Sarah Milosch, Angela Loiacono, Cassandra Porter, Cyrus Bridwell, Mari Sharpe
PAGE 28: Iga Kowalczyk, Franziska Willenbaches, Claire Cote, Reina Trifunovic, Gustavo Nunez, Ariel Cohen
PAGES 30–31: Andy Jacobs
PAGE 32: Charlotte O'Sullivan
PAGE 34: Addison Ector
PAGE 35: Marieka Jackson
PAGES 36–37: Jordan McHenry
PAGE 38: Mari Sharpe
PAGE 39: Lloyd Ah'Mir Boyd III
PAGE 40: Hagar Rotzin, Ann-Christin Schwalm, Claire Cote
PAGE 41: David Strong
PAGE 42: Rachel Mick
PAGES 44–45: Nina Lafarga, Carlos Gonzalez, Marielys Molina
PAGE 46: Kate Maxted
PAGE 47: Gus Solomons, jr
PAGE 48: Jonathan Morell
PAGE 49: Claudia Mesyasz

PAGES 50–51: Jourdan Epstein
PAGE 52: Kerttu Pussinen
PAGE 53: Aaron Hakala
PAGE 54: Rasmus Kalén, Imogen Huzel, Kert Ridaste, Kipat Kahumbu, Christopher Van Woensel
PAGES 56–57: Kerttu Pussinen, Brontë Poiré-Prest, Eric Bates, Tristan Nielsen, Kyle Cragle, Dominic Taylor, Brandon Miyazaki, Lindsay Culbert-Olds
PAGE 58: Reina Trifunovic
PAGE 59: Mari Sharpe
PAGE 60: Charissa Kroeger, Jill Wilson, Wesley Ensminger, Brooklynn Reeves
PAGE 61: Jill Wilson, Jacob Jonas, Lexi Fitzsimmons
PAGES 62–63: Kipat Kahumbu
PAGE 64: Ghrai DeVore, Daniel Harder, Kevin Franc, Michael Jackson
PAGE 65: Norma Fong, Kelly Del Rosario, Brandan Barthel
PAGE 66: Olga Karmansky
PAGE 67: Craig Smith, Reina Trifunovic
PAGE 68: Matt McEwen
PAGE 69: Kipat Kahumbu, Rasmus

...

Trifunovic, Claire Saintard

Dancers not pictured

MORE THAN 100 ADDITIONAL DANCERS volunteered their considerable talents for this project, but unfortunately they are not featured on these pages. I would like to thank each of them individually for their time, effort and enthusiasm. I absolutely love many of their images, but eventually we just ran out of space.

Alana Allende, Greg Anmuth, Steven Apicello, Michael Apuzzo, Jimmy Arguello, Meghan Barrett, Shannon Beach, Dani Becknell, Rachel Bell, Cody Berkeley, Arianna Bickle, Teddi Bircks, Christopher Bloom, Thea Blossom, Meghann Bronson, Kristian Brooks, Laura Cain, Johnny Chatmara, Indya Childs, Lauren Clementi, Anthony Crouchelli, Shaina Cruea, Kassandra Cruz, Amber D'Entremont, Victoria DeRenzon, Eoghan Dillon, DaVon Doane, Jared Doster, Maurice Dowell, Arlene Erb, Mario Espinoza, Toureau Everett, Lisa Fadeley, Vanessa Faria, Kiana Farrel, Mathieu Forget, Alexei Geronimo, Daniel Gibson, Vera Goetzee, Zui Gomez, Gina Gonsalves, Jenna Graves, Brandon Hansen, Adrian Hoffman, Rachel Hoppock, Erin Alexi Huestis, Jere Hunt, Tanner Huseman, David Ingram, Paige Jacobus, Tevin Johnson, Allison Jones, Jeremy Julian, Kelly Kakaley, Alex Kassidis, Alicia Kingsley, Mélodie Lamoureux, Laura Le Gallou, Adam LeGuerre, Aaron Lind, Melissa Lineburg, Laura Lippert, Anna Llewellyn, Andrew Llewellyn, Kadeem Maliek, Leshay Mathis, Linde Matthews, Skyler Maxi-Wert, Conor McKenzie, Marla McReynolds, Trevor Miles, Jamaris Mitchell, Luis Mondrago, Armony Moore, Brooke Moore, Paul Morland, John Neely, Matt Oaks, Leah O'Donnell, Jon Olstad, Mark Osmundsen, Stina Otterström, Lorenzo Pagano, Samantha Pazos, Megan Peacock, Maxwell Perkins, Oneika Phillips, LaQuet Pringle, Bathoni Puplampu, Seanmichael Rau, Rachel Rebottaro, Rebecca Reeves, Wendy Reinert, Katherine Roarty, Diana Patricia Gonzalez Rodriguez, Morgann Rose, Samantha Safdie, Cesar Sanchez, Pascal Sangl, Nelly Savinon, Connor Senning, Chelsea Simone, Nehemiah Spencer, Nicole Spencer, Morgan Stinnett, Dara Swisher, Kevin Tate, Anna Tello, Ezra Thomson, Amy Thurmond, Bronwyn Updike, Thomas Van Damme, Stephen Vaughn, Casia Vengoechea, Richard Villaverde, Sarah Walsh, Malik Warlick, Kaitlin Webster, Katie Wiegman, Aaron Wiggins, Stuart Winter, Léah Wolff, Sherman Wood, Oksana Yakhnenko

gratitude

I COME FROM GENERATIONS OF ARTISTS, including painters, photographers, filmmakers, musicians, and actors. Edward Steichen, Jackson Pollock, Alexander Calder, and Willem de Kooning were family friends, so throughout my childhood I saw passion everywhere I looked. I also saw turmoil. Lots of it. Stability and intensity rarely go hand in hand. As a young man I recoiled from this uncertainty and resolved to follow a more secure path. Yet as I matured, I felt a deep unrest. I had been exposed to a way of life that espoused one simple doctrine: Follow your heart. Though I had seen firsthand the challenges of an unstable career, I was drawn to one nonetheless. When I decided to turn my photography hobby into a career, I was fully aware of the long odds of success. Fortunately, the excitement of living a life of passionate pursuit outweighed the fear of failure, as it had for generations before me. I would like to thank all those who have inspired by example, who have followed their hearts, pursued their dreams, and proven that ambition can be for more than money and prestige.

This is an acknowledgments page, but I am going to refrain from writing a list of names. The hundreds of people who helped make this book possible know my feelings personally, and I would not want to exclude anyone with an incomplete account. From the designers, editors, and publishers of the book to the behind-the-scenes photographers, filmmakers, administrators, family, friends, and volunteers who dedicated themselves to this crazy project, I am honored to have collaborated with each one of you. I do not have the words to properly thank you other than to simply say, "Thank you!"

Finally, I would like to acknowledge my past life. I don't know what it was, but I must have done some serious humanitarian work to deserve all my great fortune in this life. The sense of joy I feel in my career pales in comparison to how I feel at home. There is no greater calling than parenting my children, Salish and Hudson, and sharing that journey with my incredible wife, Lauren.

PHOTO BY BOB PLOTKIN AT HUDSON RIVER MUSEUM

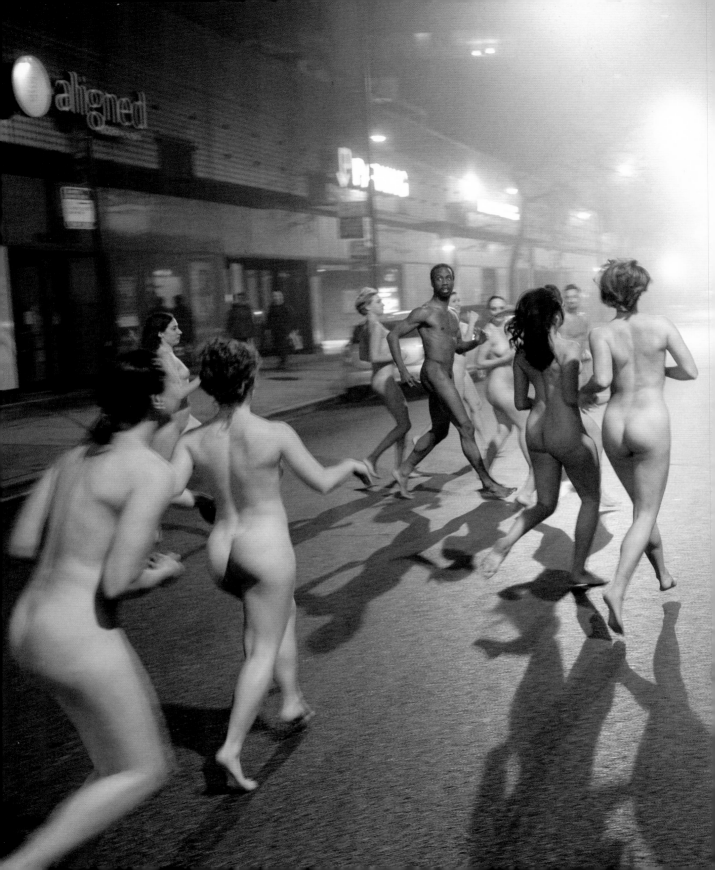